NAOMI OKAMOTO

THE ART OF

SUMI-E

Beautiful ink painting using
Japanese brushwork

SEARCH PRESS

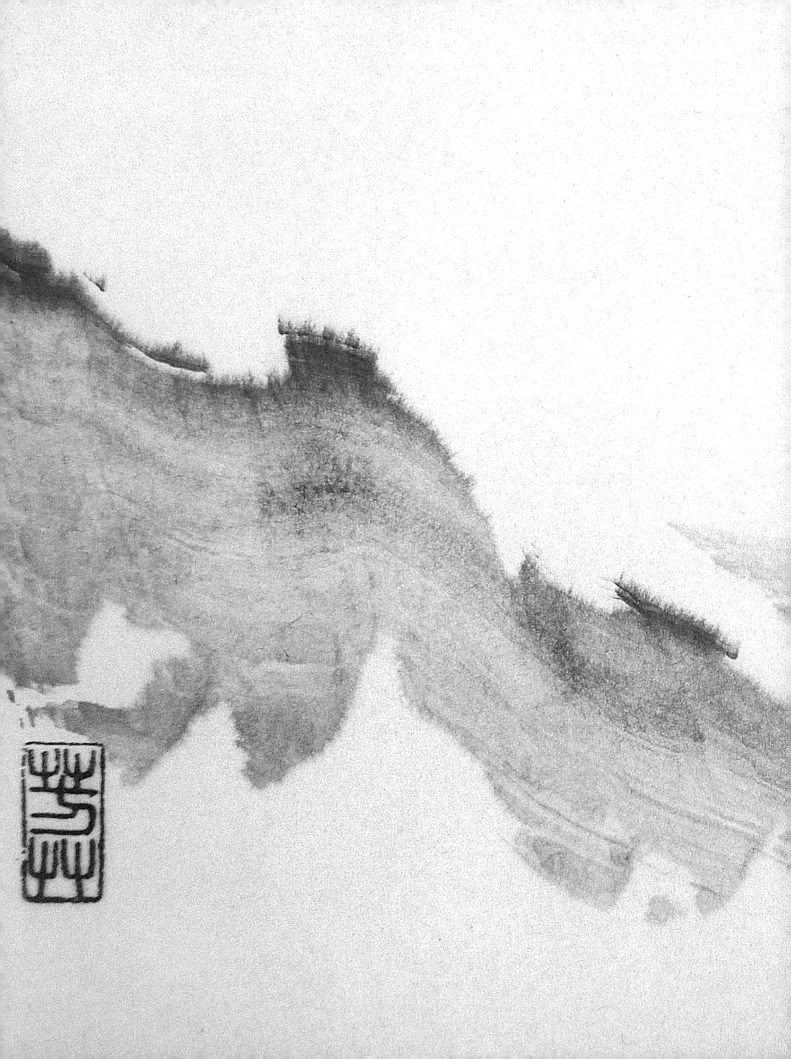

NAOMI OKAMOTO

THE ART OF

SUMI-E

Beautiful ink painting using Japanese brushwork

Contents

Introduction 7

The essence of Japanese ink painting 8

The white space in ink painting 10

Painting materials and additional aids 12
Ink 15
 The blue or brown ink stick and the grinding stone 15
 Liquid ink 16
The brushes 18
 Japanese Kumadori brush for shading 18
 Japanese Saishiki brush for colouring 18
 Japanese Menso brush for detail 18
 Japanese Sakuyo brush for drawing lines 18
 The traditional Japanese Choryu paintbrush 18
 Japanese Maruyama (Gyokuran) paintbrush 19
 The traditional Chinese Ran-Chiku paintbrush
 (orchid bamboo brush) 19
 Handling the brush 21
What you will also need 21
Painting on paper 22
 Gasen-shi paper 23
 Kozo-shi, kozo-based paper 24
 Dosabiki-Ma-shi 24
 Torinoko-shi 24
 Shiki-shi 24
Painting on silk 26
A little look at Japanese aesthetics and on the ink 'running' 28

Working with the ink and brush	**30**
Grinding and preparing the ink	32
How to fill the brush	33
Brush control – how to hold the handle of a brush	34
Brushstrokes – which one and when?	35
Holding the brush at an angle	35
Holding the handle in the vertical position (upright)	36
Pushing the brush across the paper	36
Practising painting techniques from originals	**38**
Thoughts on painting using originals	40
Exercises with lines	41
The first stroke becomes a fish	41
The second experiment: Orchids	42
The third experiment: Bamboo	46
The fourth experiment: Pussy willows with catkins	49
The fifth experiment: Plum tree branch	50
The sixth experiment: Pine tree branch	52
The seventh experiment: Bird on a branch	53
Exercises with spaces	54
Small space with two strokes – anthurium	54
Rough outline with one stroke – promontories	56
Themed exercises	**58**
Still life in ink painting	60
Exercise: Pears	61
About composition, harmony and contrasts	62
Exercise: Teapot and cup	63
Exercise: Cherries	64
Exercise: Chrysanthemum in a vase	65
Landscapes in ink painting	66
Exercise: Tree studies	67
Exercise: Weeping willow	68
Looking at reality in perception	68
Exercise: Mount Fuji – the holy mountain with pine trees	70
The study of rocks	72
Exercise on the function of dots	74
Space and composition in landscape painting	75
Exercise: Fantasy landscape in the classic manner	75
Differences between Chinese and Japanese ink painting	76
Exercise: Reflections in the water	77
Exercise: Snowscapes	80
Figures	82
From sketching to painting	82
The elongated brushstroke	84
Ideas to copy	86
Colour in Japanese ink painting	**92**
The role of colour	94
The difference between coloured ink painting and related painting techniques	95
Brush control in coloured ink painting	96
Reduction in colour	96
Applying colour in Japanese ink painting	97
Applying black ink and colour separately	97
Using black ink and colour mixed	98
Suitable colours	100
Painting flowers and animals in colour	**102**
Hibiscus – basic exercise for filling with colour	104
Camellia – brush control for oval, three-dimensional leaf shapes	106
Iris – creating a shape with a few brushstrokes	108
Butterfly – brush control to make a triangle	110
Hydrangea – brush control to make a square	112
Grape – three-dimensional sphere with light effect	114
Wheat ear and cat – painting with a spread brush tip	116
Coloured landscape painting	**118**
With few colours – stylised or classic landscape painting	121
Painting without contours – filling areas without outlines	126
The coloured landscape sketch – a precious tool in developing a picture	128
The white space in painting	**130**
The white space on Sunago paper	132
The white space on fibre paper	134
Creating the white space by tinting the back of the paper – blocking out with alum	135
The white space as an airbrush technique with a sieve	136
The white space on coloured recycled paper	138
The white space as an airbrush technique by tapping the handle of the brush	139
Appendix	**140**
Collection of motifs for cards and stationery	142
Mounting finished pictures	152
What you will need for mounting	152
How to do it	152
The seal – the personal touch	155
About the history of the seal	155
The appearance of the seal	155
My seals	156
Making your own seal	157
Carving and placing the seal	157
A little about purchasing materials	157
Afterword	159
About the author	160
Publishing information	160

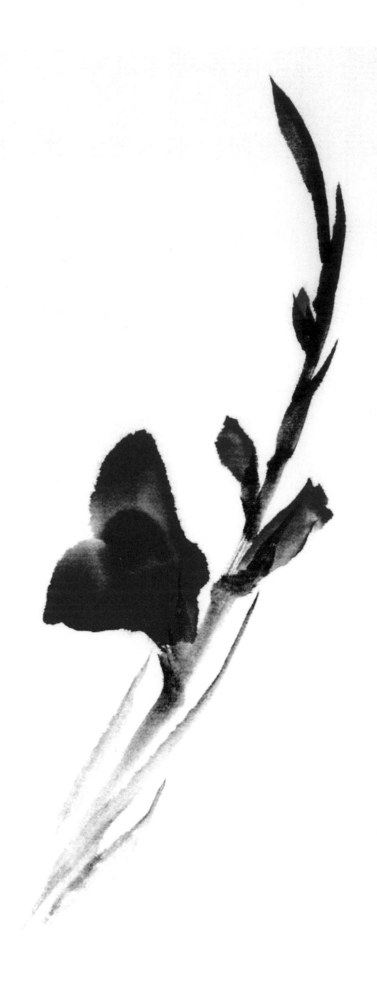

Introduction

Two decades have passed since my first book, *Japanese Ink Painting: The Art of Sumi-e*, appeared on the market. I am delighted to be taking up the subject again at greater length, and passing on my ideas, knowledge and experience. I refer to not only the purely technical aspect of Japanese ink painting, but also to its spirit, which can only be understood in the context of Japanese culture and philosophy.

When I came to Germany, I thought that the Western style of painting, which had occupied me since my childhood, would be present everywhere. However, I soon found that what is taught about Western painting in Japan has little in common with authentic Western painting. Above all, it was a shock to me to discover the cultural differences between the Japanese style and that of Western art.

Aestheticism was already an important part of my art. I tried to come closer to the secret of existence in beauty, but suddenly I had to question my painting in the Western form and confront its roots in depth.

I have always been fascinated by the atmosphere and deep stillness of the free space in ink painting. I was lucky enough to study ink painting under Japanese and Chinese masters, who are without equal in this art. When you learn from a master in Japan, you can only ever paint in his style, even after twenty years.

Then, as now, there were certain clichés about Japan and its culture. Japanese culture is extremely diverse, but there are many people who have little understanding of it and use cultural references clumsily – which never fails to annoy me! This is why I want to try and show Japanese culture as authentically as possible.

In Japan, traditional ink painting and literature are closely linked. So with that in mind, I have written this book with my own perceptions, accompanied by a number of famous poems, in order to provide a reference for the various paintings.

This is perhaps not a conventional format for a textbook on painting, however, I would like to make it easier for you to access Japanese ink painting and attempt to touch your soul a little. This style of painting is a direct expression of a subjective feeling that forms the essence of Japanese culture.

Hopefully, some of the 'graphic' aesthetics and the spontaneous nature of these paintings, will make it easier to access what may be strange and new.

I have attempted to bring the traditional principles of Japanese ink painting into the present. I am firmly convinced that anyone can learn this painting technique, and that the path is open to all those who are willing to learn from my instructions and apply them sensitively.

Finally, I sincerely hope that the emotion, beauty and art of Japanese ink painting will not be lost in the modern age.

Yours,

Naomi Okamoto

The essence of Japanese ink painting

In order to get a clear sense of what ink painting is about, I am going to explain the external differences between Japanese ink painting and European painting.

The aim of classic Western painting is to depict the world and its objects as realistically as possible. For a three-dimensional effect, it needs a precise structure composed of a foreground, a background and a central object, as well as light, shadow and, above all, colour.

Traditional ink painting needs none of these aids. Even though it, too, depicts a precise view of the world, its goal is not to produce a realistic reproduction, but rather an expression that the painter wants to convey.

Ink painting is an attempt to capture, in a condensed form, the essence of an object, a person, an animal or a landscape together with the spiritual processes within the artist. Which is why 'suggestion' plays a key role. Suggestion and simplification convey reality in a painting.

Japanese ink painting combines the traditional aesthetic of simplicity with a distinct emphasis on intuitive expression. A sense of harmony pervades every scene. This explains why paintings of flowers, birds and landscapes are so popular.

This style of painting, heavily influenced by Zen Buddhism, uses only black ink. However, according to Oriental understanding, black ink is not simply black – it contains every colour. It also represents the highest level of colour simplification.

Different degrees in tone do not represent different shades of light or brightness as they do in Europe; rather, they produce an awareness of colour by creating a contrast with the white space. This is what gives the painting the appearance of colour. The tones also serve as a direct expression of emotion, and they mirror the intensity of the painter's interest. So this form of painting has an expressive character.

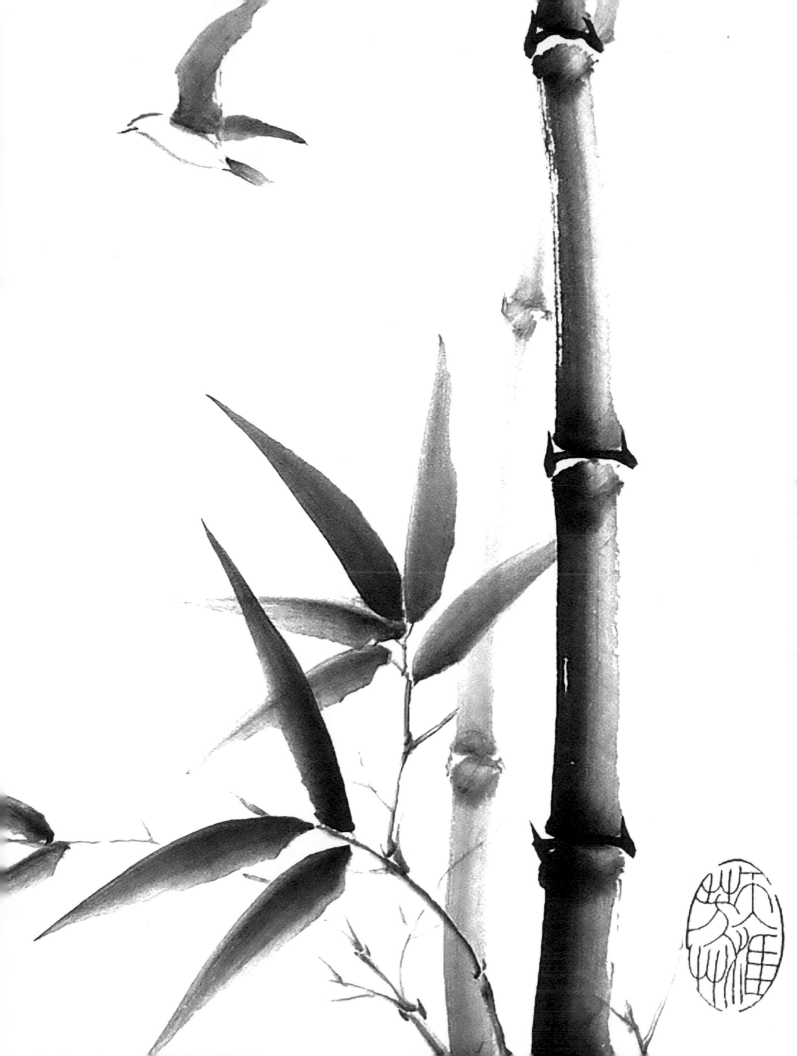

The white space in ink painting

White space is a vital part of ink painting (see also page 130).

The white space in an ink painting is not simply an open space left after the theme of the picture has been established, but in Japanese art it is an essential part of the picture. White spaces come alive and gains depth, creating form and allowing you to become one with the subject and the technique.

For example, imagine that as you look at a meadow flower, you are moved by its beauty. As the radiance of the ink is transferred to the paper with your brushstrokes, the flower eventually seems to 'breathe' and come alive in your picture. In this way, the white space receives breath and life.

In ink painting, a line does not represent the contour or the outer edge of a form; rather, it represents the inner power of the painted form itself. It represents soul, spirit and the rhythm of life.

The art form came to Japan from China and was heavily influenced by Taoism and Zen Buddhism.

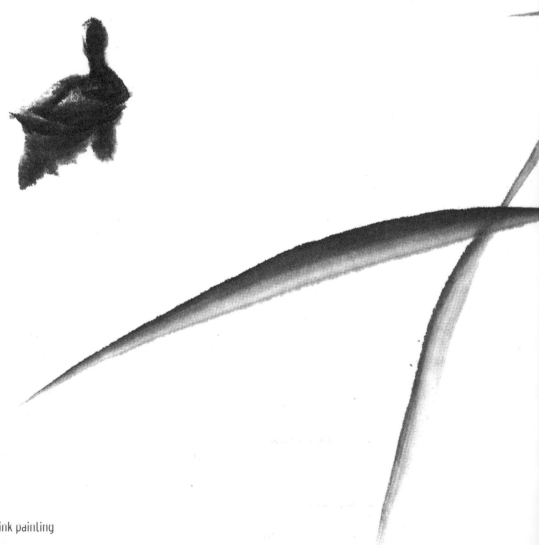

Lively stillness.
The foreground is composed of the reeds, however, the depth in the picture is expressed by the white space and the duck.

The white space directly correlates to these two philosophies: the understanding of movement – the 'real' flowing and dissolving into 'nothingness' – and the existence of 'emptiness' are of central importance to both beliefs.

The essential character of ink painting and the life force it expresses may feel strange at first because you have to become one with the object in the painting. For example, if you imagine feeling the sunshine upon you, just as a flower might, then you may start to become one with the flower.

One must reflect on the gentle sound of the ink and a simple line, created from a state of inner quiet. These features express the most powerful energy – this is what Oriental philosophy describes.

Painting materials and additional aids

The basic materials for ink painting are quite straightforward. However, this can change as your ability improves requiring you to use different types of paper, inks and brushes.

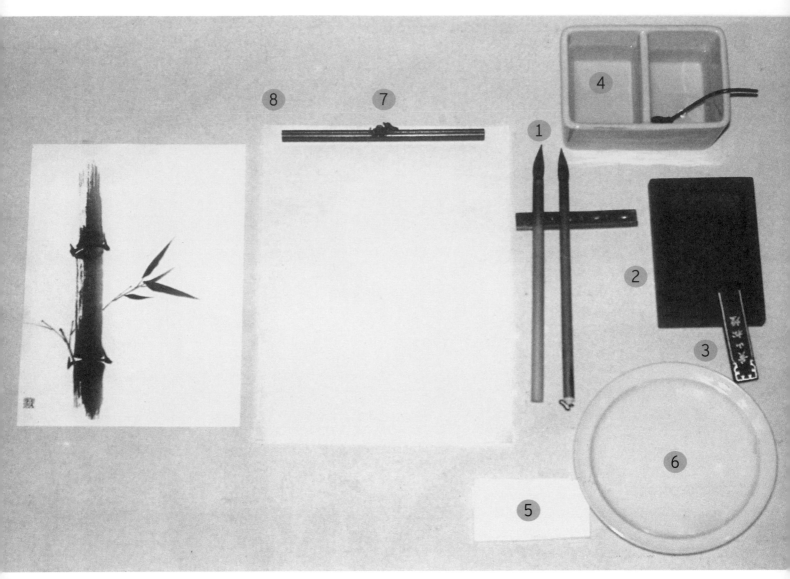

The tools for traditional
ink painting:

1 Brush
2 Grinding stone
3 Ink stick
4 Water bowl
5 Cotton cloth
6 Plate
7 Paperweight
8 Mat or pad

The brush, ink stick, grinding stone and paper are called the 'four treasures' in Japan and China, and they are handled with loving care. This is based on the tradition that ink painting (and especially calligraphy in Japan) is closely linked to spirituality.

As far as quality and price of the tools are concerned, there is a world of difference between the cheap souvenir-type items and the aesthetically adorned, expensive materials of the very best quality. Today, the look, the exterior of the item, sadly no longer provides the potential purchaser with any information on quality.

As a beginner, all you need is a simple and comfortable Japanese or Chinese brush with a good, evenly tapered head, an ink stick and a grinding stone, plus lightweight paper (see also page 157 on purchasing materials).

Ink

Hear the word 'ink', and one immediately thinks of the rich, black stroke or pen drawing created with drawing or India ink. Western artists are attracted by the strong appearance of this medium. However, transparent coloured liquid ink that contains pure acrylic or shellac as a binder is also available (and it is waterproof). Another option is Chinese Nanking ink, which is made from rubber and soot. However, I do not recommend these for original ink painting.

The blue or brown ink stick and the grinding stone

The best ink for Japanese ink painting is the solid ink stick. This ink is ground with water on a grinding stone (sometimes also called an 'ink stone'). Grinding stones are available in various shapes and colours, from round and oval to rectangular. Most grinding stones are made from a specific kind of slate, which comes in various qualities depending on the density of the surface structure. If the surface of the stone is too rough, the pigment particles from the stick will not dissolve properly, and the ink will lose its brilliance.

The composition of an ink stick is different from that of Western ink. The colour is obtained from soot pigments bound with bone glue. It also contains fragrances (e.g. lotus) that are said to be calming. The ground ink contains pigment particles of different sizes, which increase the nuances of the black ink (see the comparisons on pages 16 and 17).

In Japan, students are taught to see the blackness of calligraphy ink as a testament to the strength of the mind, and to this day it is considered on par with willpower. Likewise, the brilliance of black ink is valued and used as a measure of attitude.

Because of its natural origins, this organic ink was once said to have the same potency as Mother Nature. Japanese literature also compares it with the darkness of night, which hides the colours of all things.

What fascinates me about this ink is its ability to convey what has already been perceived, allowing it to be experienced again. You can see in it something living, something real, something almost impossible to achieve with commercially manufactured ink. Two kinds of ink stick are used in Japanese ink painting: blue and brown.

Blue is used more for sumi-e in Japan. Because it does not reflect light very well it appears to be black with a blue hue. It is traditionally made from the soot of burnt pinewood. Due to the process of burning, it can be contaminated with impure, rough particles that leave scratches on the surface of the ink stone, although this also increases the amount of nuances when painting. Due to the high manufacturing costs, mostly petroleum is burnt in China today to create blue ink sticks.

In Japan, brown ink is usually produced from the soot of rapeseed oil. The pigment particles are much smaller than those in blue ink, and it reflects more. The ink has a brown tint, which makes it seem warm and lively. It is extremely popular with Chinese painters and calligraphers.

In addition to soot pigments, ink sticks also contain animal fats that are used as glues. They absorb humidity very quickly, which makes them susceptible to mildew, quickly rendering them useless. Because of this, it is important to carefully dry and wrap an ink stick after it has been used. They can dry out, become brittle and even fall apart. Due to the fat content, they will stick to a surface, such as the ink stone, if they stay moist for a long period of time.

I always think that ink made on an ink stone is like a living being that changes over time, and that is what makes its naturalness so honest and so precious.

Liquid ink

Today, ready-made (liquid) inks from Japan and China are available in addition to ink sticks. Liquid ink is less expensive and easier to use. These inks are usually used for calligraphy exercises in Japan, where the need for rich, black shades calls for large quantities of ink.

The pigment particles in ready-made ink are larger than those in ink made on an ink stone, but that also makes it absorb far more light. Because the pigments are all the same size, the ink lacks the fine nuances. Ready-made ink contains various glues and chemical additives. Instead of pigments, it contains dyes with acrylic resin, which are hard on brush hairs.

Good advice!

Do not use ready-made ink that has been standing for a while because the pigments and water will separate. This can happen quite quickly in summer. The ink becomes dull and loses its brilliance – and the smell is most unpleasant! It is better to grind new ink after a long break from painting.

Comparing ink and watercolour. The black of the ink (below) is far more expressive than the black of the watercolour (opposite).

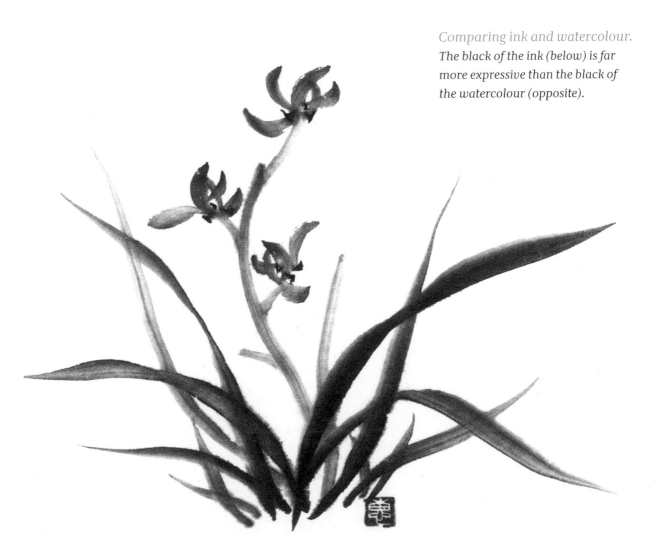

Good to know!

For some time now, a very expensive ready-made ink has been available in Japan. It is made with an ink stick and therefore contains very fine, differentiated pigments. However, because the ink stick contains bone glue, the ink also contains various chemical additives. Although I have tried using many such products numerous times in the past, I have never achieved as good results as I do with freshly ground ink.

If you want to experience the very essence of ink painting, then I can only advise you to grind your own ink. Yes,

it takes time, but this monotonous act before painting is helpful in finding an inner sense of quiet. It is a good opportunity to visualise the picture that you want to paint. This is important because there is no time to lose when painting with ink. Waves quickly form on the absorbent paper, which makes it difficult to continue working. Furthermore, the inner flow of strength should not be interrupted or obstructed.

As with watercolour, it is almost impossible to make corrections afterwards. For this reason, it is

important to know exactly what and how you want to paint before you reach for the brush. That is why the preparatory stage is so important.

Remember: the brilliance of the ink is the medium that will convey your own energy into the painting, its varied shadings allow you to express yourself. Do not sacrifice this for the sake of convenience.

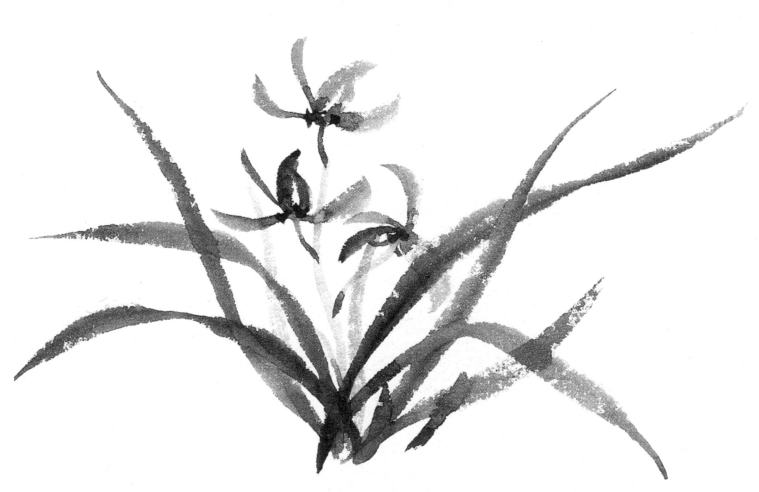

The brushes

The type of soft, flexible Japanese or Chinese brush, and the way it is used, can express a wide range of nuances in a single stroke. These different tonal values, and the ability to change the shade or nuance within a stroke, cannot be achieved with Western paintbrushes. It is true that a watercolour brush made from marten hair, with its fine tip and elastic hairs, is quite handy. However, because of its construction it does not hold a lot of ink, and it is too springy for ink painting.

Buy an ink painting brush that is easy to use and has a greater range of expression. At a pinch, you can try using a calligraphy brush. The hairs should be at least three centimetres long.

Brushes made in the Orient come in different sizes, length, construction and hair, depending on how they are to be used in painting and calligraphy. They are made from the hairs of goats, sheep, horse, badger, deer, weasel, bear, wolf and rabbits, as well as other animals. White-haired brushes are usually made from goat and horsehair.

Brown-haired brushes are made from horse, badger, bear, weasel, wolf and deer. Hair from an animal's summer fur is stiffer than that from its winter coat. Goat and sheep hair are considered soft, while hair from weasel and badger is stiffer, and the hair from the mountain horse even more so.

The best and most coveted hairs are from a specific breed of sheep. The capacity and elasticity of these hairs are far superior to any other. Unfortunately, this breed of sheep is becoming increasingly rare, and so a brush made from the original sheep's fleece has become quite expensive. Due to costs, more and more natural hairs are discreetly being replaced by synthetic hair without the purchaser being aware. However, because they have no pores, synthetic hairs only hold a little liquid.

The names of the brushes given here are the traditional ones. The composition of the hairs, prices and quality differ from manufacturer to manufacturer.

All the Japanese instruction books for *sumi-e*, Japanese ink painting, name the following brushes:

Japanese **Kumadori** brush for shading

This is a shading brush with a short, firm brush head made from horse and sheep hair. It is often used in coloured painting with ink on silk or non-absorbent paper in order to shade the brushstroke.

Japanese **Saishiki** brush for colouring

This brush is always made of deer and sheep hairs, has a good absorbency, is extremely smooth, and is very good for applying colour. It is mainly used for filling areas between outlines with colour. In painting without contours, it is only used in small forms.

Japanese **Menso** brush for detail

This is used for painting fine lines and outlines, and is made from weasel, badger or deer hair.

Japanese **Sakuyo** brush for drawing lines

This is made from sheep and weasel hair, and is a good choice for drawing lines. However, it is also often used for colouring areas such as leaves or stems. The brush has a short head and a sharp, elastic tip, which is handy for making slight changes to the width of a line while painting. Despite its excellent ability to absorb water, it is quite easy to control the quantity of ink flow.

The traditional Japanese **Choryu** paintbrush

This brush is usually made from sheep hair mixed with the harder hair of badger, horse and deer. This brush is soft, supple and elastic with excellent absorbency and a good sharp tip. A new brush can be quite difficult to handle, but the hairs become firmer with frequent use. Adjusting the moisture requires more attention than the following, slightly less expensive Maruyama. It is in widespread use in *sumi-e* schools and on courses in Japan and Taiwan.

Japanese Maruyama (Gyokuran) paintbrush

Usually, this brush is made from the belly hair of a horse with the addition of badger, sheep and deer hair (the more expensive ones will also include sheep hair). It is firmer than the Choryu and easily forms a good tip that is also suitable for creating fine shapes. It is very good to handle.

The traditional Chinese Ran–Chiku paintbrush (orchid bamboo brush)

This brush is made from weasel hair, which is a little firmer, has less capacity to hold water than the other brushes described above, and is much less expensive than the Japanese brush. It is well suited for creating rough outlines of shapes and the strong, bony, weighty lines that are so important in Chinese painting. There are several structural differences between traditional Japanese and Chinese painting brushes. Genuine Japanese painting brushes have a clean, sharper tip, whereas the Chinese ones are more blunt. This is due to different aesthetic requirements.

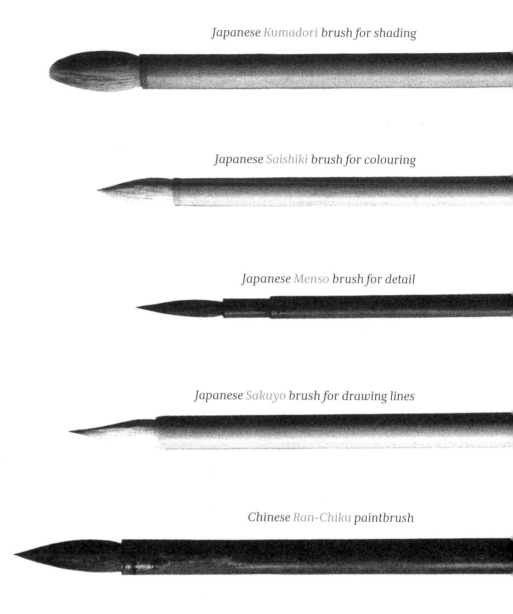

Japanese Kumadori brush for shading

Japanese Saishiki brush for colouring

Japanese Menso brush for detail

Japanese Sakuyo brush for drawing lines

Chinese Ran-Chiku paintbrush

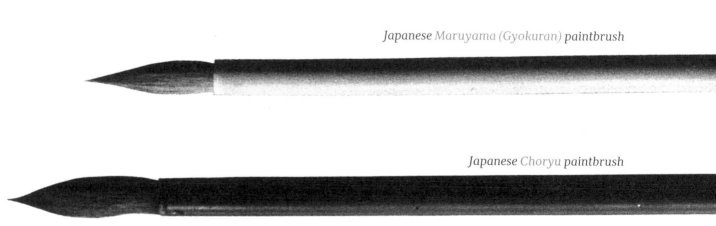

Japanese Maruyama (Gyokuran) paintbrush

Japanese Choryu paintbrush

Buying advice

Handling the brushes is not easy for inexperienced hands. I suggest starting with a brush with somewhat firmer bristles. Although there are lots of different brushes and they all look so charming (so much so that I myself have over a hundred of them), I always come back to the same brush. It is one of the traditional painting brushes. With it, I can create all kinds of shapes – from lines as thin as a hair to wide areas.

The brushes described here are available in three different sizes. The bristles on the larger brushes are about 4cm (1½in) long, on the medium–sized brushes they are about 3.5cm (1¼in), and on the small ones they are around 3cm (1¼in) long. The short-haired brush is quite easy to use, but it tends to lose ink very quickly. Because the ink/water combination has to be replaced more frequently, there can often be an uneven and 'restless' appearance to the painting. On the other hand, brushes with longer bristles are perhaps less easy to handle, but it is possible to draw very fine lines with them and to fill in large spaces. A single load of ink can last a long time.

As the difference in price is not huge, I recommend starting with the larger one. After all, in the beginning it's all about learning to master the materials. I believe we learn faster when a tool is not so easy to handle. We all know that 'practice makes perfect'.

However, the brush must always work properly. Unfortunately, this is not the case with many imported brushes. A good brush must have a clean elastic tip that does not fan out under light pressure. Also, most brush heads are glued for transportation making it possible to see or try out the quality of the brush tip.

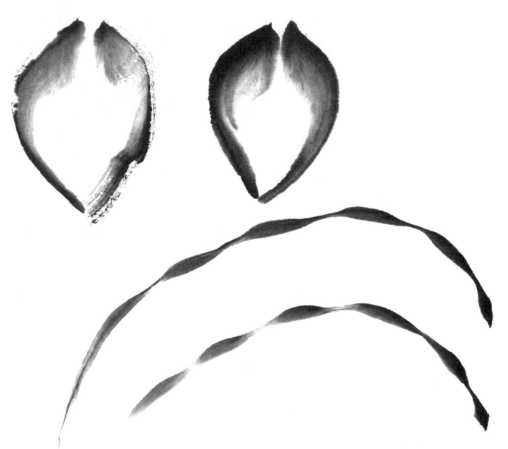

Brush comparisons.
Comparison of a watercolour brush and a Japanese painting brush of the same size.

Despite the softness of the sable hair, a watercolour brush is not inherently flexible. If it is pushed, the bristles fan easily and the brush tip will quickly lose its shape and bend under pressure. As the Japanese painting brush is more flexible, its tip stays together better.

Handling the brush

• Dip a new brush in warm water and squeeze the bristles gently between your fingers to release the glue from the bristles. Rinse. Do not leave the brush standing in water or the bristles will bend, and the glue that sticks the brush head to the shaft will dissolve.

• In Japanese and Chinese brushes, excess bristles are deliberately put in the handle along with the bound ones and then glued so that the excess ones eventually fall off. So do not panic if you find you are losing a few hairs at the beginning! On the other hand, though, if your brush is constantly losing clumps of bristles, then you do have a problem.

• Wash the brush immediately after using, otherwise the bristles will stick together as they dry. Be particularly careful with ready-made ink as the chemical additives attack the bristles and will completely destroy them over the course of time. This is something that puts many brush-makers off ready-made ink.

• After washing, shape the end of the brush into a point. Lay the brush flat or hang it with the bristles pointing downwards to dry so that the water does not settle in the shaft, penetrate the handle and dissolve the glue.

• Look out for moths when you have a brand new brush – they love them! Fortunately, they are less keen on brushes that have already been dipped in ink. It is generally a good idea to protect your brushes against moths.

What you will also need

Two non-greasy water containers without sharp edges

The containers must be absolutely free of any grease. The larger container, perhaps a jam jar, is used for cleaning the brush, and the smaller one is for clean water to grind the ink stick.

Cotton rags

A cotton rag allows you to control the amount of liquid in your brush. Immerse the rag in water and wring it out well. It is easier to control the amount of ink in your brush with a damp rag than with a dry one. If necessary, use paper towels.

Paperweight

In order to work in peace, the paper must not be able to move about. You will need paperweights to help with this. You could use little stones, metal weights or similar items.

White plate, about 20cm (8in) or more diameter

Use this to dilute the ink and mix different shades. A white plate is needed because it is easy to judge the intensity of the ink and reshape the tip of the brush. You can also use a bigger plate to make it easier to distribute the ink through the bristles.

Mat or pad

The best kind of mat or pad is absorbent felt, or else an old piece of smooth rug or terry towelling. This is necessary because the ink-and-water penetrates the thin paper, and could puddle on the surface of the pad – not what you want! That is why a pad made of hard cardboard or a wooden board would not be suitable. A hard pad would also make it difficult for the bristles to move across the paper, and the ink could run sideways.

Painting on paper

In recent years, the range of paper available has become much more varied, especially paper from East Asia. This is why it is now much easier to find paper for ink painting than it was a few years ago.

Paper that is suitable for ink painting is available heavily glued and in various thicknesses. If the paper is rough and felt-like, the ink will disperse rapidly, and the picture will look dull and lifeless.

However, if the paper looks very smooth and shiny, then it contains too much glue. The ink will collect in puddles on this type of paper, slowly sink into the fibres, and leave unintended random dark spots and watermarks. Watercolour paints, however, retain more of their brilliance on this paper than they would on more absorbent unglued paper.

You can use inexpensive machine-made calligraphy paper to practise on. Lots of the types of paper are not too absorbent and are easy to handle. They also produce varied ink shades in the painting.

Despite the huge variety on offer, you might have problems in your search for paper if your requirements are very high and you want handmade, highly absorbent Gasen-shi paper. It is not very easy to find in the Far East, let alone further afield. Every single sheet of handmade paper is unique, a one-off, so the absorbency is not always the same. Why? As paper ages, it loses moisture, so the ink lies on it differently. How the paper is stored, and the composition of the raw materials, is extremely important.

Another problem in the West is the names of the papers. Unlike when you are buying Western paper, the name alone does not provide clear information on its consistency. So it is possible that you could buy paper of the same name and then find that its consistency and absorbency are not the same as before.

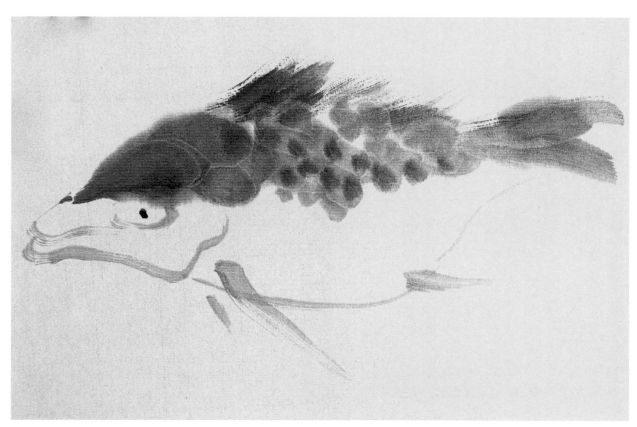

The charming effect of applying ink to Gasen-shi paper.
The white edges separate the scales, creating a three-dimensional effect. These edges occur when the wet ink is applied, causing an overlap. This effect is less noticeable with dark ink and on less absorbent Gasen-shi paper.

Lots of papers in China and Japan are traditionally named after the area where they were originally made. This is the case, for instance, with Chinese Xuan papers (Xuanzhou district) or Japanese Tosa-shi (today's prefecture of Kochi). These papers are made by lots of little businesses using traditional methods. In Japan today, they usually have random names such as Fuji, White Snow or Fragrant Orchids.

European importers choose from countless paper varieties, and can often stock them under names that provide imprecise information. Names such as Chinese paper, Japanese paper, rice paper or bamboo paper can be misleading.

As a general rule: bamboo and rice paper are short-fibred, absorbent papers for calligraphy and painting. If a paper is called bamboo paper, more yellowish in colour and made from bamboo fibres, then it will be less absorbent than rice paper, and often cheaper. Both papers are very thin and tear easily.

In the past, the familiar term 'Japan paper' was often used for fibre papers, such as Unryu or silk paper, and often, generally for paper from Japan. What is sold today under the name of Japan paper is mainly long-fibred, handmade, tough paper, such as paper with kozo or hemp, and embossed fibre paper. These papers are all more or less suitable for ink painting.

The effects and the way the ink runs are all extremely different, so everyone will have their own preferences. These days when everything seems to be about the price of things, it is not always possible to be sure that manufacturers adhere consistently to the original methods and composition of raw materials. So it is quite possible that qualities can change in a short period of time.

Gasen-shi paper

Both in China and in India, handmade papers that retain the brilliance of the colour of the ink, its transparency and the nuances of its shades are extremely popular, even though the ink runs quite dramatically. One such paper is Gasen-shi. It is made in Japan and China from the fibres of a particular kind of elm, plus rice straw and talcum. However, there are tremendous differences in the composition of the various raw materials and in the absorbency. If the paper is not given any particular treatment and is extremely absorbent, it is difficult to work on it and create a painting that is lively and glowing. Most Chinese Gasen-shi papers are more absorbent than the Japanese ones.

(1)

(3)

(2)

(4)

Applying ink to Gasen-shi paper.
1 *Dark on wet, light ink.*
2 *Overlaid ink areas in light ink.*
3 *Light on wet, dark ink.*
4 *The track of the splayed brush.*

Kozo-shi, kozo-based paper

Thanks to the long fibres, this paper – which is made from the bark of the kozo plant (paper mulberry tree) – is tough. This is the same with papers that contain hemp, mitsumata or gampi. These fibres are only visible if you tear the paper.

One other special feature of this paper is that slightly rough, dry areas develop during painting, which expresses strength or fast movement and speed. An area like this also works like a blaze of light. This paper has only moderate absorbency. Nonetheless, it is a popular choice because it is easy to handle even though it has the disadvantage, in comparison with untreated Gasen-shi, of the colour being reproduced without quite so many nuances.

Dosabiki-Ma-shi

'Ma' means hemp, and 'dosa-biki' means preparing the paper with bone glue and alum. This makes sure the colour stays bright. The more the paper is prepared, the less is seen of the various nuances of the ink, as on watercolour paper. As the paper is very tough, the ink or colour can be applied in several layers and smudged.

Torinoko-shi

If you are looking for non-absorbent paper for detailed work, this paper made from gampi fibres has always been valued. It is the colour of eggshell, and it has a smooth surface. The paper is very good for blending contours and creating gentle transitions, although this could be at the cost of the ink's brilliance, transparency and subtle shading qualities. The paper is similar to fine-grained watercolour paper.

Shiki-shi

This is a traditional paper cardboard for painting and calligraphy, created for decorative purposes. The format is almost square, and it is available in various sizes. The standard size today is 27.3 × 24.2cm (11 × 9in). The top layer of the cardboard is covered in various papers, both with absorbent Gasen-shi, non-absorbent machine-made basic papers, and also with high-quality Torinoko-shi or Kozo-shi. Shiki-shi is available in white, gold, silver, coloured and patterned versions. The main advantage of this cardboard is that it stays flat when wet (see page 90 for an example).

Good advice!

• As a general rule: always paint on the smooth side of the paper.
• It is better if you adapt to the paper you are able to obtain, and work with it happily and satisfactorily.
• In an emergency – and only then – use blank newspaper to practise working with the brush.
• If you like a handmade, highly absorbent paper, then treat yourself to sufficient stocks, as you might not be able to obtain more of it later. This also has the advantage that moisture will be drawn from the paper during its long storage, which will make the colours glow. You just need to make sure that the paper is not affected by the cold, which is when it develops brown stains. Paper needs oxygen. Protect it against direct sunlight.

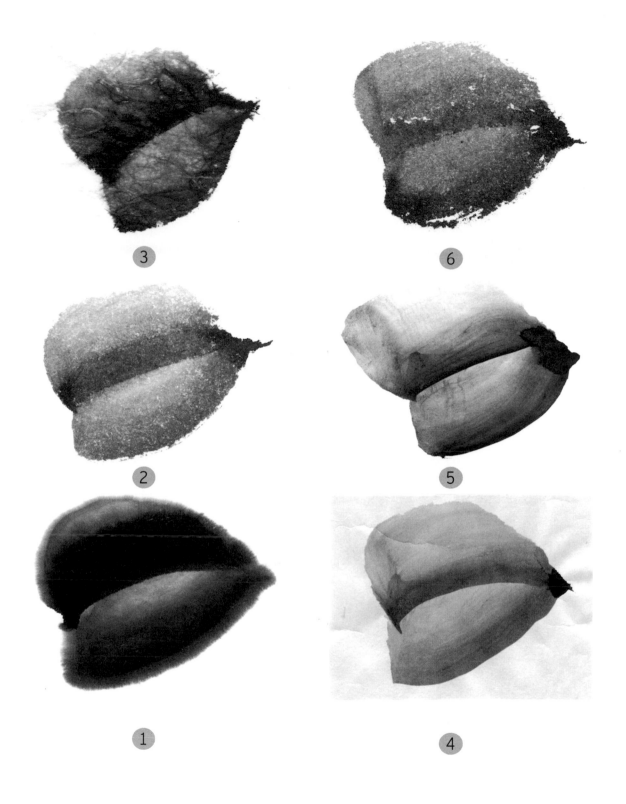

Different effects of the ink on different papers.

1 *Highly-absorbent Gasen-shi*
2 *Dosabiki-Ma-shi*
3 *Unryu-shi Japanese fibre paper*
4 *Torinoko-shi*
5 *Drawing paper*
6 *Kozo-shi paper*

Painting on silk

Silk has been a traditional painting surface in China for 2000 years.

Its benefits include a very dense, fine surface that makes it possible to draw the very finest lines along the threads on the textile structure. It is also very good for blending.

However, there has been a marked decline in painting on silk. Today, most ink painters prefer to paint on paper. The main reason for this is that many nuances of the ink do not reproduce on silk as well as they do on paper.

Painting on silk is also extremely laborious. First, you have to glue the silk to a frame and treat it with hot water to smooth it. Then a single layer of thin glue with alum is applied to the back, and one or two layers to the front.

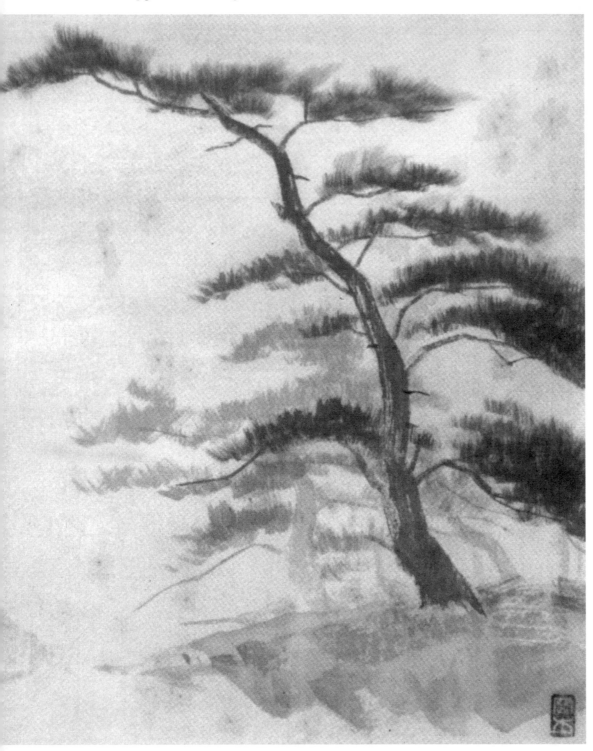

Pine motif on silk with soft, blurred contours. For this picture, the silk was first glued to the frame in the traditional method, and then treated with glue/alum water.

You can use a combination of gutta-percha (5%) and benzene, although this mix might be a little too harsh. It is better to adjust it from case to case. You can also treat it with white paint made from ground shells, after which you will be able to paint really well.

Silk also has an unpleasant tendency to shrink and is not as durable as paper. The advantages of painting on silk are evident when painting animals and birds (with fur and feathers) and landscapes shrouded in fog, for which it is ideal.

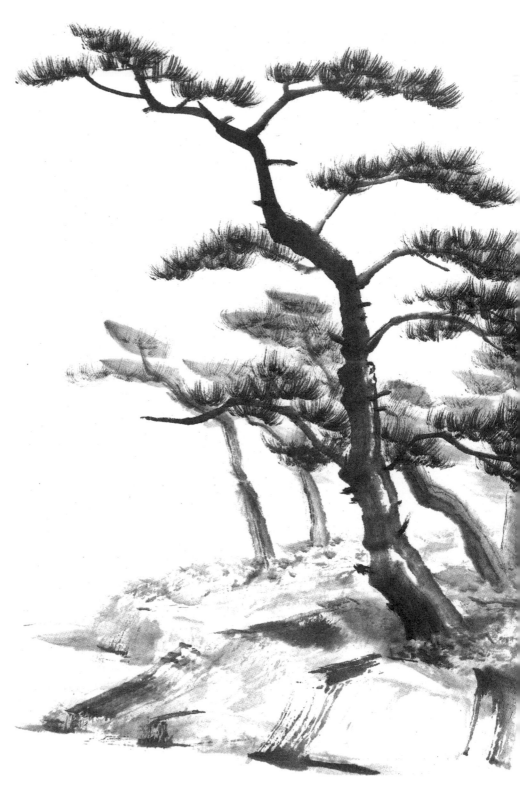

Pine motif, painted on paper, with hard contours.

A little look at Japanese aesthetics and on ink 'running'

While I was teaching, I often wondered whether many people in the West considered the way ink ran to be unpleasant or even unattractive. When the first line starts to run on absorbent paper, many respond as if they had made a mistake.

In Japan, though, the ink running on the paper is always seen as something beautiful. It is associated with the moist climate, where nature's shapes often look as if they were framed in soft outlines. That is why pictures of misty landscapes are particularly popular. For this mood, we use the expression 'like in ink painting', and the running of the ink is something people associate with their view of life and the transience of the flowing form.

Neither in language nor in the physical form do we attempt to distinguish the 'true' form. The Japanese believe that the ink flows into the paper, which is why it is important to them that the paper should be absorbent.

A Japanese paper manufacturer once told me that a European importer was willing to pay any price for some paper that was less absorbent than usual due to a development error. However, the manufacturer could not bring himself to make this paper which, according to Japanese standards, would be flawed.

I am sure that Japanese paper manufacturers have never questioned why the Europeans do not prefer absorbent paper. I have observed that in European culture, shapes, like words, must also be separated from each other. An area is usually created by colouring the space between the outlines, or contours. I suspect that when a European sees the ink running into the outer contours, to him it is effectively the shape falling apart and becoming unclear.

I was surprised when a student once remarked to me after her first attempt, 'Isn't it lovely when the ink flows?'. Others usually take a little longer to come to this observation.

Sometimes, I still ask myself whether I also perceive the flowing of the ink as something beautiful. What I do know for sure is that I want to appreciate and use the beauty from the abundance of nuances of the black ink. That is why I cannot be without Gasen–shi paper, even though it is often difficult to handle.

This flower, painted on silk, has a unique radiance that I cannot express in words.
It is the world of the Yugen. In Japan's Zen culture, this means 'deep-rooted, absolute silence'. This term is often used to describe a tea ceremony or an old misty landscape painting. The world of ink is also the world of the Yugen. I wanted to express this atmosphere in this picture. It is also an expression of wabi-sabi – plain, simple beauty.

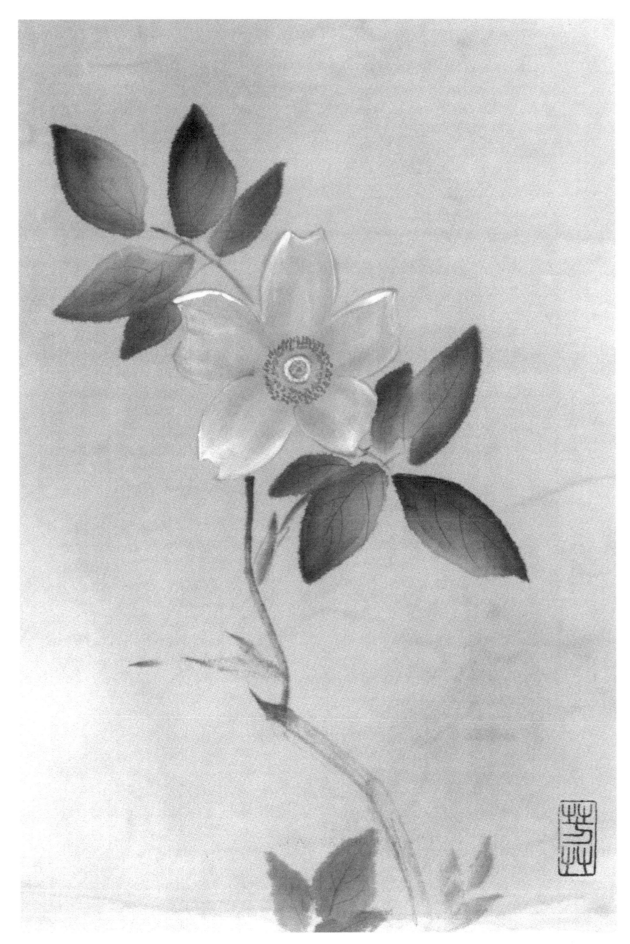

Working with the ink and brush

You have already been introduced to the grinding stone and ink stick for making the perfect ink. In this chapter, you will find out how to grind the ink and how to handle the brush.

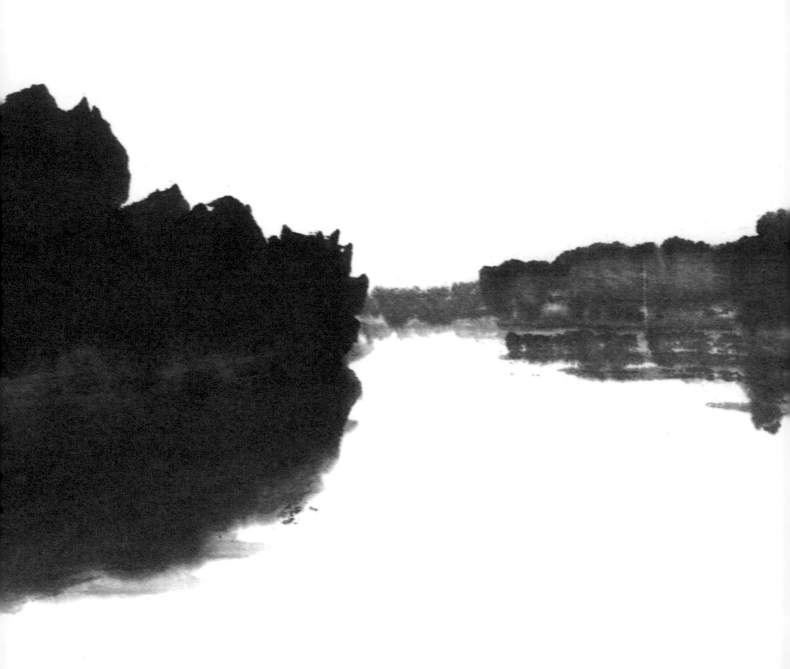

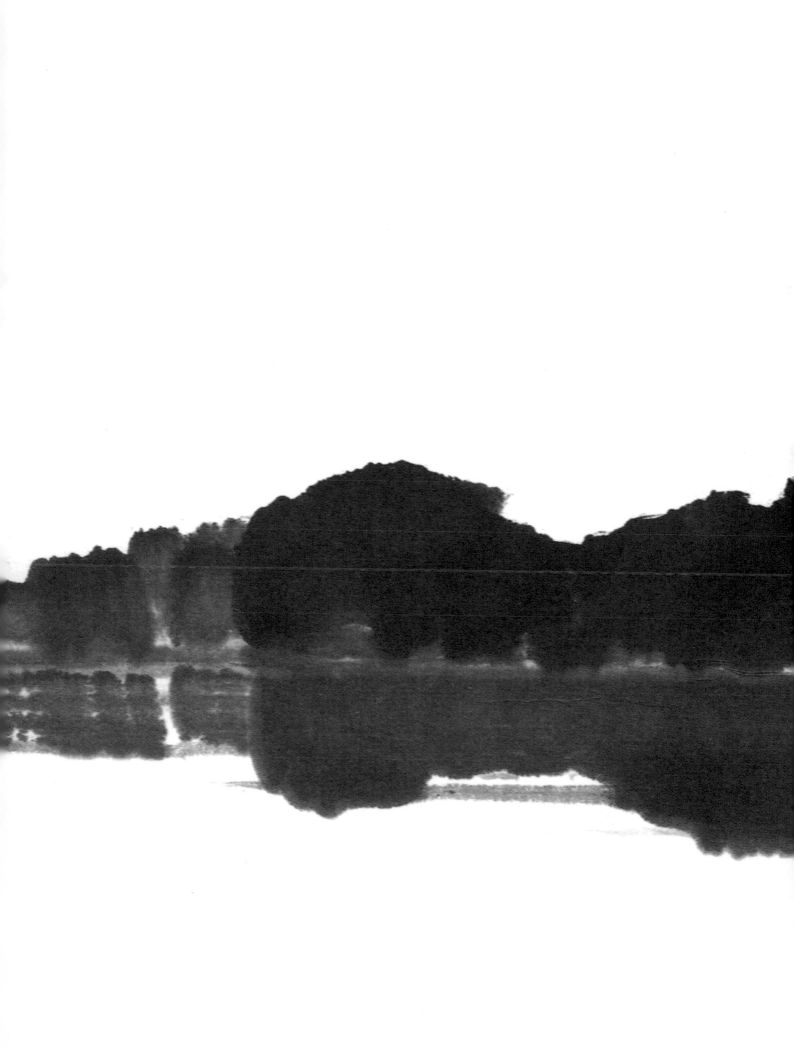

Grinding and preparing the ink

• Grind the ink lightly on the grinding stone, otherwise the surface will get too warm and start to foam. If the ink is ground with too much pressure and too quickly, the pigments and glue will no longer adhere to each other, and will run too much on the paper. This happens in particular on surfaces where the ink is applied in layers.

• Make sure that the ink stick has minimal contact with the water, otherwise it might crumble too much later on.

• A pretty picture always has something shiny, something glowing about it – a certain radiance. The contrasts between the many layers of the black ink and the white paper contribute greatly to this. Grind the ink to the richest level. This is what provides the variety of tonality. However, the ink must never become pasty – this makes it impossible to achieve fine nuances.

• The darkest ink on the grinding stone and its depth will, over time, be diluted by the moisture of the bristles, but it can also evaporate in very dry air. Keep grinding new ink when your ink is no longer of the richest consistency.

• Wash the grinding stone when you have finished working. The ground ink will dry relatively quickly. It will then be extremely difficult to remove, since the glue content settles in the pores of the grinding stone as it dries. If ink is ground on a dirty stone, it will become blunt and lose its brilliance.

Making the ink

• *Place the grinding stone in front of you with the flat section facing in the direction shown in the picture. This flat part is called the 'land', the deep part the 'ocean'. If you place it the other way round, you will keep dipping the brush head straight into the indentation. The strokes will then often only be black or grey.*
• *Take about a teaspoon of water from the small container on the 'land', the flat section.*
• *Stand the end of the ink stick upright in the water on the 'land', and move it in a wide, circular motion over the stone until you have an even, smooth liquid.*
• *Push the viscous ink into the 'ocean'.*
• *Add another teaspoon of water to the 'land' and repeat the rubbing process until you have the desired amount of ink in the 'ocean'. This will give you the darkest, blackest ink with a good consistency in the 'ocean', from which you can then develop many new shades.*

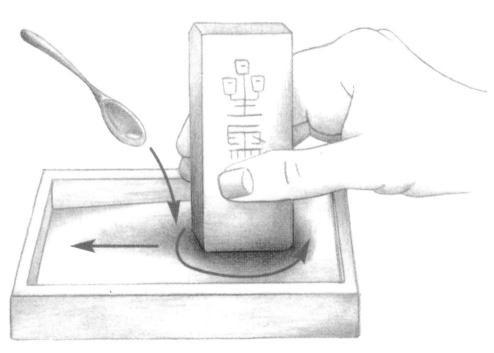

How to fill the brush

At first, people often complain that it is difficult to take up the ink with the brush. It is important that you do not take the ink from the grinding stone too quickly, but fill your brush slowly and with care. If you do have problems filling your brush, then that will be because you simply have not allowed yourself enough time. So take my advice:

• Fill the whole brush with clear water.

• Adjust the amount by wiping your brush over a damp cotton rag as appropriate for what you want to paint. Always move the brush in the direction of the bristles. A large area requires a lot of moisture; a small, thin line or area very little.

• Dip the tip of the brush in the shallow portion of the stone. Take just enough ink for the first third of the bristles to darken on one side. Lightly draw the brush over the plate to spread the ink to the base of the bristles.

• If you notice that the ink is becoming too light, repeat the process.

• Dip the tip of the brush into the darkest portion of the ink one more time.

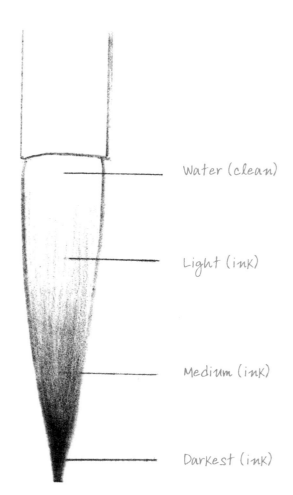

Water (clean)

Light (ink)

Medium (ink)

Darkest (ink)

Remember!

• The ink on the grinding stone should always have the most intense consistency. *Diligence* is essential for success.
• Fill only one side of the brush with ink, not all over. *Take care.*
• Move the brush to the grinding stone as little as possible. Make one filling last longer. *Frugality.*
• Be patient while determining the proper amount of wetness. Brushes have a great capacity to hold water. *Patience.*

Filling the brush with ink.
The darkest colour is at the tip of the brush.

Brush control – how to hold the handle of a brush

When we talk about holding and moving a brush, we distinguish between how to hold the handle of the brush (the grip), and how the brush moves in relation to the painting surface (at an angle or vertically).

When you first hold a brush with ink, it will feel odd. If you hesitate, your painting strokes will look shaky, or the brush will wobble.

Hold the handle confidently but without interfering with the mobility of your hand.

The bristles of an ink brush are not as deeply anchored in the handle as those on a watercolour brush, so they are particular smooth, especially when holding the brush vertically. Your 'inner emotions' will be transferred directly to the paper.

There are two different ways to hold the handle, regardless of whether the brush is held vertically or at an angle. In the beginning, I recommend the Sokou style of holding the brush.

Later, when you have become more familiar with the technique and can rotate the brush between your fingers, I suggest trying the Tankou style.

The Sokou grip.
Let the handle of the brush rest against the top of your ring finger, holding it between your index and middle fingers. Keep it in place with your thumb. This is a kind of 'paw grip' that will enclose the brush securely in your hand.

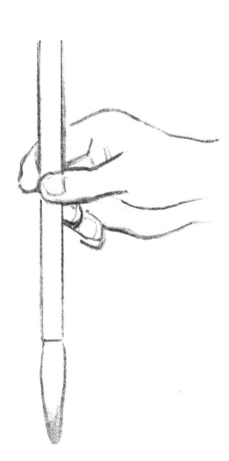

The Tankou grip.
Let the handle rest against the top of your middle finger, holding it between your index finger and thumb. You can easily move the brush in this grip. The middle finger can be used as support from behind.

Brushstrokes – which one and when?

The results of ink painting are greatly influenced by the way you hold the brush and apply the ink to the paper. Learning to load a brush properly and using good brush movements will enable you to create ink in many different shades, and allow you to paint everything from dots to lines to spaces.

Holding the brush at an angle

When creating a space, the brush (by that I mean the part with the bristle section, the head of the brush) is brought into contact with the paper and moved over it at an angle. The tip of the brush is always kept in the same position. The width of the painted line will depend on the length of the bristles that come into contact with the paper. The flatter the brush is held, the wider the area will be.

When the brush is held like this, the head will glide smoothly over the paper. If the pressure becomes too strong, resistance will increase and the bristles will spread.

A line painted with the brush held at an angle will vary more in its width, have more varied shading, look smoother and evoke more feeling than one that is painted with the brush held in an upright position.

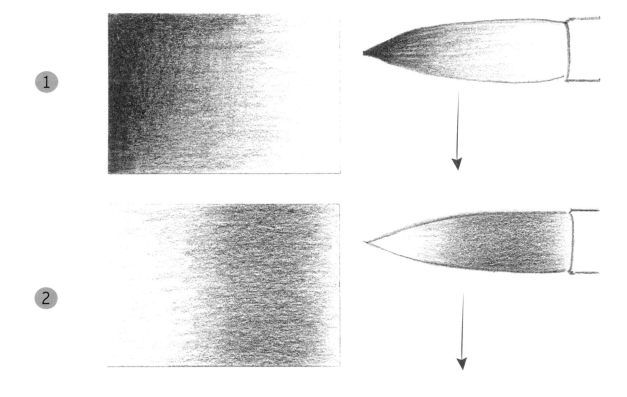

1 The brush loaded in three concentrations and the results on the paper.

2 The same brush and the results after dipping it in water once more.

Holding the handle in the vertical position (upright)

1 *If the tip of the brush is held at a right angle to the paper, you can change the width of the line by changing the pressure on the brush. As the bristles bend, the tip remains on the centre of the line, which will look positive, strong and powerful. At the end, lift the brush up and out of the movement.*

2 *This position, in which only the tip touches the painting, produces tight, 'living' lines. They are ideal for stems and thin branches.*

3 *How to get from a broad line to a narrow one in one movement: Rotate the brush lightly (around the handle), reduce the pressure and move the brush on, holding it vertically.*

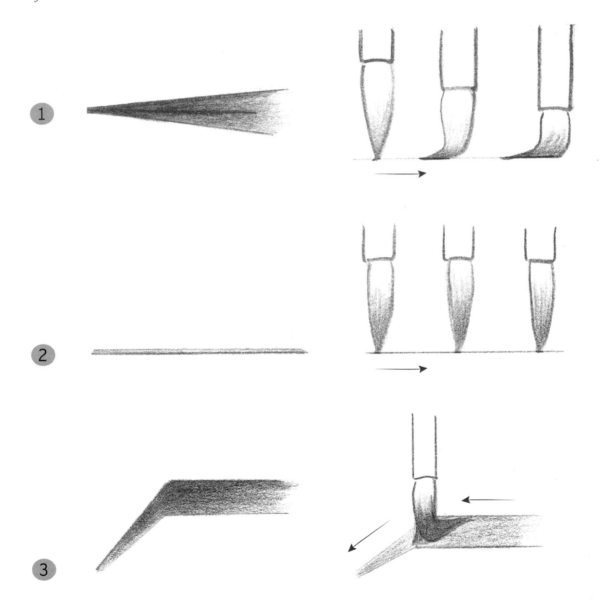

Pushing the brush across the paper

When you push the brush across the paper and can feel the resistance of the bristles (as the bristles begin to bend), the line that is created will appear stronger, firmer and heavier. This will often create interesting textures within the lines. This movement is used for painting branches and tree trunks.

Good advice!

• Pressure, speed and the wetness of the brush influence form and appearance. You need to practise these three points until you are proficient. They are excellent ways to control the flow of ink on the paper.

• Move a wet brush over the paper quickly and lightly, and a drier one slowly with a little more pressure.

• The movement of the brush comes from the heart, through the arm, then through the fingers to the tip of the brush. Do not rest your elbow on the table, so the arm and thus the path from within are completely free.

• Try to paint with a 'long breath' rather than lots of small broken lines.

• Try to outline objects in broad strokes, changing the movement of the brush as little as possible. Hesitating and painting in stop–and–go strokes will temporarily disconnect you from your inner depth, influencing the energy and harmony of the whole.

• Think carefully about what you want to paint before you start. As soon as you take the brush in your hand, allow it to guide you, and just start painting. Let go of 'thinking'. Learning to trust is difficult, but it makes you stronger.

• Every moment exists just once, and the same is true of every line you paint. A brush is so sensitive, so agile that it mirrors every emotion, and so the same situation can never be repeated.

• Never correct your lines or cheat in any way.

Practising painting techniques from originals

You might not find it easy to understand the way the Japanese view their art or the practice of copying originals. Even though, in the past, Western art academies taught new students artistic techniques by requiring them to copy the old masters, experts today hesitate to teach in this way; 'by numbers'.

However, this is still considered the most effective teaching method in the Orient. This is particularly the case when unfamiliar techniques and aesthetics are being taught. In this situation, the method is very sensible and effective.

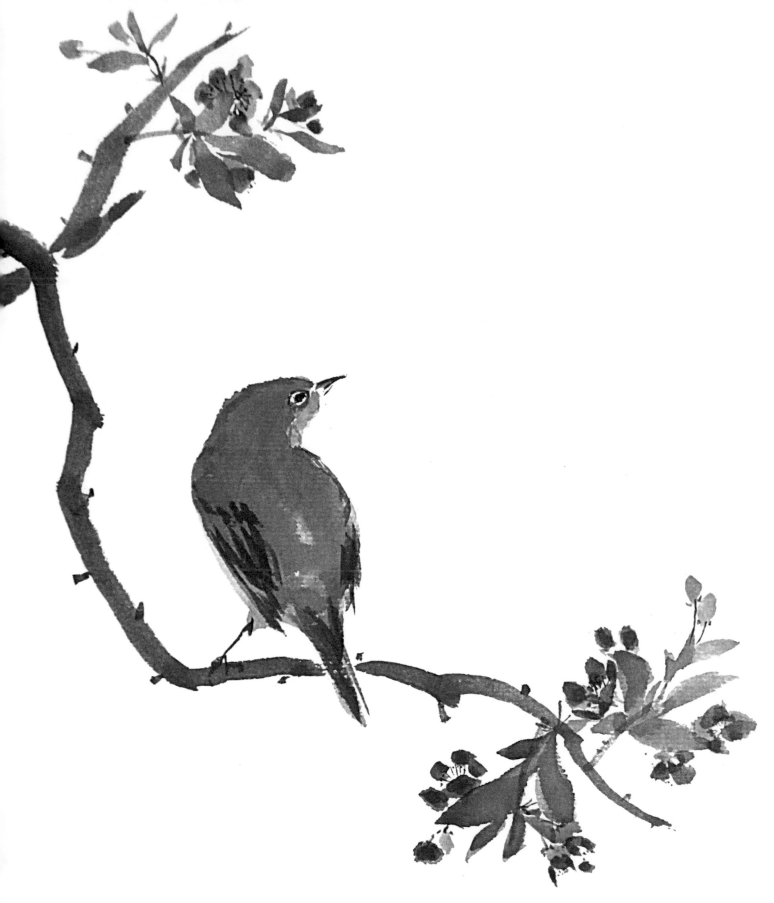

Thoughts on painting using originals

To be able to paint exactly as shown in the examples, you need to have already mastered the techniques. During my studies, the master teacher would paint a picture in our presence. Then we would practise duplicating it until the master finally said, 'Good. Now I will paint the next example.'

In addition to learning through this method, reproducing an ink painting or calligraphy is viewed differently in the Orient. In general, Japanese culture is shaped by the adapting and incorporating of foreign influences.

The expression of the external form, the original exterior ('the idea') is not valued as highly in Japan as it is in Europe. Much more important is the authenticity of what the artist is expressing and how deeply it touches the viewer's heart. Of course, virtuosity is also required.

Your own emotional reaction and acceptance of the original precedes the act of copying, and the painting is your own personal interpretation of it. It is no longer the original. Use a sensitive brush, and it will be impossible to conceal your personal reactions.

I often meet people who reject this kind of learning and teaching from the outset. They always say, 'I have to be able to paint freely, and just try it out.' I am amazed at these people, who already seem to know what they must free themselves from, and just what they can experiment with in this way.

And yet at the same time, I am sorry that they fail to see this as an opportunity to really try new ways to express themselves.

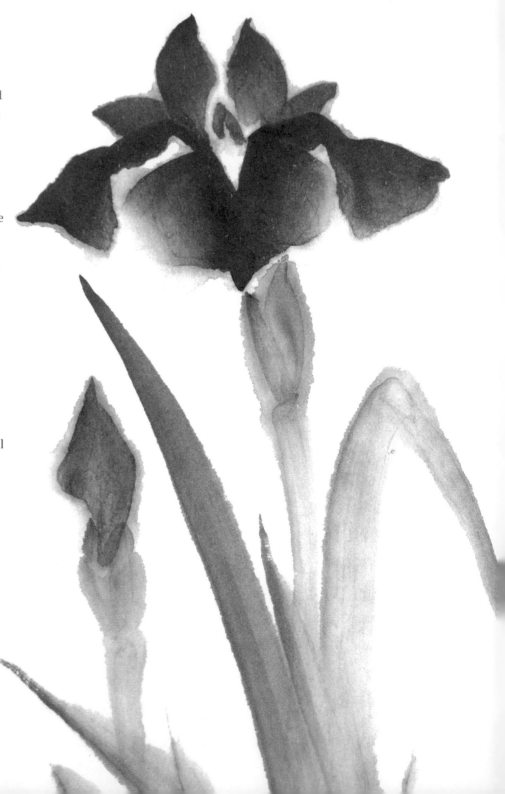

Exercises with lines
The first stroke becomes a fish

This is an exercise in holding a brush vertically. The goal is to experience the special feel of working with ink brushes, paper and ink. Blending water and ink on paper creates many different shades. Although the ink is black, it is not a sober, cold 'inorganic' black, as is the case with the blacks of watercolour and oil paint. It has a particular kind of warmth; it breathes.

In front of me lay a blank piece of white paper. 'Do not be afraid,' the master said to me as he reached for my hand and guided the brush, already filled with ink. Slowly, first the tip and then the body of the brush made contact with the paper.

Ink and water began to flow onto the paper, and as they began to blend, the head of the fish appeared, then the body, and finally the tail, all created with a swift movement of the brush across the paper.

I had an instant sensation – my feet, instead of the fish and its tail – had just touched the water. After the second fish was drawn on the paper, I sensed the spatial expanse that my master had created. I became part of the painting. And that was my first experience of ink painting.

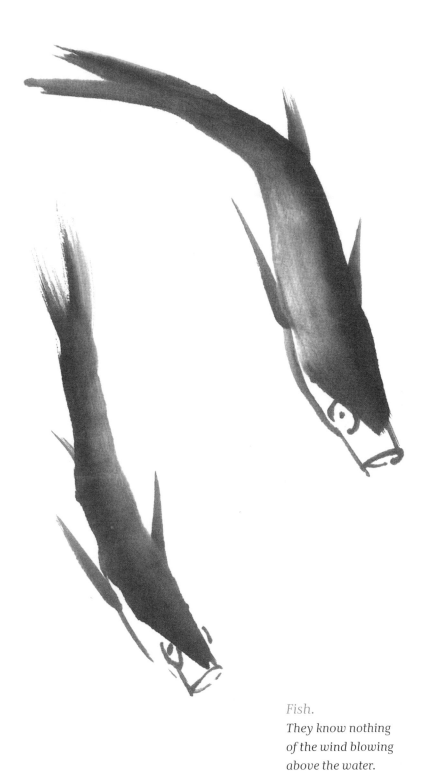

Fish.
They know nothing of the wind blowing above the water.

Painting the fish.

For the body, first load your brush with the three different shades of ink. If you hold the brush upright and draw a line, you will create a narrow body (left of the illustration); if you hold the brush at an angle, a somewhat wider body with darker edges will emerge (middle of the illustration). On the right side, the body is completed with ①, the second tail fin, by placing the brush at the base of the tail and pulling it swiftly towards and over the edge of the paper. Control the wetness of the bristles so that the tip is drier and becomes stiffer. This ensures that the tip of the brush widens evenly. Draw the eyes and mouth with a strong line. Apply a little pressure for the left side of the body at the point where the curve begins to make the line a little wider and more organic. Figures ② to ⑨ denote the painting sequence.

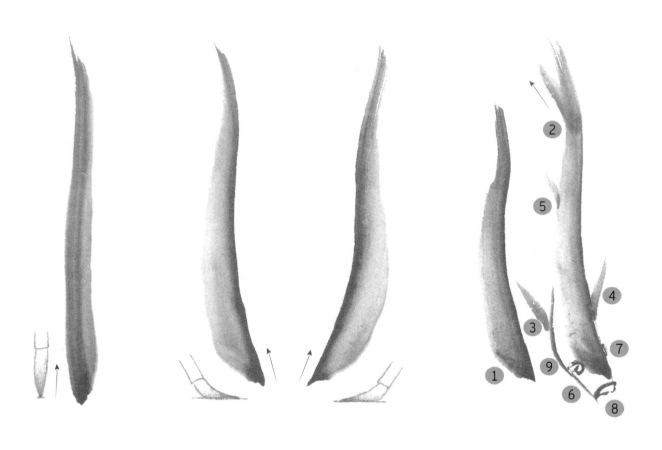

The second experiment: Orchids

Women painted many of the old masterpieces depicting orchids. Their graceful paintings were expressions of their hidden emotions. Behind the restrained, gentle forms of the orchid, women hid their pride and their passion. At the time, people believed that the ink the women used released the fragrance of the orchid and that the ink stone itself was like an orchid field.

This is an exercise for painting lines with rhythm. It illustrates the principle of stylised orchid painting. For the long leaves, paint a curved line on a long breath to make it come alive. The line is painted quickly, alternating the pressure on the brush. Practise from left to right and vice versa until you can move the brush quickly and freely in both directions. Then practise at different speeds.

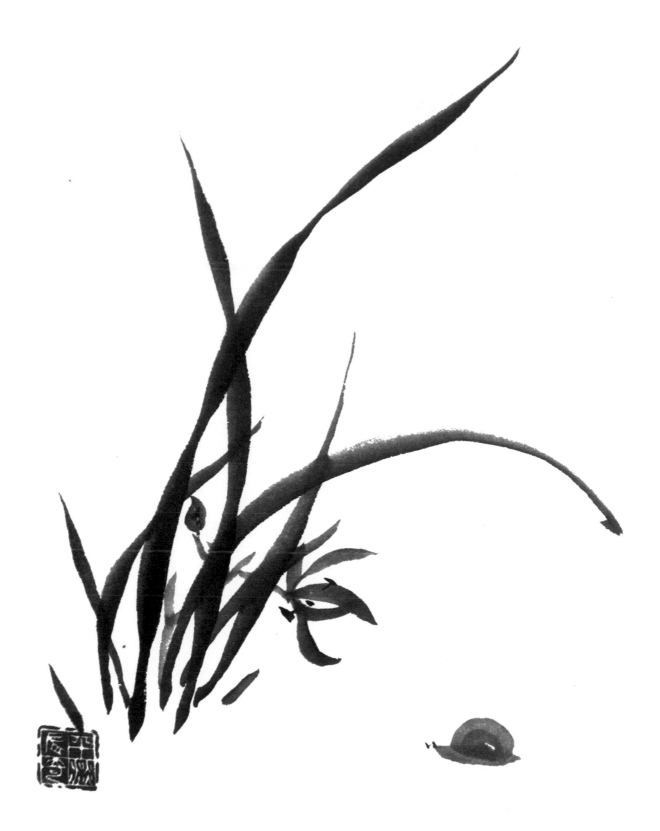

Orchids and snail.
What the seal means: 'Out of serenity
comes something different.'

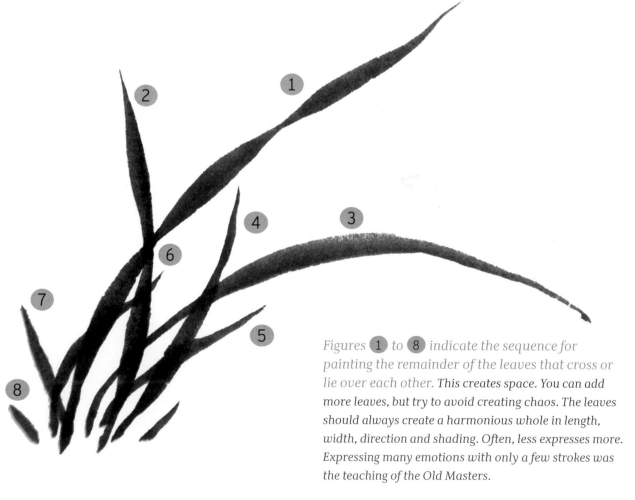

The leaves are created.
Load your brush with the three different shades of ink. Hold the brush upright and apply pressure first to the tip of the brush so that the stem of the leaf looks as if it were rooted in the earth. Feel the force of movement in the tip of the brush. This represents the energy of growth; use it to create the following line that will become the whole leaf. Continue to pull the brush slowly over the paper, alternating the pressure. First reduce the pressure, then increase it, and then reduce it again. Alternate this rhythm, and finish the leaf with a soft curve. At the end of the leaf, pull the brush across and beyond the paper as if its tip were reaching gently into the distance.

Evaluation

Did you resist resting your elbows on the table when you were painting, and instead let your arm and the brush move as one (for a strong, flowing line)?

Figures **1** *to* **8** *indicate the sequence for painting the remainder of the leaves that cross or lie over each other.* **This creates space. You can add more leaves, but try to avoid creating chaos. The leaves should always create a harmonious whole in length, width, direction and shading. Often, less expresses more. Expressing many emotions with only a few strokes was the teaching of the Old Masters.**

Flowers, flower stems and stamens.

These are painted with the brush held vertically. Add a little more dark to the top of the bristles. Again, paint with alternating pressure so that the lines change to a three-dimensional form. Paint the stem, gently embraced by the delicate petals, in a soft shade working from the tip to the base. Seen together, the shapes that make up the stamens as you touch the paper with the tip of the brush and then remove it, resemble the Chinese symbol for 'heart'. After you have placed gentle little dots in the darkest shade of ink inside them, the flowers will look radiant and alive, as if they have opened their hearts, like the love mirrored in a woman's eyes.

The grasshopper.

Transience is a subject in painting as well as in Japanese literature. Because an unexpected texture was created in the grasses that gave the grasshopper more expression, I gave the painting a seal that means 'wonderful'.

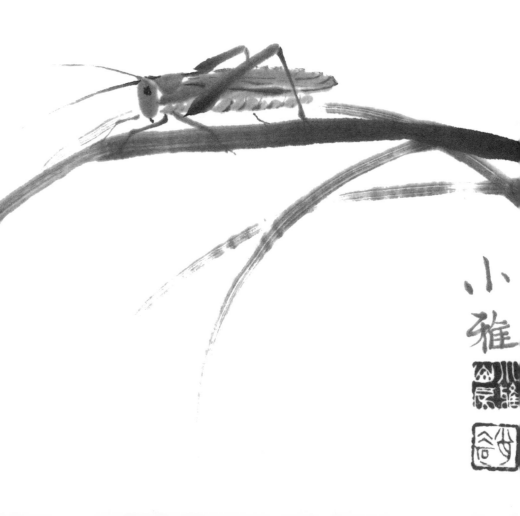

The third experiment: Bamboo

A bamboo stick is often compared to life. Each segment of the woody stem has a distinct beginning and end, just like the 'hellos' and 'goodbyes' in life, you could say. Life continues on a nodule. In Japanese, the word 'nodule' is written with the symbol for 'moderation'. A lack of moderation makes life difficult.

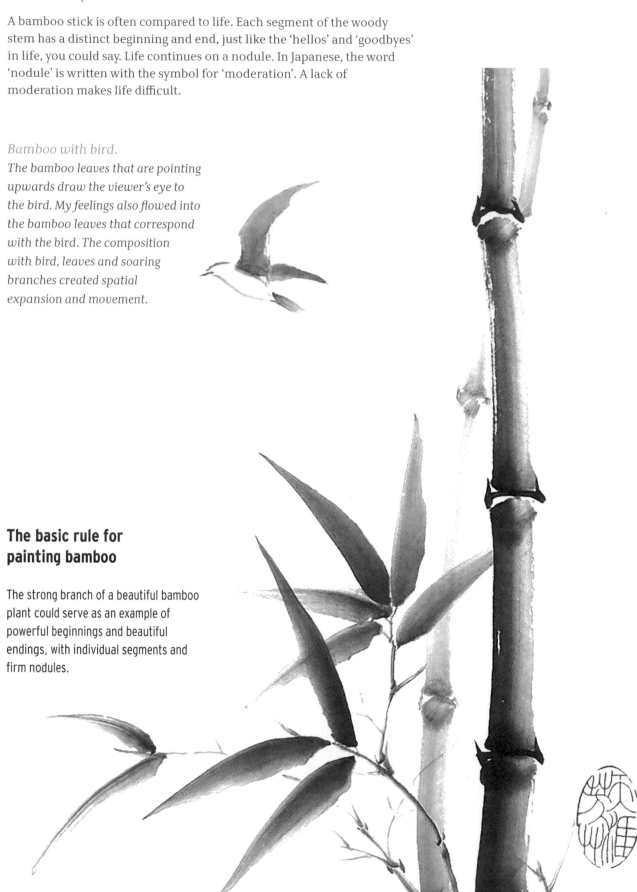

Bamboo with bird.
The bamboo leaves that are pointing upwards draw the viewer's eye to the bird. My feelings also flowed into the bamboo leaves that correspond with the bird. The composition with bird, leaves and soaring branches created spatial expansion and movement.

The basic rule for painting bamboo

The strong branch of a beautiful bamboo plant could serve as an example of powerful beginnings and beautiful endings, with individual segments and firm nodules.

Bamboo stalk.

Load the brush with the three shades of ink and set it on the paper with the bristles flattened out. The width of the stem depends on how much the bristles are in contact with the paper. Push the brush in the direction of the growth of the stem, finishing each segment by applying light pressure to the brush. The brush will lose much of its moisture over the lower segments. The bristles will fray, creating a dry, only slightly coloured segment, as if light were shining through. This effect can be controlled by increasing or limiting the amount of moisture in the brush, and by changing the pressure and the speed with which the brush is guided over the paper.

Bamboo segments.

Once you have painted them, place the nodules in the gaps. Shape a slightly moist brush into a straight tip on the plate or rag, and dip the tip into the dark ink. Hold the handle of the brush upright, and let only the tip come into contact with the paper. The tip will look like a hook. Then pull the brush sideways and conclude by increasing the pressure on the paper again. Move the brush off the paper in an up or down swinging movement and allow the ink to fade into the white space. This creates stems with clearly defined nodules!

Branches.

Paint the branches growing out from the nodules with very little pressure and a very dry brush. The numbers indicate the suggested sequence.

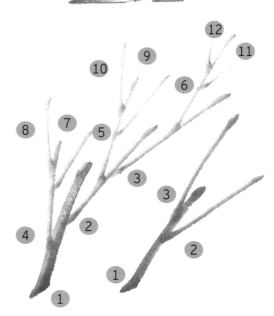

Bamboo leaves.

Load the brush with the three shades of ink. Hold the brush vertically and pull it along quickly in one movement of the arm, without stopping. The first pressure becomes the width of the bamboo leaf. This process applies for all leaves regardless of their position.

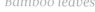

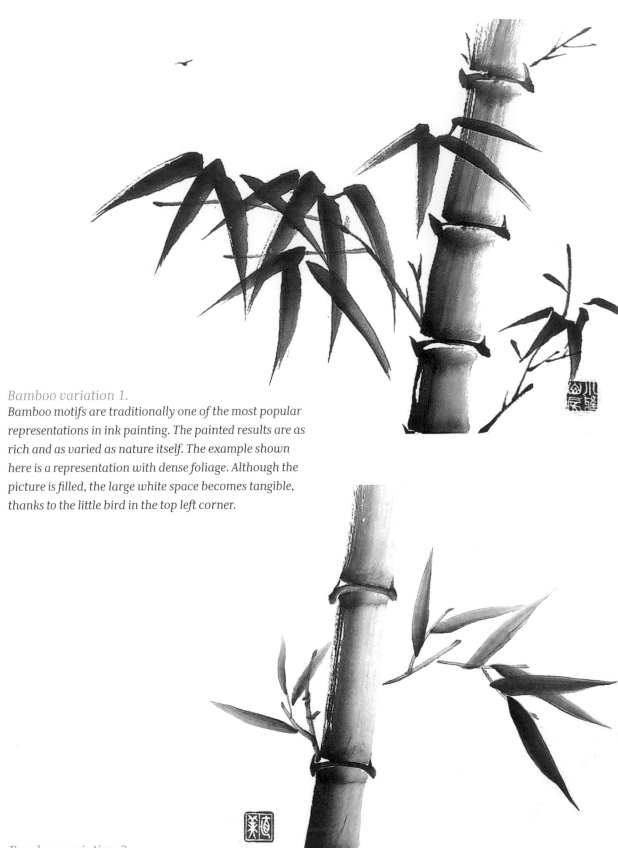

Bamboo variation 1.

Bamboo motifs are traditionally one of the most popular representations in ink painting. The painted results are as rich and as varied as nature itself. The example shown here is a representation with dense foliage. Although the picture is filled, the large white space becomes tangible, thanks to the little bird in the top left corner.

Bamboo variation 2.

Here is a sparse creation that radiates peace. The strong stem is the dominant feature. The rhythmic arrangement of the leaves also hints at the movement of the air and the passage of life.

Bird and flower painting

There are two types of ink painting: landscape painting, which is called 'mountain and water painting' in Japan, and 'bird and flower' painting. The latter group consists of three main groups: flowers, trees, and animals with birds.

This type of painting emphasises the contrasts between stillness and motion, between soft and hard. 'Stillness' is represented by flowers and trees; 'motion' is depicted by animals such as the bird. Contrasts bring a picture to life.

Painters, in admiration and love of nature, reach for their brushes, go outside, and use these motifs in their paintings to capture their emotions. A bird on a branch will often tell us whether the artist is longing for freedom or a warm nest. However, often in my courses, I have noticed that the face of a bird painted by a student gives away so much that I have to chuckle to myself. People are often more satisfied than they think they are. They do not want to leave their nests!

The fourth experiment: Pussy willows with catkins

What at first seems to be quite a daunting task, namely painting catkins, is something that even beginners manage quite successfully.

Here you can see how the running of the ink makes the catkins real. The composition adds rhythm and movement to the picture. With a brush that is loaded with a bit more water and an ink that is not too dark, paint the catkins by dabbing the brush on the paper. Use a drier brush and darker ink for the sepal, and paint the twigs as for the plum blossom.

The fifth experiment: Plum tree branch

Although the plum tree blossom appears in February, the coldest month in Japan, together with the pine and bamboo trees it is a symbol of stability and of good luck for the new year. This is also celebrated as the welcoming of spring. The delicate, fragrant plum tree blossoms that break forth from the old, gnarled branches - despite the cold temperature, are harbingers of spring, hope and the energy of life.

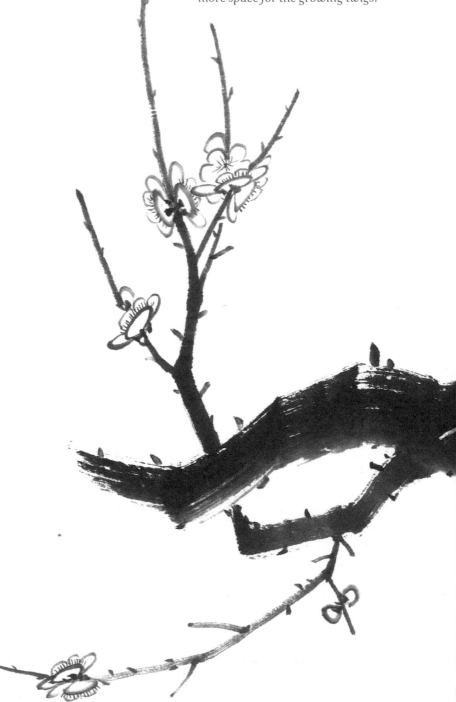

The old branch with white plum tree blossoms.
The white plum blossoms are painted with contours. The white areas left make the blossoms appear white through the contours. This picture shows the contrast between the old branch and the young twigs with the flowers, expressing the continuity of nature. The branch is placed a little lower in order to leave more space for the growing twigs.

Evaluation

• Does life energy flow into the tips of twigs and branches so they can radiate strength and vitality? Painting over a previously painted surface prevents the life force from flowing!

• A pretty picture of plums requires the contrast between the delicate blossom and the hard branches. Can you detect in the branch its many years of growth, the sign of its life?

• Has the white space gained depth because of the lively criss-crossing of twigs and branches?

Painting branches, twigs and plum blossom.

For the large branch, load the brush in the three different shades of ink. Push the brush, held flat or at an angle with the tip bent over ❶ , and push it quickly to the base of the first branch ❷ . If you can feel tension in the bristles of the brush as you move over the paper, this will make the branches strong and alive. When you get to point ❷ , rotate the brush handle to make the branch narrower. Follow the steps up to point ⑪ . For the twigs, position the tip of the brush with very little liquid held upright on the branch, then pull it away swiftly and with even pressure. Do not let the end of a line blend into the paper. Leave some space for blossoms you might want to paint later. Choose soft shades for the red petals, and paint each one with a single application of the brush. Hold the brush upright for the white petals and buds. The different shadings are created by changing the pressure on the individual lines. The individual petals should not be too pointed or sharp. The sepals are the connections between blossoms and twigs, and are painted in the darkest ink with the bristles almost dry.

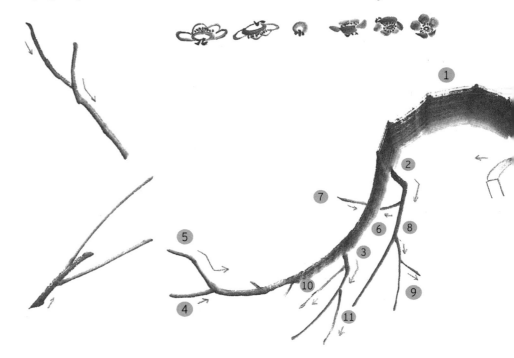

Branch with red plum blossom.

The petals of the red variety are painted in full. The soft grey hints at the pink. There is much white space in this composition to indicate the vastness of the sky. As soon as the tip of the brush has touched the paper, pull the brush away with a swift motion, as you did for the stamens of the orchid (see page 45). For the stamens, shape the almost-dry tip of the brush into a sharp point. The line must be lively despite its fineness. Dark spots are added to this line.

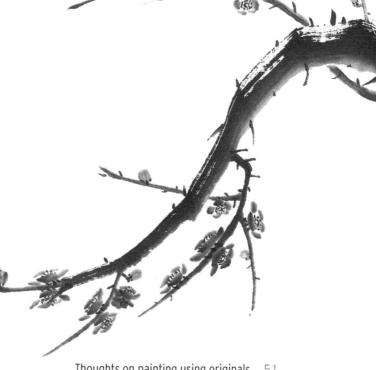

Thoughts on painting using originals 51

The sixth experiment: Pine tree branch

Branches of pine trees have a completely different character from the plum tree, and they are therefore also painted differently.

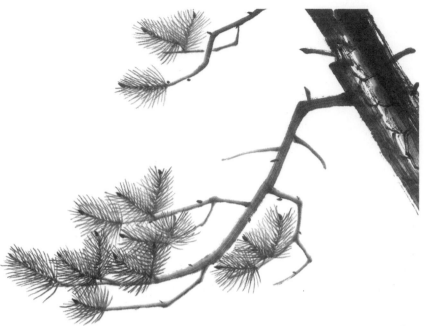

Pine tree.

The island country of Japan is surrounded by pine groves. A great deal of attention is paid to the branches growing sideways on a pine tree in a garden or grown as a bonsai. The unpainted area of the sky is made more effective by bringing a section of the trunk into the picture. This painting is used to practise reproducing the toughness of the trunk and bark, and the needles as fine lines.

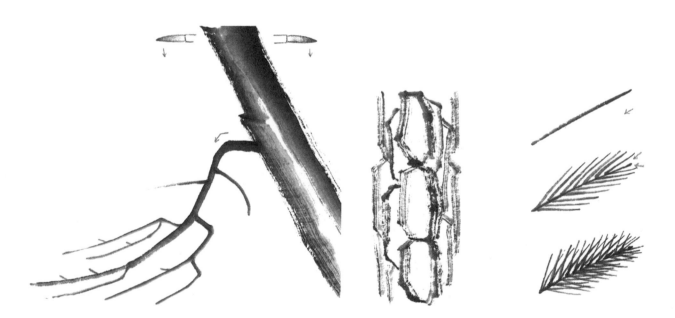

The stages of painting.

Hold the brush at an angle to paint the trunk. As with the plum, paint the large branches first and work down to the smaller ones. Paint the needles with an upright, almost-dry brush working from the outside in; do the same for the bark, dry and dark. Push the brush forward to paint a solid line.

The seventh experiment: Bird on a branch

When painting birds, we usually start with the beak, first with the upper half and then the lower. The position of the beak determines the position of the bird's head and body.

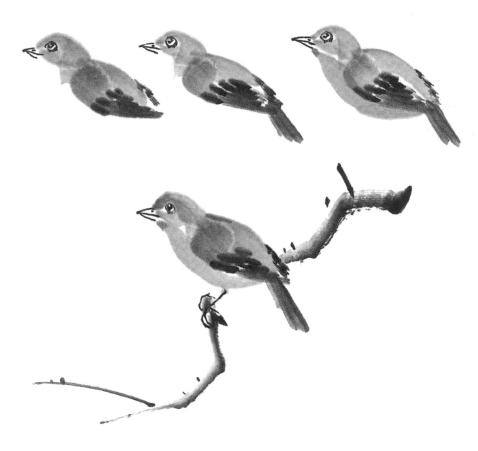

Painting a bird.
Paint the firm, hard beak and the matching eyes with the same dry brush. The way the eyes are painted determines the expression. Use the darkest shade for the pupils. Continue by painting the head, wings and tail in that order. Use a lighter shade for the chest and belly, and perhaps add some darker ink to the wings and tail. Paint the latter before the lighter area dries. Finish with the legs and claws using a dry brush with dark ink. It is helpful to paint the whole body of the bird in a lighter shade first, then overlay the wings and tail in darker ink. This will prevent any unevenness in the finished painting. Wait until the whole bird is finished before you paint the branch that provides it with a firm base.

'Dreaming bird waiting for a bud to open.'
This seal loosely means 'Our true home exists only in a dream'. In ink painting, pictures were traditionally given a calligraphy that included the name, time of creation, a poem, comments, text seal and so on. The painting and the written word blended together. This tradition still lives on in China, whereas the feeling in Japan is that pictures should work by themselves, and should only be given a signature and/or seal.

Exercises with spaces

Small spaces can be created with one or two strokes with the brush held flat, as seen in the following examples.

Small space with two strokes – anthurium

Whenever I look at an anthurium with its long stem, I think of a kite soaring gracefully in the sky, and I, too, want to fly.

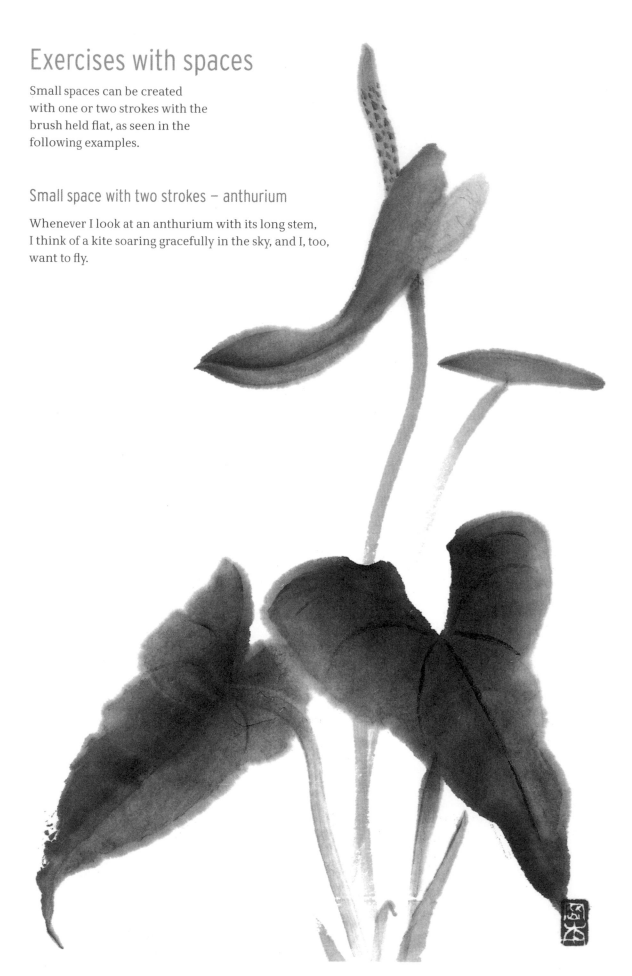

The stages of painting.

To paint the flower, load your brush with a little ink in the three shades. Hold the brush flat when painting, and push the bristles down until a third of the length of the bristles is in contact with the paper. Without hesitating, pull the brush, while rotating the handle, swiftly upwards to the right. *Then complete the underside with a second stroke in a lighter shade. The leaves are painted in relatively dark ink. Paint the large leaf in two wide strokes placed beside each other. The seam must be as unobtrusive as possible. This will only work if the dark sides of the* two strokes meet. *The tip of the brush moves along the centre at an angle from the top to the base. When the ink is almost dry, paint in the veins in dark ink. The stems are painted in a lighter shade from the top to the bottom.*

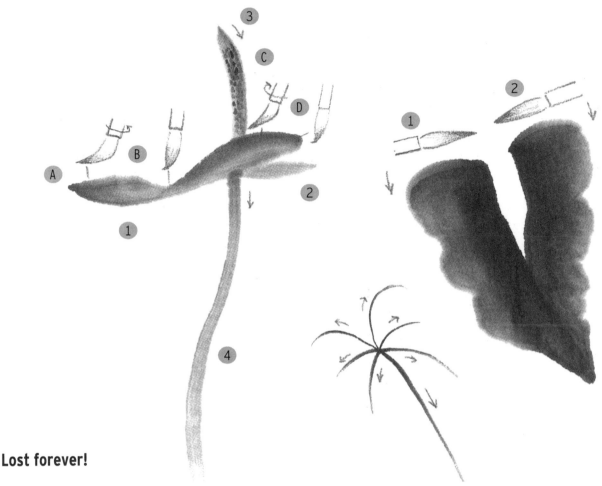

Lost forever!

Time and again the question arises whether strokes should be corrected. My answer: There is no law saying that you should not. However, you will quickly learn that when you, for instance, add another line to correct the one already on the paper, something irretrievable has been lost even if you have improved on the original form and made it more beautiful or more realistic.

This concept also applies to Japanese tea ceremonies, where the central meaning lies in the uniqueness of the moment.

In order for this unique encounter to be fully experienced, the shape and course of each individual motion or movement is determined beforehand and reduced to the minimum. As with brush control, this form is practised until it becomes natural.

In contrast to the concept as practised in Western art, where the end product is more important than the individual line, in ink painting every brushstroke must be right because correction is not possible. Each individual line tells the story of the process. Each line is connected to the next and to the whole. Each line is important as it appears on the paper, and each line is a mirror of the attention, energy and soul of the painter.

What is lost in trying to make a line more beautiful is the tension in the silence, a place of purity where the energy of silence is present. That is what makes ink painting fascinating and moving.

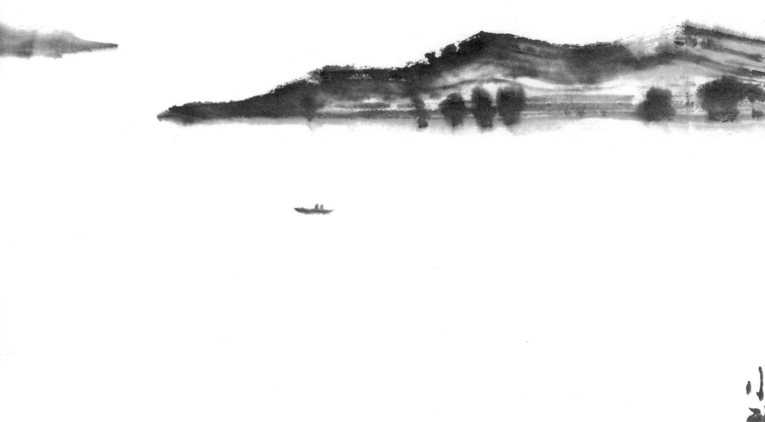

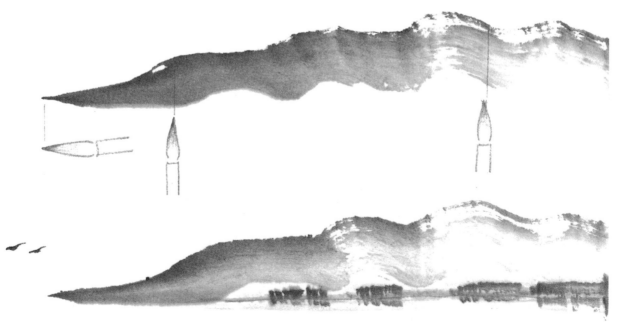

Promontory with fishing boat.

A student of mine, returning from a holiday on the Mediterranean coast in the South of France, told me that he had 'seen' the image of the painting he had painted in my class. He was talking about the picture with the promontory and the fishing boat that he had painted for me. He felt that he had literally experienced the Mediterranean coast as reality while he was painting, and I was overjoyed.

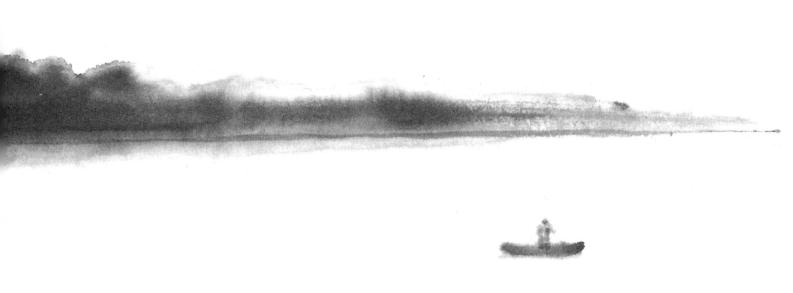

Painting the mountainous promontory.

I am sure that at some time, somewhere, you have seen a promontory similar to the one on this page. Try to make a rough outline of it with just one stroke. Then everything that is inessential is left out, and only the essentials remain. Add only those details that are truly important to you. Load the brush sparingly with three shades of ink. First, determine the position of the horizon. Lay the brush flat and pull it horizontally to the right. If the promontory is to feature a mountain chain, then rotate it so that the tip of the brush creates the mountain peaks. If you want to 'plant' trees, hold the handle of the brush at an upward angle, pulling it horizontally with a gently vibrating motion. If you want to create a greater space or produce movement in an otherwise static painting, add a bird and make it seem as if it is flying to a faraway place.

Themed exercises

In the bird and flower painting section (see page 49), I addressed one of the main subjects in ink painting. However, the full range of themes includes landscape, figures and still life, the essence of which becomes especially clear in ink painting.

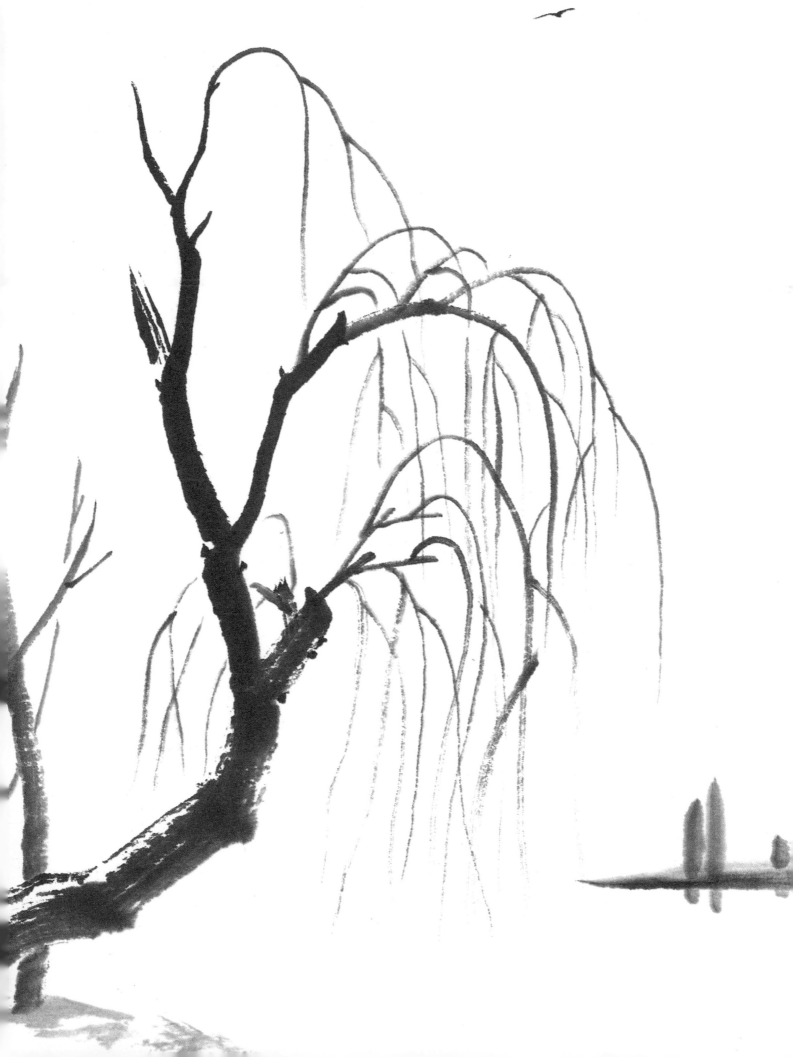

Still life in ink painting

While in Japanese the phrase 'still life' is written in the Chinese symbols for 'quietness' and 'object', it is understood that this art form does not represent an arrangement of 'dead' objects, as in Western art. Instead, a still life is an arrangement that tries to convey the deeper nature that exists within.

A still-life ink painting has three-dimensional qualities without the light and shadow that are changeable and temporary. It does not use horizontal images or objects, such as a tabletop for placement, and, above all, it does not use a background.

In a still life, the space is the whole cosmos. It is not created by the painter by trying to conquer the picture area (the space), but by immersing the self, by penetrating the picture area. It is a space where everyday life becomes one with eternity. The cosmos is all-inclusive but not limited; it is in the vast expanse of nature.

When I saw the still-life paintings by Italian painter Giorgio Morandi (1890–1964) again after immersing myself in ink painting, it became clear to me what I had not noticed before: his is the Western, artificially enclosed space, defined by the use of light, shadow and the painted background.

The still life in ink painting is not an attempt to describe an object, but rather the reproduction of your subjective, spiritual perception that brings out the reality.

In contrast to Western paintings where a painter tries to capture reality by adding details, in an ink painting you will attempt to capture the essential with as few brushstrokes as possible, and bring it to life by finding its energy.

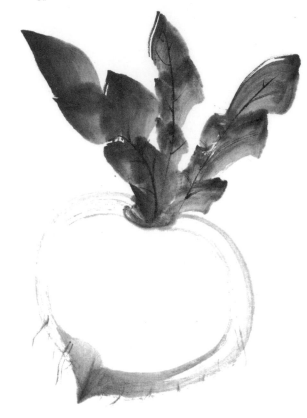

White turnip.

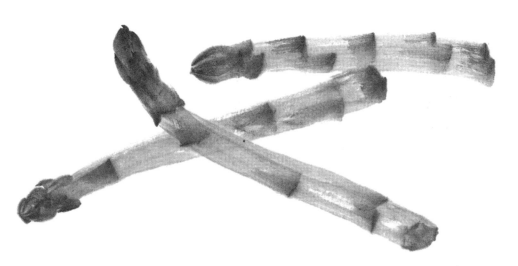

Asparagus.

Exercise: Pears

Two pears.

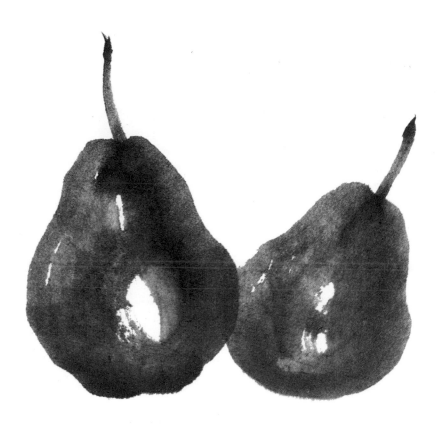

Creating the pears.

Start with the front pear, which is emphasised. Shape each half of the pear by holding the tip of the brush to the outside. Rotate the brush to paint the width of the bottom part. The width of the pear is determined by the length of the bristles. Paint the second pear, which plays a supporting role, in slightly lighter ink. The left stroke can overlap the right one because the darker area is dominant, making the lighter area appear to be behind it.

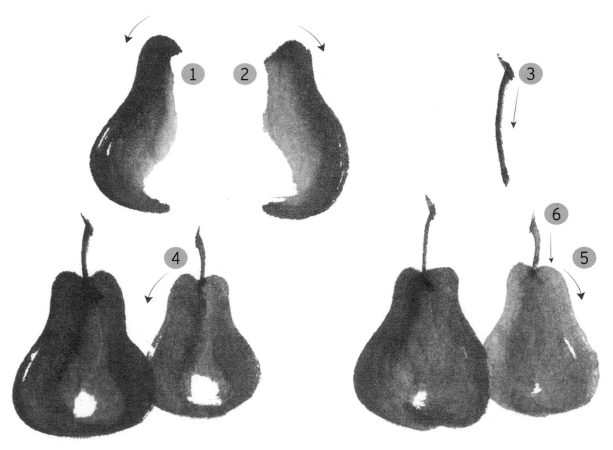

About composition, harmony and contrasts

In ink painting, the composition is determined by the harmonious relationship and distinction that exists between emptiness and fullness and between a star and the supporting actor. The picture is divided into the emptiness – where there is nothing – and the painted fullness. The contrast is created by parts that are sparse and dense, heavy and light, dark and bright, large and small, and distant and close objects. Although emptiness and fullness create contrast, they must complement each other and exist in harmony. It must be clear what is primary and what is secondary. The picture must show the relationship between the primary and secondary objects in the way they respond to each other. Paint the primary object first and then the secondary one. In a composition consisting of three shapes, such as the three pears, then one of them – the middle one – will be in the foreground. The other two are secondary. The relationship between them creates life and balance in the picture.

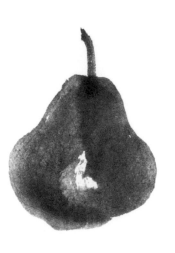
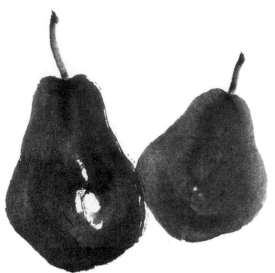

A fractured association.

The two pears on the right face the one on the left as a pair. I have exposed and dramatized this association by angling the pear stalks. As the figure on the right is turned away, the main figure in the middle is already oriented to the left in search of a – possible – new association.

Chestnuts.

Here, the 'main character', the primary object, is the chestnut in its shell. Although it is not in the middle of the picture, it dominates because of its size. The two peeled chestnuts are placed freely beside it, in the field of tension created by the blank space.

Exercise: Teapot and cup

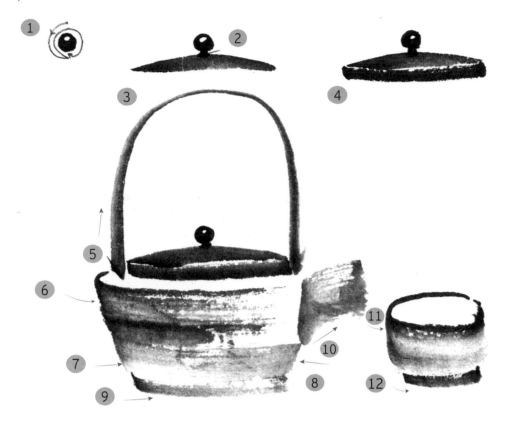

The stages of painting the teapot and cup.

We start with the smallest item, the knob on the lid of the teapot. It is painted with the tip of the brush, which is rotated sideways from the top to the bottom, and then immediately moved back to the top and then down again to the other side and (1). For the lid, hold the brush horizontally and draw it to the right, rotating it to the outside at the same time, (2) and (3).

Paint the base of the lid with the brush held upright, (4). For the teapot handle, again hold the brush upright and paint the arch from left to right, (5). For the belly of the pot, hold the brush at an angle, (6) and (7), and then brush once in the opposite direction, (8). Hold the brush upright again for the base, (9). Paint the mouth from the base to the outside, (10). For the bowl, load the brush with three shades of ink and hold it at an angle, starting with the tip of the brush on the left, (11). Rotate the brush to move swiftly to the wide area, and finish at the bottom with the tip of the brush, from (12).

Exercise: Cherries

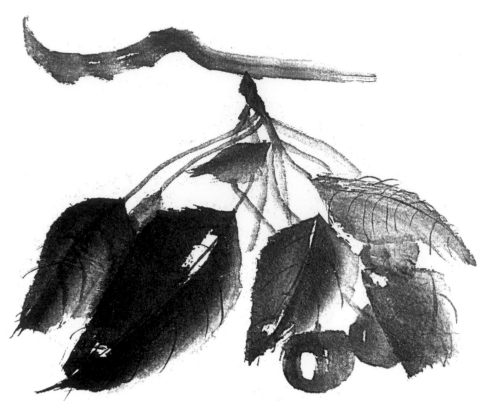

Dark red cherries.
This example shows how real it looks when the black ink is used with lots of nuances.

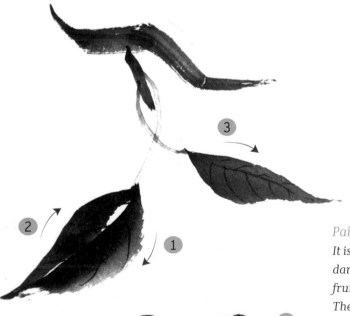

Painting the cherries.
It is very easy to reproduce the dark red cherries in the dark shades of ink. Light reflections on the leaves and fruit are created by leaving certain areas unpainted. These white areas bring the picture to life. Try to make the cherries, leaves and stalks 'juicy'. This also creates a contrast to the woody twig. The numbers on the various elements indicate the sequence when painting.

Exercise: Chrysanthemum in a vase

In 17th-century China, the chrysanthemum was one of the 'four aristocrats', along with bamboo, orchid and plum blossom; in Chinese textbooks they are referred to as the 'mustard-seed garden'. The chrysanthemum and its fragrance symbolise the passing of autumn and of loyalty.

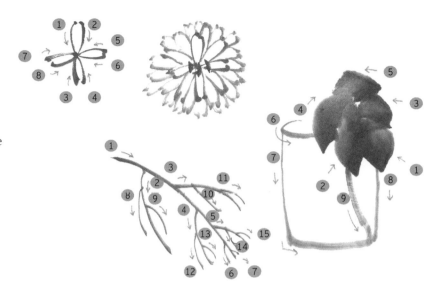

The stages of painting.

Begin by painting the flower from the middle out in three lighter shades and holding the brush upright. The two lines for the individual petals are painted from the outside to the inside. Paint the outlines in different widths so they do not look like wires. As with the bamboo nodules (see page 47), set the tip on the paper with a little bit of pressure, and pull the brush to the centre of the flower. This will make each petal tip a little prominent and three-dimensional. Use slightly darker ink for the leaves.

Paint each leaf as a divided area. Create the leaf as a whole unit, from the tip to the base, so paint each line from the outside to the inside. Paint the vase swiftly in three lighter shades. The contrast between the white space and the ink will make the vase appear to be made of glass. If you also paint the stem in a lighter shade with the brush held upright, it will look as if the vase is filled with water. Then paint the veins in dark ink as shown in the sketch, and hint at the stamens in the middle of the flower.

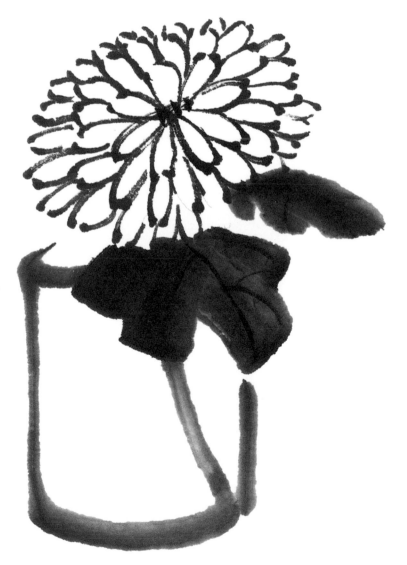

Chrysanthemum in a vase.

As the bottom of the vase and the stem are painted wet and with plenty of shading, it looks as if the flower is standing in water. That is why I have not added the surface of the water to the vase.

Landscapes in ink painting

Landscapes were painted in northern China in stylised form as early as the 10th and 11th centuries. Distinct lines dominate these paintings.

Classical landscape paintings have always occupied a very special place among ink paintings. In Japan, they are called 'Sansui-ga' (mountain and water pictures). However, Sansui paintings are distinctly different from today's landscape paintings. In ancient times, it was thought that mountains and rivers were the places where the gods resided. People believed in the great power of nature.

Sansui paintings still hang beside Buddhist paintings in the temples today. They represented ideas and honoured nature. It was therefore important to create mountains, rocks and trees as lifelike as possible, to give them life. This was accomplished with very strong brushstrokes and, in contrast to Western paintings, by avoiding a specific point of focus.

Visual forms seemed to grow from within the lines, creating a painting of the universe. A Sansui painting did not attempt to be a representation of the manifold objects present in nature or to convey a personal impression of a particular part of nature from a particular vantage point; instead, the painter used mountains and water in an attempt to reconstruct the universe. As this type of art developed over time, it became more and more stylised (see, for instance, the painting on page 121). Paintings that use more diffused contours developed in the milder and more humid climate of the southern parts of China (see the painting on page 75).

Although many of the paintings in the West today are two-dimensional, by getting to know this stylised type of painting you will learn how to create spatial effects without the use of colour, light or shadow.

Tall mountaintops, not meant to be climbed.

Exercise: Tree studies

Trunk, twigs and branches.
To create a two-dimensional tree trunk, you would normally start with the thickest branch and paint down to the base. When outlining a trunk, you may move your brush freely in either direction. Try to draw lines without hesitation, changing the width at the same time. Do not use small strokes ('feathers') as you would in a pen-and-ink drawing. Paint the thicker branches first, then the twigs. Generally speaking, twigs and branches on the left side of a tree are painted from the top to the bottom and from left to right, and those on the right from bottom to top and right to left.

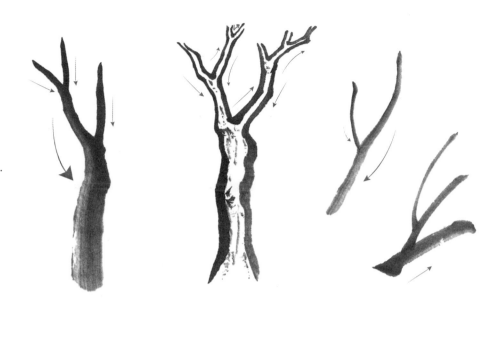

Leaves.
Leaves can be painted in two different ways. The orthodox method involves painting only the outlines, while in the other way, which developed later, the ink is dabbed on the paper with the tip of a brush without a clear outline. Leaves with serrated edges are dabbed on the paper with an old brush that has short bristles.

Crowns.
Before you paint the crown of the tree with the leaves, paint the framework of the tree with the trunk, branches and twigs. The two-dimensional representation of the crown is achieved by dabbing the leaves from the outside in so they are denser on top and the outside than towards the bottom and the inside. Darkness versus light, and wet surfaces versus dry spaces, when properly distributed, will give dynamic energy to the tree. When painting a group of trees, always start with the one that is closest to you, and then work on the ones that are farther away.

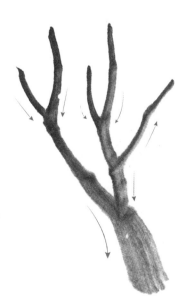

Exercise: Weeping willow

When painting the trunk of a weeping willow, pull your brush from the top down towards the root. As your movement progresses, the stroke will get lighter and wider towards the bottom. This makes the eye move towards the darker tip, which makes the tree look bigger. It's different with the hanging branches: you paint these outwards towards the tips, from the thicker to the thinner ones.

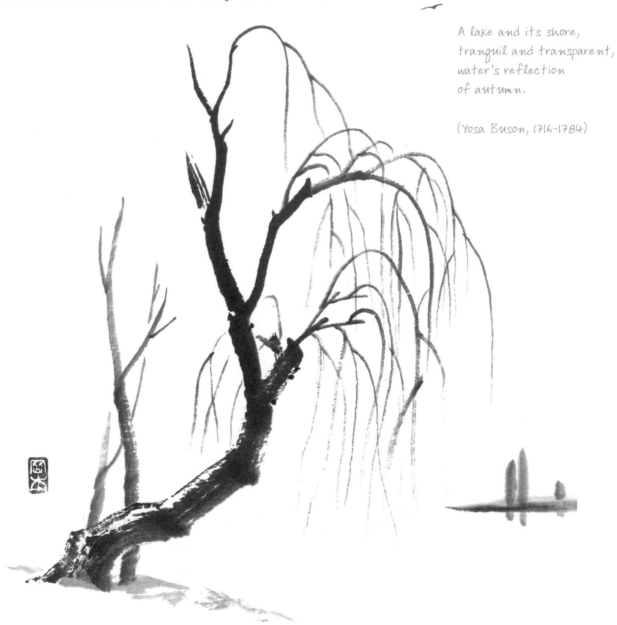

A lake and its shore,
tranquil and transparent,
water's reflection
of autumn.

(Yosa Buson, 1716–1784)

Looking at the reality in perception

'It was a magical experience. Suddenly, I was surrounded by the soft light of spring, sensing the cool air on my cheeks, as the buds of the leaves began to sprout through the ink dots on the bare branches. Then I found myself in the glow of the white light, and I breathed in the fresh summer air, and the trees were so densely covered by the dots of ink. I was walking along that river – in my memory.' As in the example on top of the opposite page, perception – of light and colour, indeed of the whole atmosphere – can be invoked by the shades of the ink, by dry or wet ink and white paper.

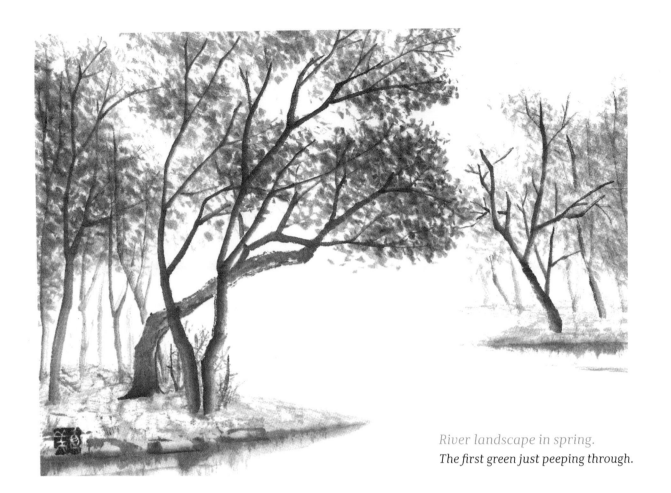

River landscape in spring.
The first green just peeping through.

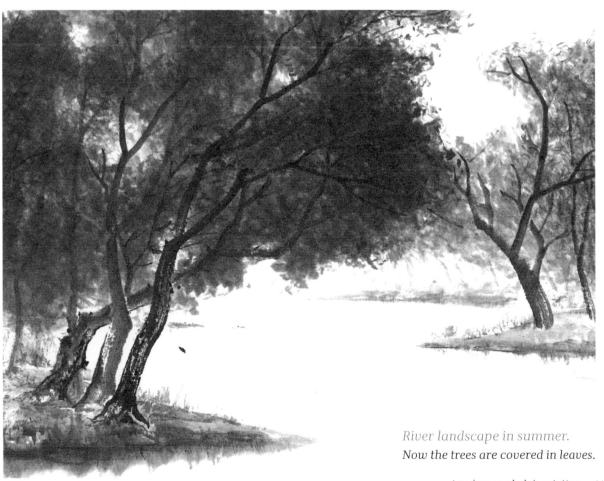

River landscape in summer.
Now the trees are covered in leaves.

Landscapes in ink painting 69

Exercise: Mount Fuji – the holy mountain with pine trees

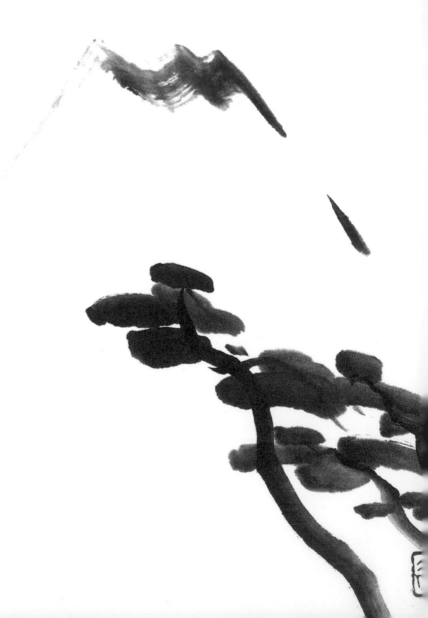

The stages of painting Mount Fuji.

Set the tip of the brush on the paper and begin by pushing it at an angle from bottom right to top left to the edge of the summit. Without stopping, continue in an up-and-down movement to the end of the left edge of the summit. From that point on, pull the tip of the brush down and out over the left edge of the paper. The painted line disappears slowly into the white space.

This is such a popular motif that it is painted over and over again. It is practically the symbol of Japan. At 3,776 metres (12,388 feet), Fuji is the highest mountain in Japan. It rises cone-shaped from a wide base with elegant proportions. Due to its height, its appearance is constantly changing depending on the weather, the light at a given time of day, and the season of the year.

Today, Mount Fuji is a symbol of the beauty in Japanese aesthetics. Together with the pine tree, the symbol of long life, Mount Fuji is also the symbol for luck. During the month of January, a picture of this mountain, including the pine tree, decorates the Tokonoma alcove in Japanese houses.

Looking at beautiful Mount Fuji will make everyone's heart skip a beat.

Mountain lake.
The empty spaces between the front, middle and back areas, and the movement of the birds and boat, make the picture space look bigger. The expressions created in ink paintings cannot possibly be achieved with black-and-white photography.

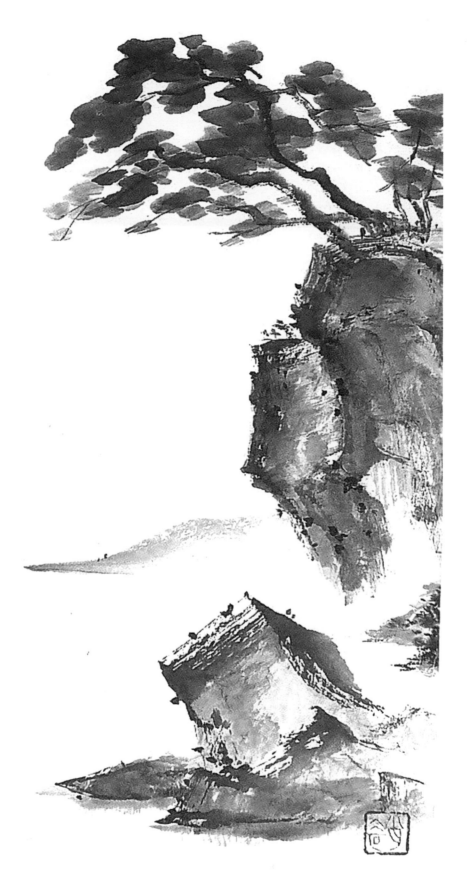

The study of rocks

In addition to depicting objects in a naturalistic style, East Asian art also shows objects abstractly. However, abstract objects never appear to be dead, inorganic or geometric; rather they are the essence of life, an energy.

A rock is part of the mountain, and at the same time its basic shape. First, you need to try to give spatial character to the basic shape. It would be wonderful if you could give a three-dimensional quality to a stone with one swift stroke of the brush. A line drawn with one brushstroke has strength and vitality, and so it looks alive.

A rock is given life through the dynamic use of a brushstroke. It has to look three-dimensional, hard, solid and heavy. This is achieved by varying the width, pressure and shades of the line, and with different brush movements. Your hand must be sure because with every hesitation of the brush, ink builds up in the tip and flows out suddenly when you continue, making a line appear to be soft. This means you must know the whole shape – the construction of the stone – before you take your brush in your hand.

The image of summer grass is all that is left of the warrior's drum.

(Matsuo Basho, 1644–1694)

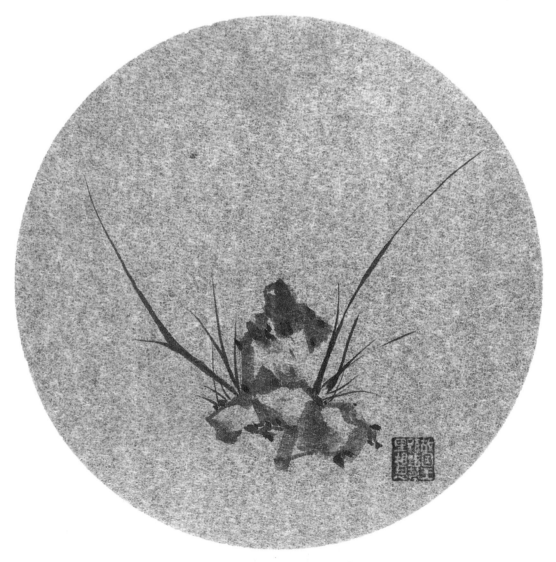

Basic form of the rock with one and two brushstrokes.

A *Start on the contact surface. Move the brush tip at an angle and with slight pressure first to the left, then turn it sideways and increase the pressure as you move it upwards. When you reach the upper portion of the rock, pull the brush down, with the tip again at an angle, allowing the line first to become wider, by rotating the brush, and then narrower. As the brush is pushed sideways, the bristles spread out, which creates white spaces. If you are working with two brushstrokes, proceed as demonstrated on the bottom rock.*

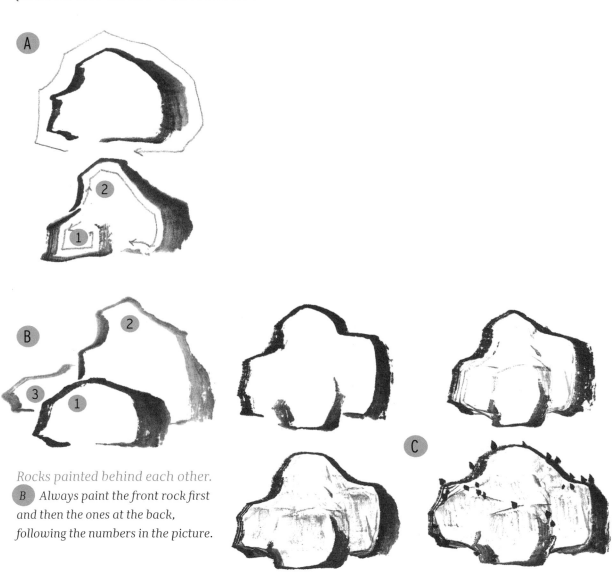

Rocks painted behind each other.

B *Always paint the front rock first and then the ones at the back, following the numbers in the picture.*

Heavily structured, uneven rocks.

C *Outline the rough, basic form first. Continue to paint with short, alternating overlapping lines (called 'folding lines') that indicate depth (volume) or shadows. A more compact line looks darker, indicating shadow. If necessary, emphasise part of the area by painting with the brush held at an angle. Grainy dots, called 'rice-grain dots', are used to indicate roughness on the surface of the rock.*

Exercise on the function of dots

Small dots are added to the basic shape of the rock at the end. They are called 'moss dots' or 'rice-grain dots' and, like the line and area, are an important design element in ink painting.

If these dots are dotted moist onto a stone, rock or trunk, they form dark, damp areas that give the surface of the rock a damp look, as if it were covered with moss. Dotted individually onto rocks or a tree trunk, they add roughness to the surface.

Dots painted close together at the front of the picture represent moss, while in the background of the picture they represent bushes or entire trees. Groups of dots make up the leaves on trees

(see page 121). Dots are also added to a landscape as accents or decoration. They add vitality, tone and rhythm to a painting. Colour can be mixed in these classic elements of expression to represent bushes. I would imagine that dots of moss can also open up new forms of expression in modern landscape paintings.

If one is not familiar with these dots in paintings, they will probably appear rather strange, and quite possibly superfluous, at first. Consequently, they are often placed anywhere, thoughtlessly and without regard. But at some point, one starts to understand the function and purpose of the dots. Many people say how important it is, and

yet how difficult it is, to make and place the dots correctly. When every single dot is in the right place and in the right quantity, each with its own rhythm and life, then the effect is assured! Then we understand why the Old Masters spent decades practising placing these dots correctly. When I talk about this in my courses, a lot of people smile – politely.

An old, worn-out brush is best for shaping the moss dots. As is evident in the pictures, there are lots of different shapes: long ones, elongated ones, round ones, square ones, ones that are shaped like oak or bamboo leaves, and so on. The nuances are also extremely varied: dry, wet, hard, soft etc.

Brush pulled at an angle

Brush pulled at an angle with little pressure

Dotted with the brush held upright and pulled

Dots in a group

With a damp brush

With a splayed brush

Just using the tip of the brush

Small circles

Space and composition in landscape painting

Space in a landscape. In contrast to Western paintings, which have a perspective from one particular viewpoint, space in ink paintings is always viewed from several points, called 'the three-distance method'.

This method includes horizontal distances, from right to left or left to right, and the depth to the back.

The third distance is the vertical from the top to the bottom and vice versa. By examining the distance of a mountain from above and from below, the artist not only determines the height of the mountain, but also its volume.

The composition of a painting. Conventional paintings are created by dividing the area of the picture into the foreground, middle ground and background. This is an easy way to achieve depth and create a natural spatial impression. However, this is not a hard-and-fast rule. You might want to leave out the middle ground and paint the background bigger and in dark ink, if that is your main interest.

Once again, I want to emphasise that an ink painting is not necessarily meant to produce a realistic, naturalistic picture; rather, it is an attempt at finding the essence of an object or landscape, your own personal perception. For that reason, always start with the level that is your main interest. Of course, a painting will look more natural if objects in the foreground are bigger and painted in darker ink, and those in the background are smaller and painted in lighter ink.

The ideal composition is a harmonious interplay between contrasts and the white space that forms the open depth, both literally and figuratively, e.g. the detail and the whole, movement out of and into the picture, primary and secondary interest, and so on.

Exercise: Fantasy landscape in the classic manner

Two different kinds of ink painting developed in China. In northern China, where the climate is really harsh, the method is clear, precise and more objective. By contrast, in the milder climate of south China, where southern light and high humidity shape the landscape, since the 13th century the style of painting has been more nuanced and two-dimensional with differentiated tonal shading. These paintings are more lyrically expressive.

It was particularly important to these masters, who included the Zen monks, to achieve the depth of space through omission and unpainted areas. Try to paint your ideal of a lyrical landscape painting to the classic elements you have learnt so far.

Farewell.
'First I built the cabin and settled down inside it, then I planted trees beside the hut, set the rocks and sprinkled them with moist earth. I concluded the painting with the seashore and the mountains, and added the birds flying off into the distance and then the boat on the horizon.'

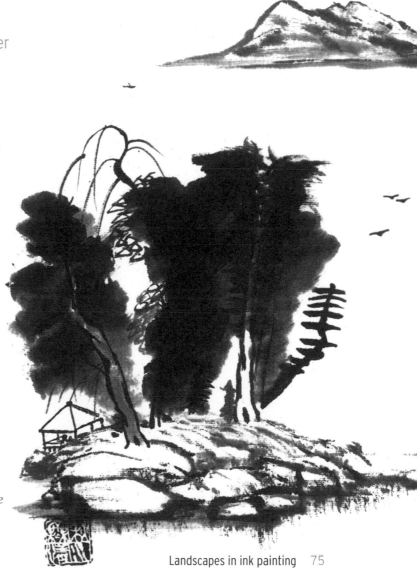

Differences between Chinese and Japanese ink painting

The roots of Japanese ink painting go back to the 14th century. They came from China where, as already mentioned, two different styles already existed that, like Zen and the southern style, were brought to Japan. The Japanese aesthetic sensibilities are evident in these and later expressions.

The story of the orchid

My Japanese teacher, as a way of introduction, was painting an orchid in absolute silence and extreme anticipation, using only a few brushstrokes that were almost invisible. Another student, watching in amazement explained that it was difficult for her to describe the beauty that she saw.

Only a hint of ink touched the paper, making the 'breath' of the orchid so quiet, so delicate. The flower was only a shimmer of life on the paper, but the space surrounding it was like a large protective veil. The petals of the orchid became the centre of the cosmos. It was an experience that gave me a sense of complete happiness. All of us felt the beauty in the presence of that flower.

However, this orchid was not what my Chinese master understood an ink painting should be. For him, the orchid should be created in the clear, distinct form required by Chinese tradition.

For that reason, he drew a pencil sketch to show me what an orchid looks like in nature.

Although stylised Chinese ink paintings are most definitely not realistic representations of nature, like a photograph, they are very naturalistic studies of nature. However, this kind of painting has as its underlying concept a desire for idealisation that does not allow the depiction of a problem.

The story of the pine tree

A German student proudly showed our Chinese master his painting of a bare, dying pine tree on a mountain. The master immediately reached for his brush and painted needles on the branches. With his brush, he filled the free space with how strong and enduring the pine tree is.

The student was speechless and then outraged that his depiction of the destruction of nature had been changed. However, for the Chinese master, bound by his tradition, it was unthinkable that the pine tree, the symbol of long life, should shed its needles.

The master often said, 'No, that does not exist! Have you ever seen anything like that in nature?' This 'observing with the intellect' is an objective attitude, as when a painter expresses in works many of the theories and principles that are to be adhered to when creating a painting, and which have been handed down to us. They are extremely common in Chinese painting; in contrast, in Japanese painting, observations are much more influenced by feelings.

As well as preferring a more objective, logical depiction, Chinese ink painters also admire the clarity expressed in dynamic lines. If something is meant to be hidden, it is often shown in symbols. Japanese ink painters often use symbolism or suggestive nuances of mood.

For my Japanese master, as for me, painting was a 'being inside'. If he painted a flower, it longed for the light, the open space. Its longing blended with the white space.

To my Chinese master, painting was a 'portrayal'. When he painted trees, they would stand arrogantly against the white space, which they nonetheless perceived to be a blessing from beyond. When I looked at Morandi's *Trees in Daylight*, I was immediately reminded of trees as my Chinese master painted them.

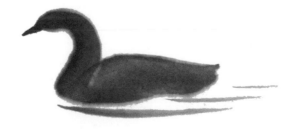

Exercise: Reflections in the water

Once I saw how the ink flowed with the water, I created white lines along the shoreline. This gave me the impression of reality, and so I made reflection in water the subject of ink painting. I was fascinated by doubling the space with the mirroring, which also hinted at infinity. This theme always reminds me of the paintings of water lilies by the French impressionist Claude Monet. In his pictures, just as in ink paintings, he was always trying to become one with nature. The reflection of the sky in his paintings reveals depth and eternity, which, even though it is painted in dynamic brushstrokes, appears to me to be similar to the white space in ink paintings. In contrast to Monet's wonderful symphony of colour, no worldly colours are used in the following ink paintings. Without colour, the atmosphere of stillness and radiant peacefulness is intensified in these pictures. The harmony in the painting is created by the asymmetrical balance of reality and illusion in the reflection.

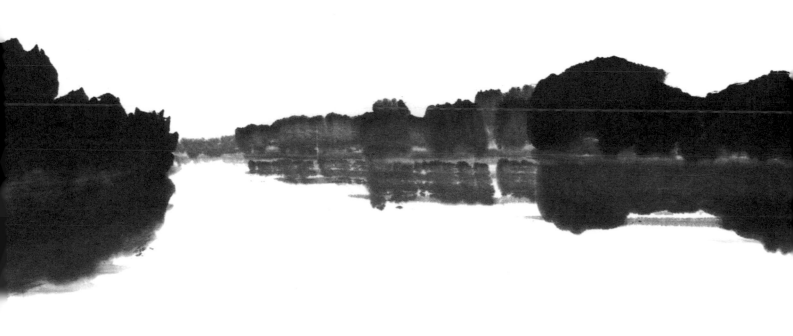

Reflections in water.
Start by painting the trees on the land, making the ones that are nearest larger and darker, and those in the distance smaller and lighter. Then paint the reflection of the trees in the water. While the ink is still wet, paint the narrow strips of land in ink that is a little lighter and make the reflection darker.

Anchored boat.

The bows on old Japanese rowing boats are not pointed, but flat. When painting the boat, start with the visible side. Put the brush on the left of the front edge, and pull it from the front to the back edge, then push it to the end of the back edge, which is at a right angle. Then push the brush under resistance to the other edge of the bow. This gives the boat vitality. Paint the other objects with the moisture remaining in the brush. Paint the clouds by holding the handle of the brush at an angle, as for the promontory.

Pause for thought

All painters find something lovely in their first picture even if it contains a few technical flaws. However, continued attempts to eradicate these flaws will not result in a pretty picture. It is much more important to be completely calm and relaxed when creating one's idea of the whole picture.

I keep trying until I am happy. It's sure to happen, happens quickly – and exactly when you release yourself from this desire, this urge, to achieve technical perfection. I do not think this is a coincidence. I always tell my pupils this: 'The first one is always lovely in some way, but something lovelier will come along!'

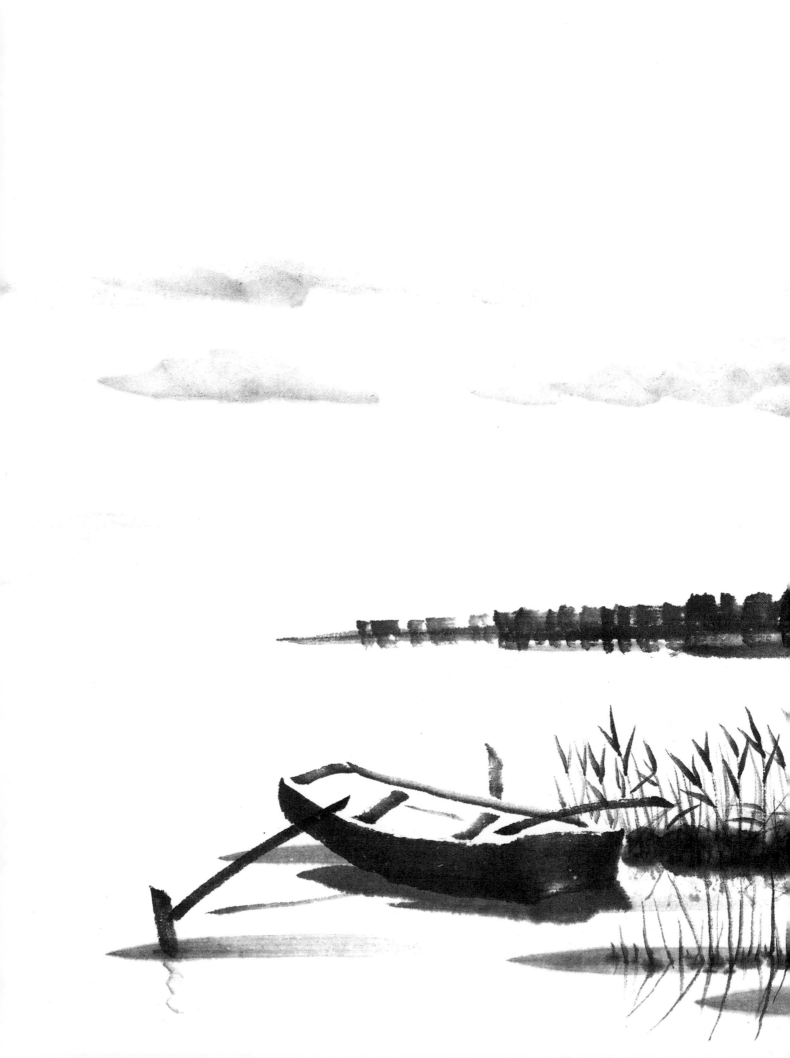

Exercise: Snowscapes

Snow symbolises purity and transience, and is a favourite motif with ink painters. The snow is not 'painted', of course, but rather the snowy areas are left unpainted and white. Only the parts of the picture that are not covered in snow are painted. However, in a snowscape under a cloudy or night sky, the whole picture is painted with very thinly diluted paint, as shown in the pictures on pages 81 and 125.

Snowscapes are often painted on heavily glued paper such as Dosabiki-Ma-shi and Torinoko-shi. Soft transitions between the painted and unpainted areas can be achieved by blending the ink.

The Rubihorn.
A little look at colour in ink painting. Just a touch of light blue brings the memory of the sunny view of a snow-covered landscape back to life.

First snow.
To familiarise yourself with painting snow, start by painting a simple shape such as this one.

Snow-covered hut at night.
Experiment with different types of paper. Absorbent Gasen-shi was used here. In order to prevent harsh contours, the wet brush, filled with three shades of ink, is guided along the edge of the snow with overlapping strokes.

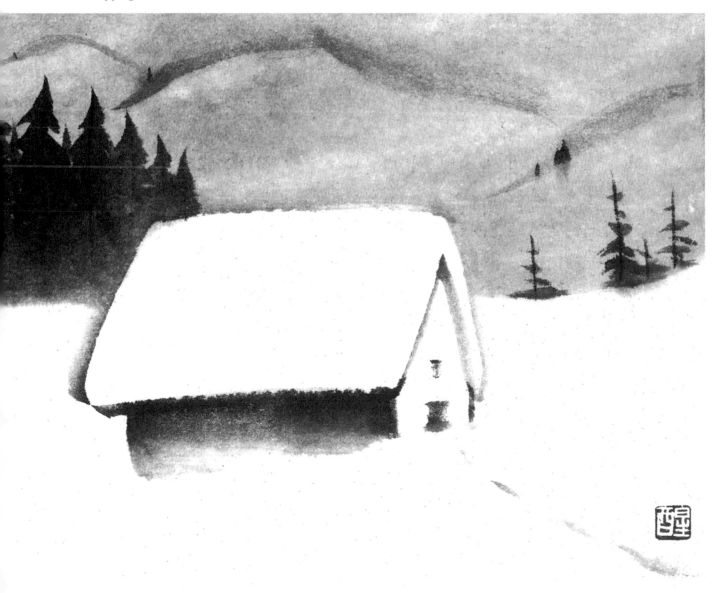

Figures
From sketching to painting

Since ink paintings do not attempt to depict objects in photo-like realism, you do not need to be totally occupied with the relationship between the size of objects or with light and shadow.

Nevertheless, you need to have a clear idea of what you want to paint before you reach for your brush. Always make a sketch of your painting first. It may sound surprising, but this will reflect your impressions much more intensely and more clearly than photos will.

Sketches are particularly helpful in ink painting as drafts, or to jog the memory, because it makes it much easier to draw the actual ink picture from the emotion. A single line will determine if an object is a stone – or a potato!

The structure and characteristics of an object must be clearly defined in order to paint in deliberate and determined brushstrokes. Even more important are the enthusiasm and positive attitude you bring to the process of painting and to the motif.

Sketch only what has touched your imagination. You will then be more aware and see more clearly, because you want to capture the essence of the picture you are painting.

Sketching an object will help you to see how to express your idea: how to divide the space and the direction of the movement within the picture. The same applies to the lines – how long and wide they should be, and what the shading should be.

Then think again about what it is you want to express (more often than not, the sketch will tell you!). Simplify the form, if required, and reduce the lines down to the absolute essentials.

Female nude in chalk.
I am fascinated by the posture of this woman, and particularly by the open space surrounding the closed and at the same time free-flowing lines, beginning from below and flowing upwards over the back into the right shoulder.

Female nude in ink.
The picture of the chalk sketch with reduced lines.

The elongated brushstroke

In classic representations of figures, the line is reduced to the essential and drawn with a fine, supple brush, as in the picture *Male, standing*. The female nude and *Dancers* are examples of just how expressive elongated brushstrokes can be. I discovered that from painting nudes.

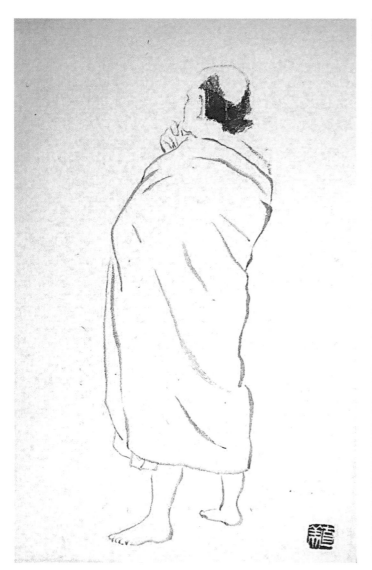

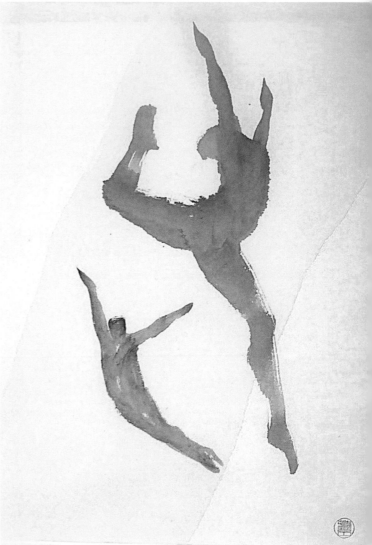

Man, standing.
In this picture, the black fringe of hair helps to keep the lines together and add calm to the picture.

Dancers.
This picture was astonishingly close to the real forms. The few strokes depict the whole figure and the surrounding space at the same time.

Female nude.
While my eyes followed the outline of the model, the
brush in my hand moved almost by itself. Lo and behold
– just a few strokes, and atmosphere and emotion
develop in the painting.

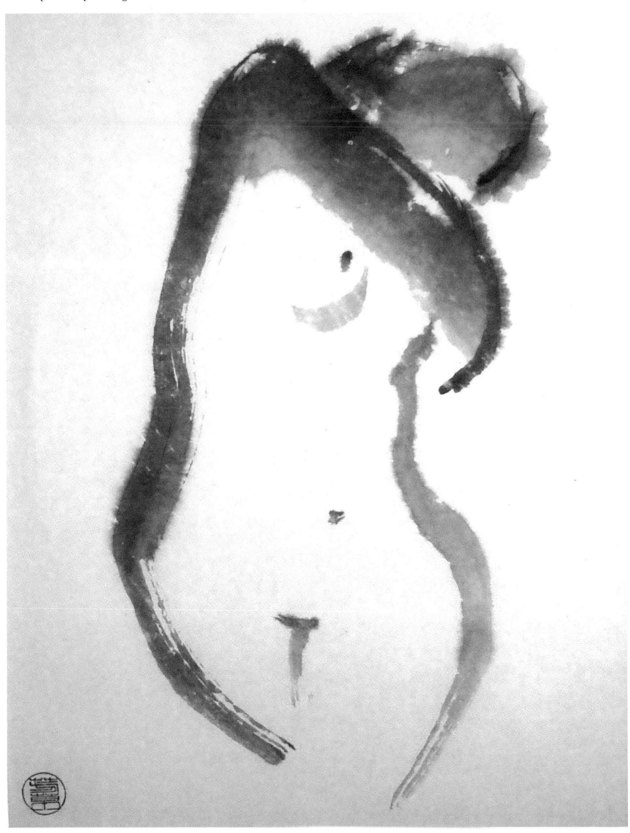

Ideas to copy

The following pictures show a number of charming and popular motifs, mostly without information on painting them. They are just some ideas for playing about with motifs and materials (and an initial approach to using colour), which you can reproduce to your ideas using the skills you have acquired so far. The captions help to create atmosphere.

Cows.

I saw these two cows in a meadow during a moment of absolute quiet. They were so curious and unafraid. Only the sound of their ruminations betrayed their existence. This composition is the result of the first impression I had when I discovered them. The picture comes alive because of the unity of the lines and spaces, with which I attempted to convey the heaviness of the animals.

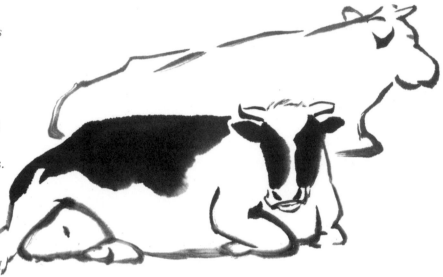

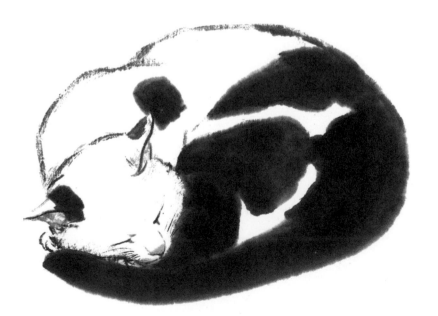

Cat.

Somebody pointed out to me that cats are a frequent motif in Japanese paintings. Could it be because of their lovely black-and-white fur? Or because of their delightful personalities? As she is lying there, I'd like to think that the cat is dreaming and traveling back to the very beginning of existence. The seal says, 'Dreams are my home.'

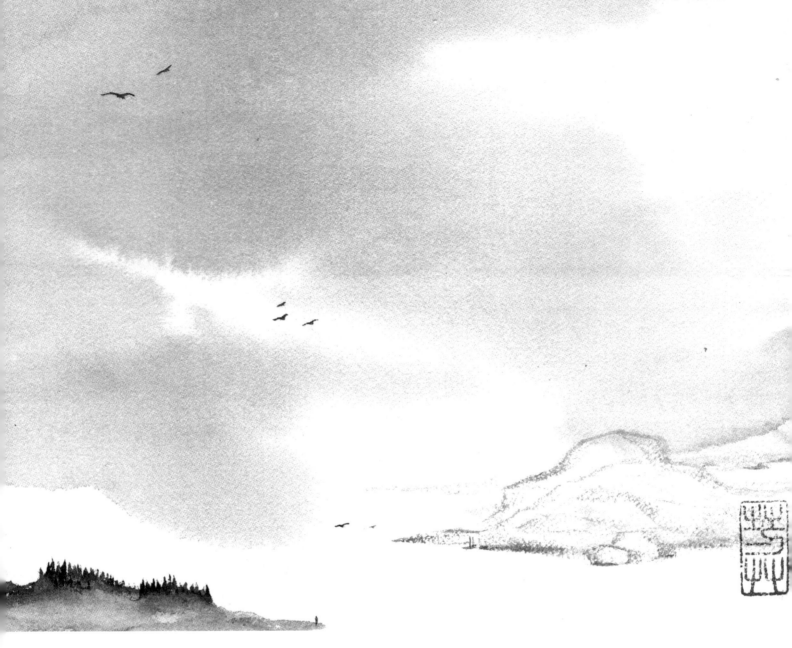

*Hatsuboku-san-sui, painted on
watercolour paper.*

*Hatsu means 'pouring on', boku is 'ink' and
san-sui means 'landscape'; it also means
'mountain and water'. Hatsuboku is a technique
for subjective, spontaneous and expressive
creations. As with the wet-on-wet method in
watercolour painting, you begin by moistening
the paper and then pouring very light ink onto
it. When the paper has dried, add other
elements such as mountains, trees and birds,
letting the inks blend in naturally.*

Abstract landscape.
As a child, I used to dream of floating with the clouds. In this picture, I first painted the 'direction' in which the clouds were moving. You may follow this by adding cumulus clouds with a wet brush, allowing them to run into each other. Clouds come alive and 'move' through the splayed bristles.

Boat.
The most beautiful part of this
painting is the white space. The light
at the height of summer is so bright
that it offers a glimpse of eternity. In
the midday quiet, this moment
blended with infinite time.

89

Farewell – painted on Shiki-shi paper on a gold-coloured background.

In this painting, I combined the sailboat with a classic motif. Many paintings during the 16th and 17th centuries used paper covered with gold leaf. Even though the intent was purely to add a decorative touch, the effect of the reflection and the space seemingly bursting with brilliant light is truly enchanting. The image of eternity comes to mind.

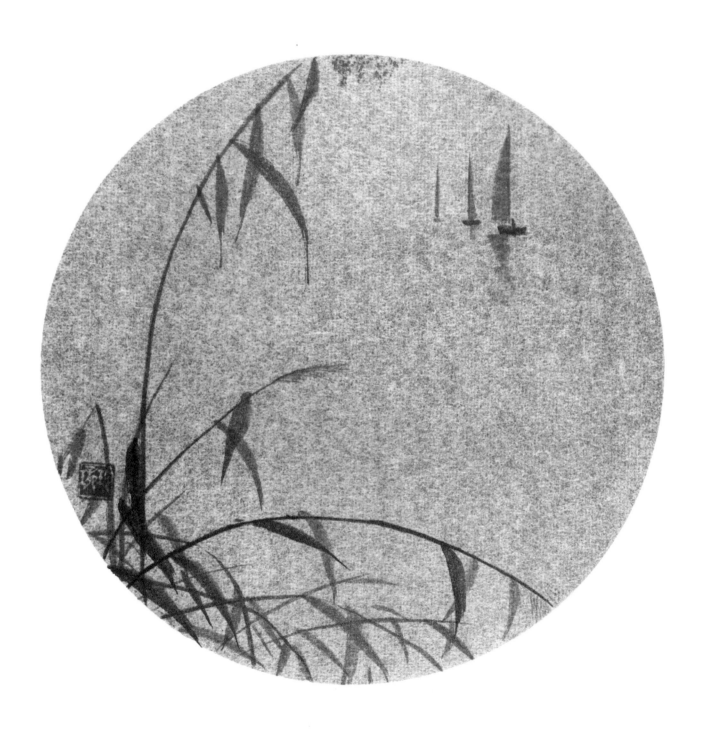

Cyclamen.
With its flowers dancing on a 'globe of leaves', this is my favourite plant. Birth and death meet on the merry-go-round called Nature. To me, the cyclamen never loses its beauty.

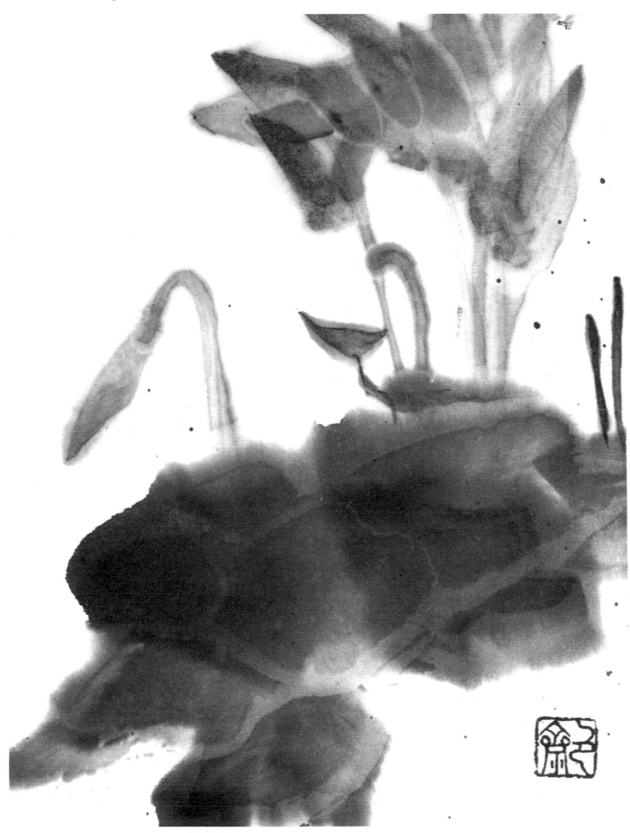

Colour in Japanese ink painting

Today in Japan, there are two different types of ink painting. Black ink plays the major role in one kind, which is called Sui–boku–ga (*sui* = water, *boku* = ink and *ga* = painting, picture). The other kind is coloured ink painting using black ink and lots of colours; it is called Boku–sai–ga (*sai* = coloured).

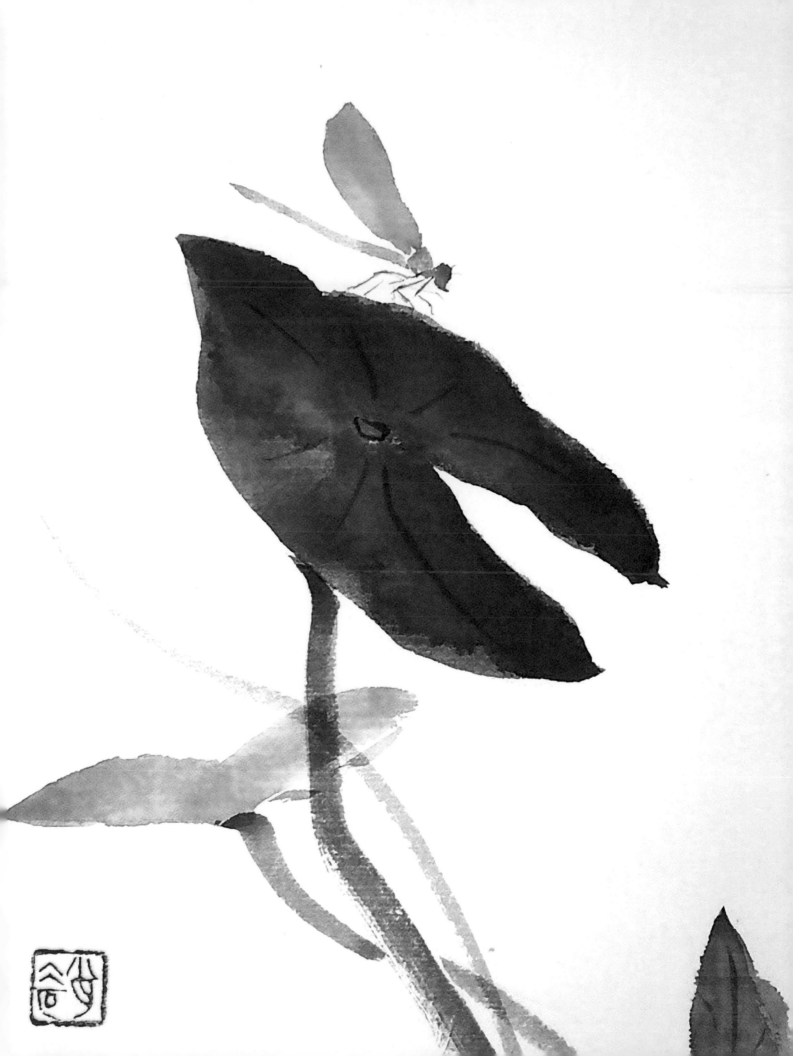

The role of colour

In ink painting, which is heavily influenced by Zen Buddhism, the perception of colour is replaced by ink in varying shades. There is no 'worldly' use of coloured paint. Even though orthodox Chinese ink painters insist that the intensity of ink, the wet and dry application of ink to the white paper, can express every existing colour as well as light and dark, colour has always been used in painting with the sole exception of Zen painting.

Paintings that include colour are only called ink paintings when ink is also used, and the shapes are created by guiding the brush. However, if you are using colour, then the picture should be even more beautiful than if it were being painted only in ink. In other words, the colour and the ink must enhance each other.

If you are painting yellow chrysanthemums, then the yellow petals need to be made even more radiant, more fragrant and more appealing through the contrast with the black ink.

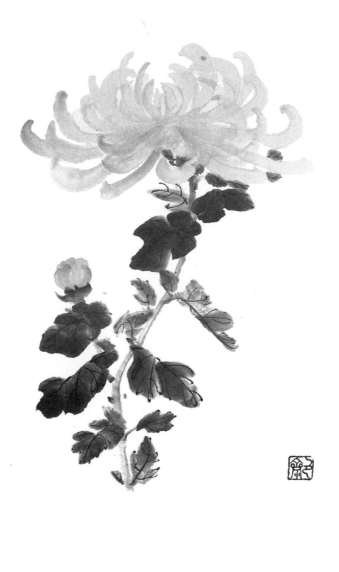

Large chrysanthemum.
The black ink on the leaves makes the
yellow more radiant.

The difference between coloured ink painting and related painting techniques

First, it is necessary to illustrate the fundamental difference between European watercolour painting and Japanese Nihon-ga – 'Japanese-style' – paintings.

This is not Japanese watercolour painting, but ink paintings in colour, although watercolours are also used. You will learn this type of painting starting from the very bottom in order to use it correctly. I really believe it will open up a whole world of expression to you. In both kinds of painting, Sui-boku-ga and Boku-sai-ga, black ink made from soot is a key element. However, now it is combined with colour for painting, rather than being used by itself, as in the past.

As already mentioned, I found that black ink on absorbent paper – which can often be tricky because of its special characteristics – is most effective in its depth. The black ink, colour (if used), and the water penetrate the paper fibres, flow into the depth, and there create an endlessly vast space. It is surrounded by light and atmosphere. It is the white space mentioned earlier (see pages 10 and 130).

In every other painting method, the colours lie on the surface, i.e. on the paper – beside each other, above each other and within each other. Three-dimensionality is achieved with light and shadow, and central and aerial perspectives, which means it is also necessary to fill the area. Otherwise, in object painting, the objects in the painting would 'hang in the air'. That is why no large, white areas should be created there.

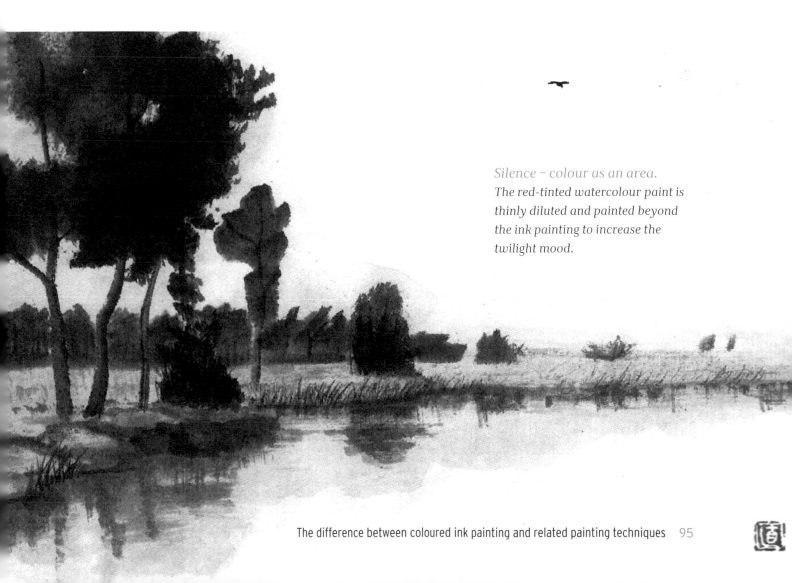

Silence – colour as an area.
The red-tinted watercolour paint is thinly diluted and painted beyond the ink painting to increase the twilight mood.

Brush control in coloured ink painting

The shape is created not from the colour, but from the way the brush is used. As with black ink, a brushstroke of colour can enhance the whole three-dimensional shape, the surface texture (i.e. rough or smooth), or the consistency (e.g. hard or soft). As with the black ink, the brush head needs to be filled with various shades or even different colours. A cypress painted with a single stroke can look more natural and more alive than one created from lots of strokes (see page 127). The sensitive, supple brush can condense nuances, feelings and life in a single stroke.

Reduction in colour

The reduction of colours is no less important than the reduction of the form. In this type of painting, it is not considered important to change the colour with light. So colour is only used to express the essential. The Chinese symbol for 'colour' contains this term as used here, and it also has other meanings such as eroticism and sensuousness. That is how the delicate colours of the cherry blossom are also perceived. The effects of colour are further enhanced if they are used sparingly. Colour should also be used sparingly in ink painting. Remember, though, that the same colour will look different on different papers. The colour often looks extremely matt on absorbent paper on which the ink appears in transparent, differentiated, fine nuances. This is why it is not possible to precisely reproduce the colour that the eye absorbs so enchantingly in nature. In fact, we often forget that a colour does not stand alone in the picture but – as in nature – has its environment. Colour changes in its relationship to its surroundings. That is why the 'identified' colour in the representation of the contrast needs to take into account its emphasis or harmony with other colours or to the black ink. In ink painting, colour can only be reproduced as it is seen with the heart. It can look more real and truer than in watercolour painting if the essence of ink painting is not forgotten.

Ammersee – colour as a brushstroke.
Here, the colour is applied subtly with a broad brushstroke after painting the boat and the mountains in the distance. The red-tinted shade adds warmth to the coolness of the evening.

Applying colour in Japanese ink painting

In coloured ink painting, it is best if you choose as few colours as possible, and use them with restraint. Above all, avoid using them as they occur in nature. If you get carried away by too many colours, you could find yourself unable to achieve what you originally intended to express. There are several ways of using colour in ink painting. Ahead of the detailed instructions that follow, the following are the most frequently used methods for applying colour.

Applying black ink and colour separately

If the colour is desired for a specific part of the picture, then use it there instead of the black ink. This area will look more emphasised.

Mallow (also called 'hibiscus').

I was enchanted by the delicate, pale pink hibiscus, reaching up to the sky. Despite the understated colour, I thought there was something bright and striking about it. I thought the pale pink of the flower created a strong contrast to the leaves in shades of black ink. The flower glowed even more strongly on the paper than in my imagination. The ink gave life force to it. Coloured leaves would not have been able to recreate the impression of 'glowing'.

Using black ink and colour mixed

To paint a calm, harmonious picture in colour, you can combine black ink and colour in parts of the picture or all over it. Add just a little ink to the colour. Although the colour will lose a little of its brilliance through the ink, it will gain calm and depth. With highly absorbent Gasen-shi paper, there is also a more distinct separation of the areas with white edges. This can be helpful in adding another dimension.

The Loreley.
This striking rock is painted swiftly with a dry brush and black ink. The picture is brought to life by the large free space in the middle, the river that disappears quietly on the horizon, and the staggered mountains. We feel it is a sunny, slightly misty autumn day. A few strokes of colour add a touch of cheer to the picture.

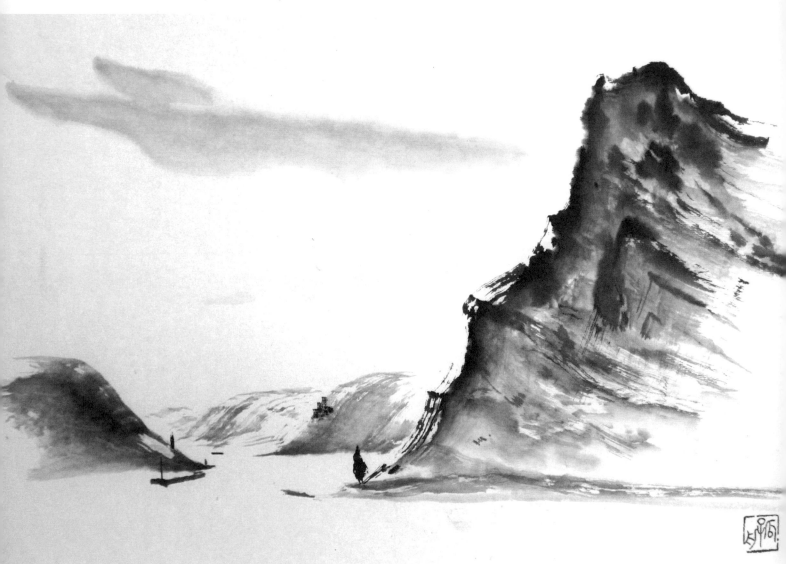

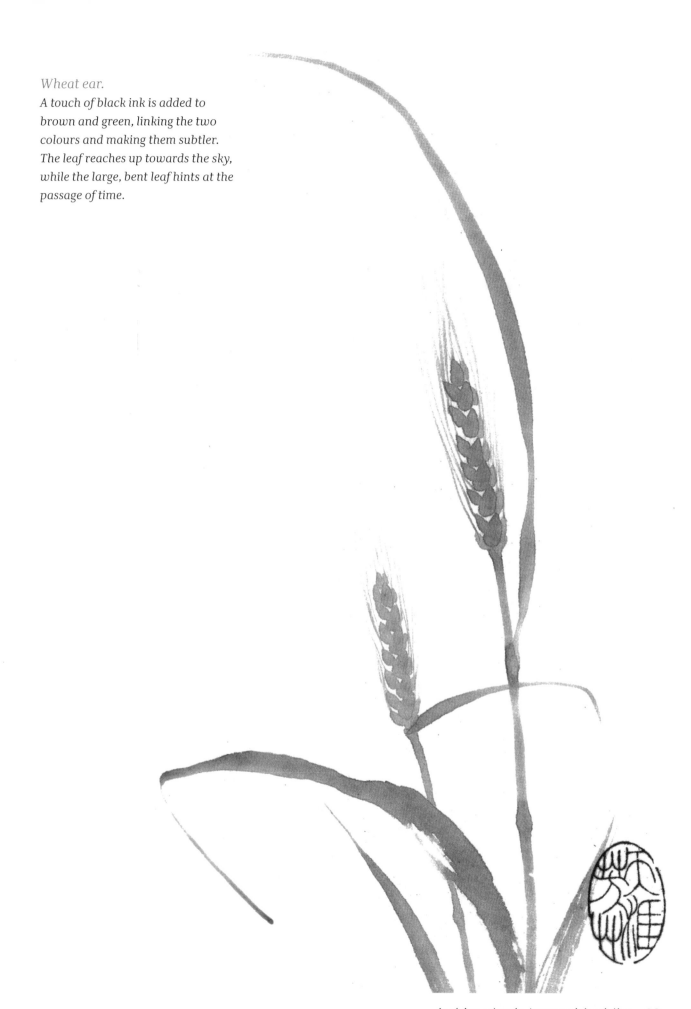

Wheat ear.
A touch of black ink is added to
brown and green, linking the two
colours and making them subtler.
The leaf reaches up towards the sky,
while the large, bent leaf hints at the
passage of time.

Suitable colours

Generally, you can use any kind of paint for ink painting provided it can be diluted with water. However, different paints have different characteristics that make some more suitable than others, and they already have a long established tradition. To illustrate the differences, in the picture with the iris, I have painted the various colours in their pure forms on absorbent Gasen-shi paper. Black ink was mixed into the colour for the stems and leaves. Compare the flow, the possibilities for combining with the black ink, the radiance, brilliance and coverage of every colour.

Iris.

These are examples of the appearance of various colours on absorbent Gasen-shi paper.

1 *Japanese coloured ink stick Saiboku.*

Ink sticks are made from high-quality pigments, and ground with water on a white grinding stone. Thanks to the extremely fine pigments, they have a rich consistency with excellent coverage, which is why they can also be applied thinly. The silky sheen and shape are retained on absorbent paper. Almost any paint will blend well with black ink. Saiboku also works well on silk.

2 *Chinese coloured ink stick.*

Is ground the same way as Saiboku. However, this Chinese coloured ink is more coarsely pigmented than the Japanese variety, looks more transparent and runs more. It blends relatively well with black ink.

3 *Japanese Gansai watercolour.*

This pan-shaped paint is used extensively in coloured ink painting in Japan. It is ideal for light applications of paint and runs like European watercolours, but it also retains its glow and brilliance on absorbent paper. It does not blend very well with black ink. It has the least glue, and does not stay well on paper.

4 *Japanese Kansai covering paint.*

Like the Japanese Saiboku ink stick, it is finely pigmented and so can be applied thickly or thinly, as well as layered. As all the colour pigments are about the same size, the various shades all blend well, and most of them blend with black ink as well. The brilliance and silky sheen are retained on absorbent paper. Kansai runs less than Saiboku.

5 *European watercolour paint.*

This runs well on absorbent paper; applied thinly, it runs even more. It runs less when applied thickly, but it also loses its brilliance then and looks quite matt. The colour pigments do not blend well with black ink. The paint separates from the ink on application, and runs beyond it.

6 *European gouache.*

This hardly runs on absorbent paper. Diluted thinly, it loses its brilliance completely and looks quite matt, but it stays relatively brilliant when applied in a thick layer. Gouache does not blend very well with black ink.

7 *Coloured drawing ink.*

This ink is intense, bright, striking, transparent and waterproof. It dries very quickly and blends well with black ink. Its only disadvantage is that it is difficult to cover small or narrow areas with it, and shade it on application.

Painting flowers and animals in colour

In this chapter and the next, you will be practising filling the brush with paint and using the brush correctly.

I will demonstrate by using a mallow flower as an example. This painting requires blue, red, yellow and white covering paint. You will also need a little black ink, very thinly diluted.

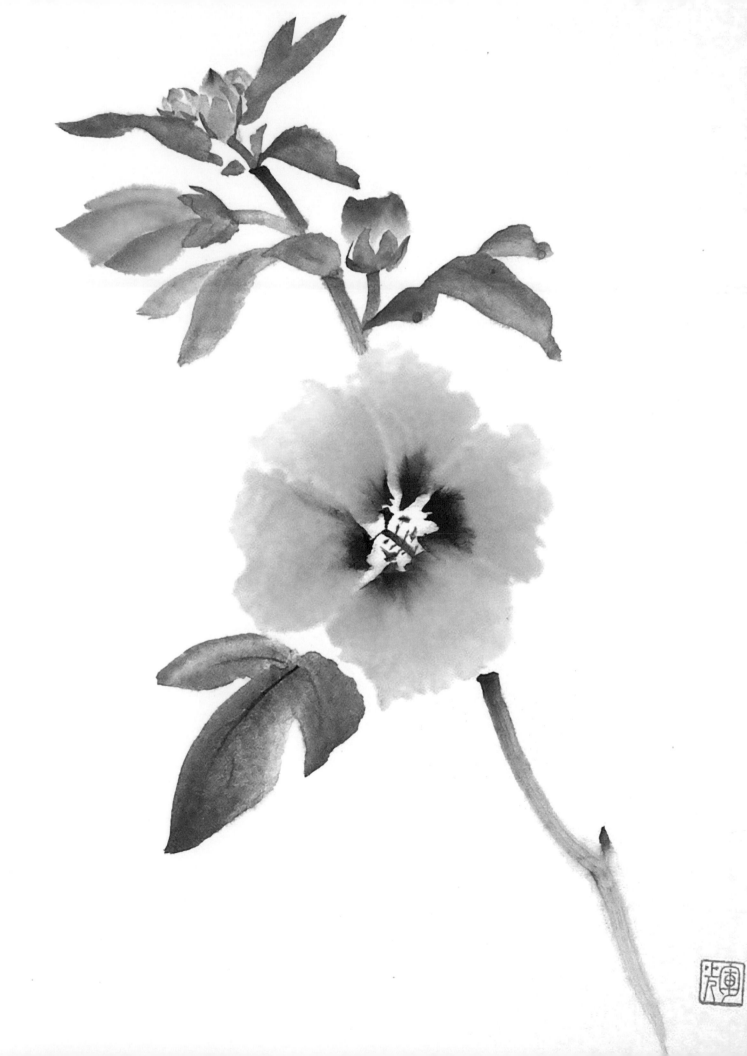

Hibiscus – basic exercise for filling with colour

Filling the brush.

Dip the brush in water and use a pulling movement to wipe it on a cloth. This adjusts the moisture in the bristles. Fill the bristles with a little diluted black ink. Then fill the brush head with a soft lilac mixed from blue, red and white. In order to dilute the paint in the bristles, gently press the body of the brush down on the plate a few times as you do for filling with ink (see page 33). Then put red ink just on the tip of the brush head.

Light grey

Purple

Red

Painting the hibiscus flower.

The hibiscus has five slightly overlapping petals that form a circle. Position the tip of the brush in the middle of the flower. Push the brush with the soft purple – the brush head held angled to flat on the paper – down on the paper five times for each petal, working anticlockwise. Exert minimum pressure on the brush. Try to move your elbow generously and loosely, otherwise there will be too much resistance on the paper, and some of the bristles will stick to it. Experiment as you like and prefer for the flower when filling with colour. With this type of filling, it is not possible to control the blend precisely. This means that every flower will consist of different shades. One particular characteristic of this flower is the strong red in the middle. In order to highlight this, fill a little more red into the brush tip for each petal. Finally, add some tiny stamens in black ink as shown in the main picture.

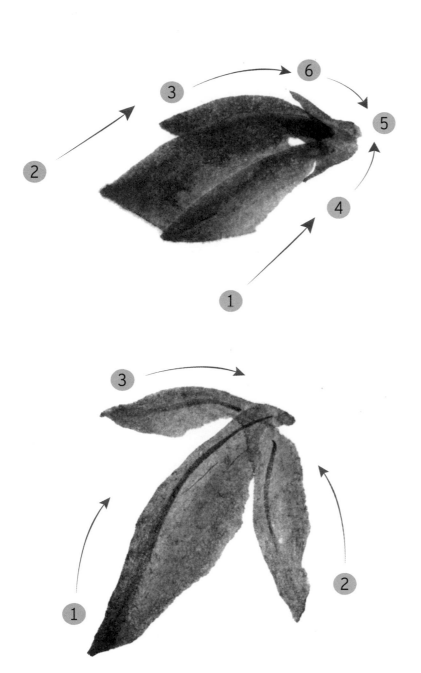

Leaves, buds and stem.
Mallows are as varied as the shapes of their leaves. For the three-part leaves seen here, fill the brush with green paint mixed from blue, yellow and a little ink. Again, you can experiment and make a green that will really show your flower at its very best in your picture. For the large leaf and the half-open bud, I guided the brush from the outside to the inside, and I did the same for the small leaves and forms. Then paint the stem in the main picture with an almost dry brush using a little brown, mixed from red, yellow, blue and black ink. As you can see, the stem is dark at the top, which means this line was drawn from the top to the bottom.

Camellia – brush control for oval, three-dimensional leaf shapes

This is an exercise in which the brush is held flat to make the leaf shapes that are to look three-dimensional. The brush is guided with alternating pressure on the body of the brush and the tip to make two different shapes.

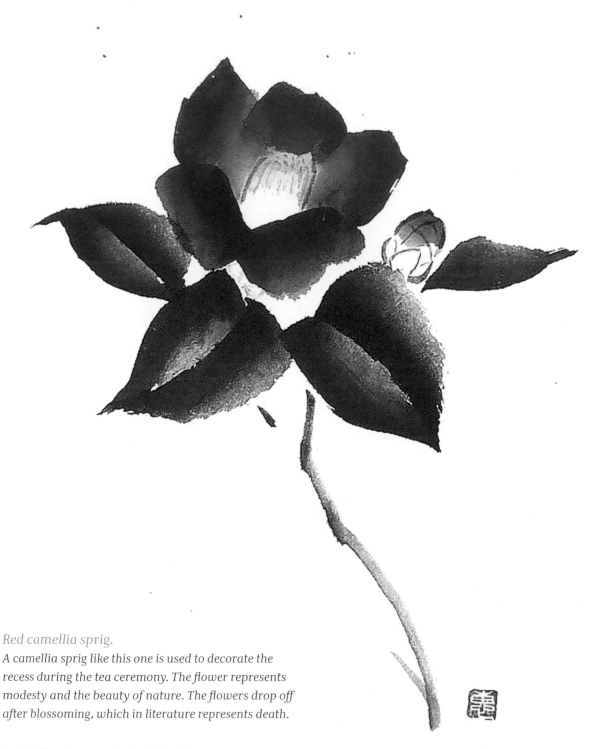

Red camellia sprig.
A camellia sprig like this one is used to decorate the recess during the tea ceremony. The flower represents modesty and the beauty of nature. The flowers drop off after blossoming, which in literature represents death.

A *Leaf rounded on both sides.*
The brush is placed flat to the left and then drawn down. Exert a little more pressure on the tip of the brush, but mostly in the middle of the shape.

B *The leaf with a straight edge.*
Most of the pressure is exerted on the body of the brush. The pressure is slowly increased, and then gradually reduced from the middle of the shape. The pressure on the tip of the brush remains the same. If both (**A** and **B**) overlap and attention is paid to light and dark areas, the leaf will look three-dimensional. For different shapes, the handle of the brush is guided at a right angle to the direction of movement.

C *The rectangle.*
The brush is placed flat with the tip pointing to the left. The pressure is the same from the tip of the brush to the base. This technique was used to paint the small leaf on the right of the picture with the camellia in a single stroke.

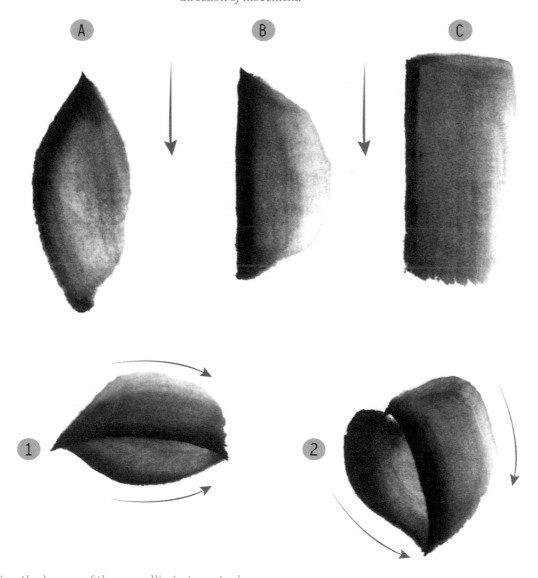

Painting the leaves of the camellia in two strokes.
Start leaf 1 or 2 by painting part **B** , and then part **A** . Both versions, whether painted from the tip of the leaf to the stem or vice versa, have a distinct delineation in the middle, and create a spatial effect. If painting in the opposite sequence, that is **A** first and then **B** , the dark part of **B** will run into the light area of **A** . This will not create a clean demarcation, nor will there be a genuine spatiality (refer to the two middle leaves of the camellia on the opposite page).

Iris – creating a shape with a few brushstrokes

Ever since the Middle Ages, the 'Children's festival' has been celebrated in Japan on the 5th of May. Now as then, the reproduction armour of the Samurai is decorated with lilies for the festival. The Japanese iris – the typical colour is purple – is a close relation to the yellow European flag iris.

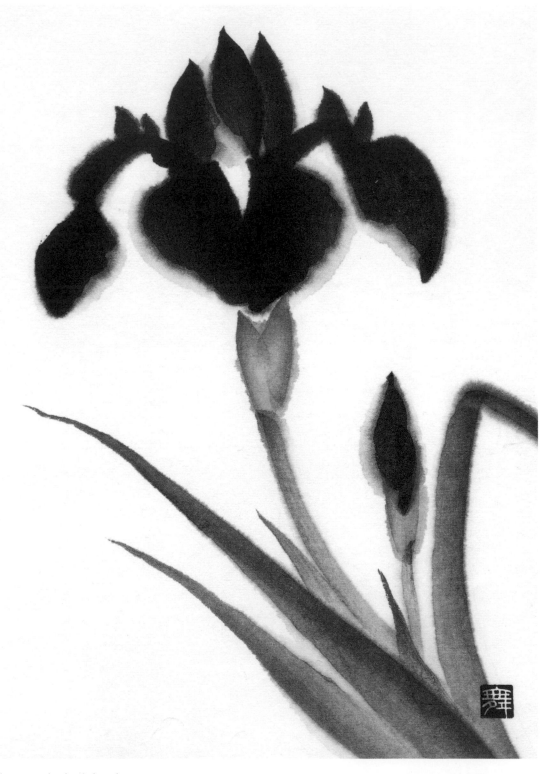

Painting the iris.

This painting was created on untreated Gasen-shi paper in the sequence shown here: blossom, calyx, bud, bud calyx, leaves, and stem. Use the Choryu brush and gouache in the colours ermine, light ultramarine, indigo and Indian yellow, plus black ink.

Structure of the flower.

Start with the large petal at the front, consisting of two overlapping strokes. To make the seam less noticeable, fill the brush in two shades of colour, and when painting the two brushstrokes, allow the tip with the darkest part to run towards the inside. If the two dark areas overlap, the seam will hardly be noticeable (1 and 2). Petals 3 and 4 – hanging down at the side – are shaped by changing the pressure and rotating the brush handle. The tiny petals in the middle and the small ones on the side (6 to 11) are created by rotating and pulling the brush handle to the outside.

The sepals.

These are painted in two strokes (12 and 13). The brush is rotated and pulled to the outside. If you use light paint, the seam between the two strokes will be visible. That is correct here in order to show the rounded shape.

The leaves and stalk.

Paint with an upright brush that is pulled from the tip to the bottom with increasing pressure. For leaf (a), fill the tip of the brush with a little dark paint. Hold your breath and pull the brush towards you. For this, 'the breath should be in the abdomen'. Paint the other leaves in the same way, from the tip to the bottom. The dark shade of the leaf tip creates the illusion of expansion as if the leaf had not stopped growing. The movement is created in the stillness. The minimal bending of the tip stands for rich life force; it is like a wind-filled sail. For stem (b), put the brush under the calyx and draw the brush downwards.

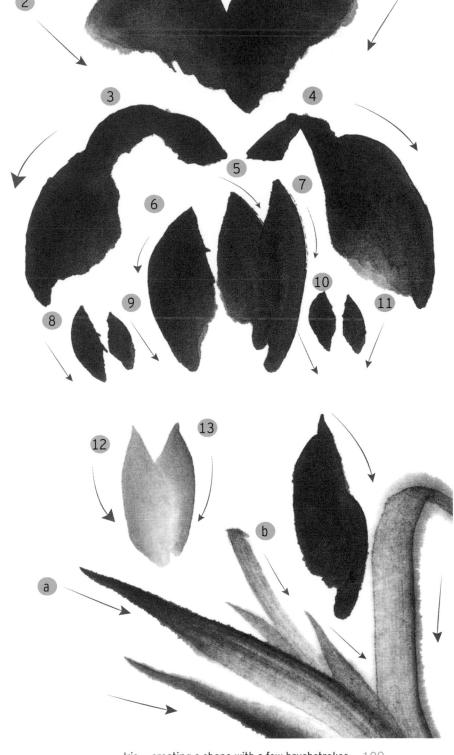

Butterfly – brush control to make a triangle

This exercise adds something strange to a natural movement. Imagine you were learning to tap dance. At first you would have to think about every step, but after a while you will be able to dance freely, even to unfamiliar music.

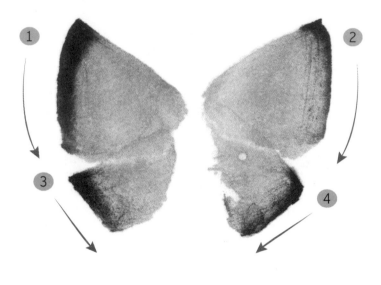

Blunt wing sections.
The brush is filled in two stages with blue and black ink. Start with the large wing section at the top left. Hold the brush flat, and put it on the paper with the tip facing outwards to the left. Now pull it downwards at a slight angle, swiftly and without stopping, to the bottom edge of the wing. You have made a kind of triangle (1) . The opposite wing is painted in the same way with the tip of the brush in the other direction (2). The two small wing parts at the bottom are painted in the same way, but with the tip a little shorter (3 and 4).

Wing, sharp and rounded.
Here, too, the brush is placed flat for the large wing but with the tip facing upwards. Focus on the tip of the brush as you move the brush from the top left to the bottom right, gradually lifting the body of the brush from the paper (1). Paint the opposite side (2). For the bottom wing pair (3 and 4), move the brush at an angle with the tip facing up. Place the brush so that it slightly overlaps the top wings. Then, under increasing pressure, draw the brush to the outside at an angle.

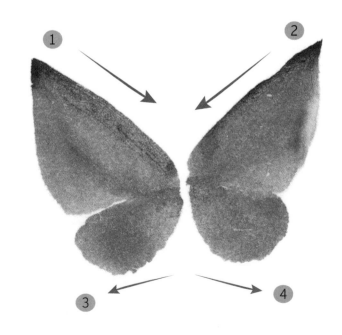

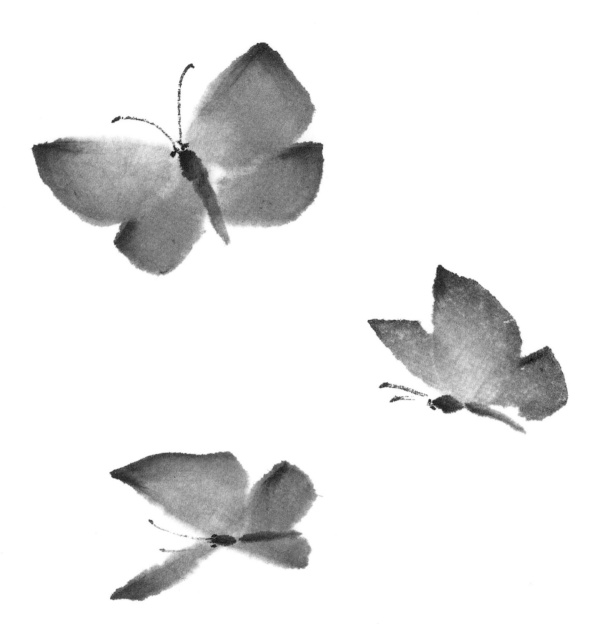

Butterfly in my hand – as if it were a
spirit, unearthly, unsubstantial!

(Yosa Buson, 1716-1784)

Hydrangea – brush control to make a square

July is the rainy season in Japan, and hydrangeas blossom all over the country. As they love the shade, they are regarded as the symbol of a 'shadowy existence'. Not only are they found in atmospheric paintings, there are also constant references to them in literature and song texts.

Creation of the picture.

In most pictures of flowers, as in this one here, the brightly coloured flower is the main issue. For that reason, it is painted first, followed by the leaves and twigs that are painted here in black ink. Gasen-shi paper is used here to create an overlapping effect. The paints are Chinese watercolours in red and dark blue, and gouache in cadmium red with a little black ink. It is easier to see the shape and brush traces if you use gouache instead of watercolour paint – as you can see in the detail pictures. To achieve an impression of space, start with the large dark leaf in the foreground. This will move the smaller, lighter leaves to the back. Only then should you paint the stems.

A little reminder

Let me remind you again of the unpainted area in the layout. That is the cosmic space! In the picture of the hydrangea, consider it the 'sky'. It must contain depth, light and air. What you have painted needs to be able to breathe through the white space. If you try to become one with the painting, you will definitely not overload the picture. You simply must have the free space!

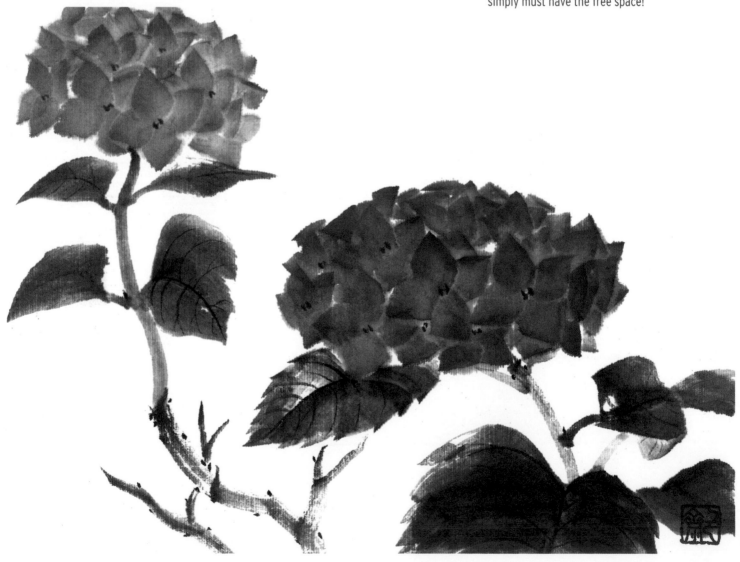

The flower head.

The flower head of a hydrangea is made up of lots of individual little flowers. Your task is to create a unit that consists of individual, almost square flowers. For the single petal, the brush is drawn from the inside to the inside. For the large flower head on the right, start with the three dominating flowers that hardly overlap. Then paint the bottom row, then those at the side, and finally finish at the top, three dimensionally and in a hemisphere. Paint the smaller flower heads in lighter shades. Top up your brush occasionally with more intensive paint to make the results more dynamic. Add dots in dark colour to some of the flowers as the stamens.

The stems.

If your brush still contains residual moistness from painting the leaves and veins, this is perfect for painting the thicker, woody stems at the bottom. Add dark ink from the plate to the tip of your brush. Always paint the stems from top to bottom. To make the newer parts look lighter and more moist, briefly dip the tip of your brush in the water, then draw your brush over the plate under light pressure and reshape the tip. For the leaf stems, paint towards the leaf and fill the tip of your brush with a little more ink from the plate.

Painting the individual flowers.

For the almost square single flower, the brush is drawn from the outside to the inside. Work in the sequence of the numbers. The outer edges of the individual petals are always darker than the inside of the flower.

Leaves and leaf veins.

To make the leaf edge smooth at the base, draw the brush from (what will later be) the base of the stem to the outside. However, it is better to draw the brush from the outside to the inside to create the sharp serrated edges of the leaf edge. Paint the veins as dark lines when the paint for the leaf is almost completely dry. They combine the two separate parts of the leaf with each other. If the brush is too damp, the ink is too light, or you exert too much pressure, the veins will run. By the same token, it is difficult to draw thin lines if the leaf is already completely dry, and the surface no longer smooth. Some people think these veins are superfluous, but without them the leaf will not look so dynamic.

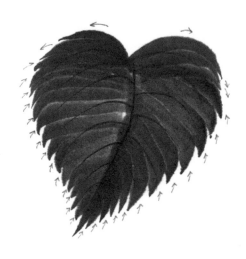

Grape – three-dimensional sphere with light effect

The impression of a three-dimensional sphere is achieved both by increasing the pressure on the tip of the brush and by adding light effects. The areas that reflect the light on the individual shapes are not painted.

Pictures with hanging or lying grapes look particularly lovely in black ink. In fact, they look so plump and juicy that you immediately think of blue grapes. And yet the coloured version, like this one here, also has its own charm. Whatever you do, do not fill the white space with tendrils. I remember well that I used to love drawing these lines and found it difficult to stop. Yet I knew well that the tendrils of a grape vine were never that long. Perhaps the hand just likes drawing spirals. I particularly liked the end of the tendril spiral. I felt as if I were high above the clouds, completely surrounded by endless space.

Before you start painting, mentally divide the space into areas for grapes and tendrils. Decide the direction of the main motif. Remember, do not forget the white space!

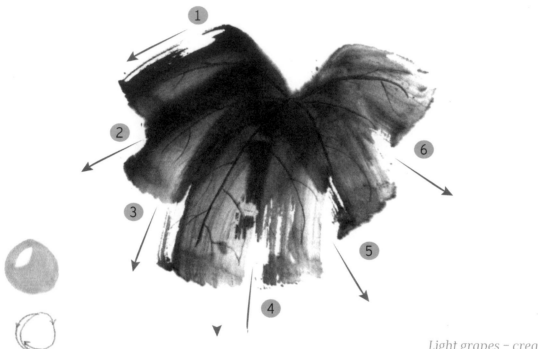

Painting method for leaf and grape.
To paint the leaf, move the brush from the inside to the outside. Start at the top left and continue in the sequence of the numbers. If you want the leaf to look luscious, add a little more dark ink to the brush and move it slowly. Move the brush more quickly to obtain light effects – reflections – on the leaf. Paint a fruit with a single movement of the brush. Hold the brush upright and move it as shown in the sketch. If the light falls from the left, start at the top left. Draw a semicircle, anticlockwise, to the bottom, and then reverse the direction to make a full circle. When the tip of the brush is at the top curve, increase the pressure to make the line wider so the sphere looks three-dimensional. If you continue to the bottom without pressure, you will have a circle rather than a sphere.

Light grapes – creating the picture.
Start with the large leaf. For the small leaf, paint the dark areas first and then the left side. Then it is time for the bunch. To create the spatial effect, the individual fruits should overlap. Make sure the brush is not too wet for the stalks and tendrils. Solid lines require very little moisture. It is also easy to create slight textures within the stroke if your brush is dry. Now paint the stalk and draw the leaf veins in black ink. At the end, let your hand move freely as you complete the picture with one or two fine tendrils.

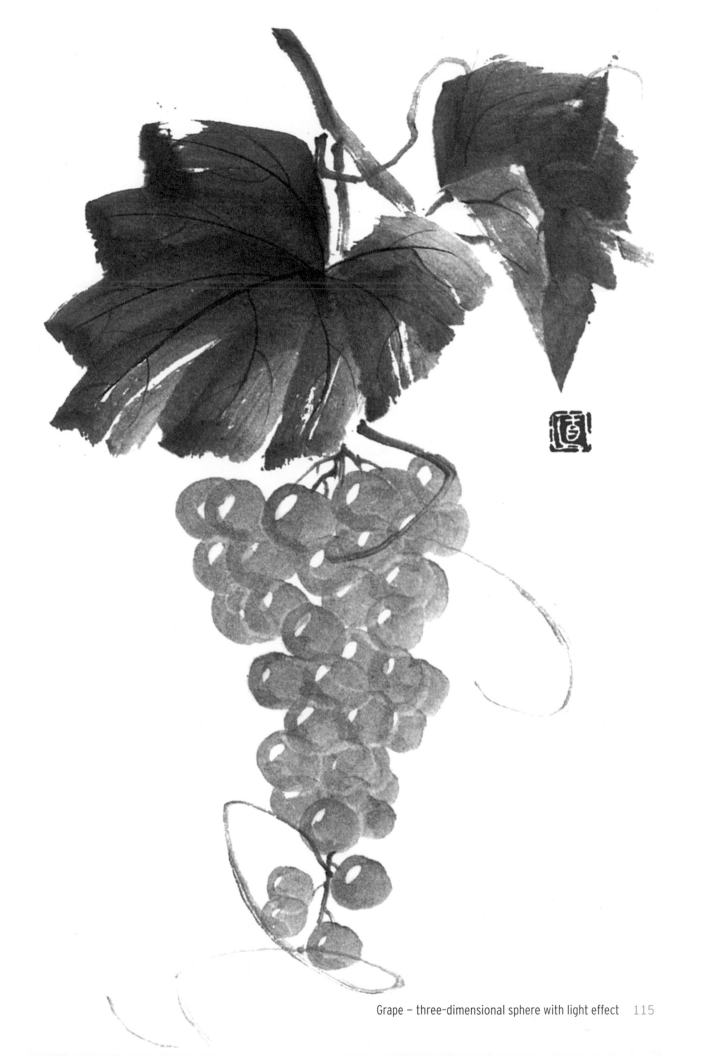

Wheat ear and cat – painting with a spread brush tip

Painting with a spread brush tip is a good way to
create very fine lines; for instance, to reproduce
grasses and wheat ears – and even water. This
technique is also used for painting furry animals
such as cats.

The wheat ear.

*Adjust your brush (filled with clear
water) on a rag to suit the lines you
want to paint. Fill the brush with
colour and rotate it on the plate
under pressure until the bristles
spread. Then squeeze the hairs
together again slightly on two sides.
The drier the brush is, the finer your
lines will be – ready to paint objects
such as hair or grasses or, as here,
the parts of the wheat ear. This
example is good for practising.*

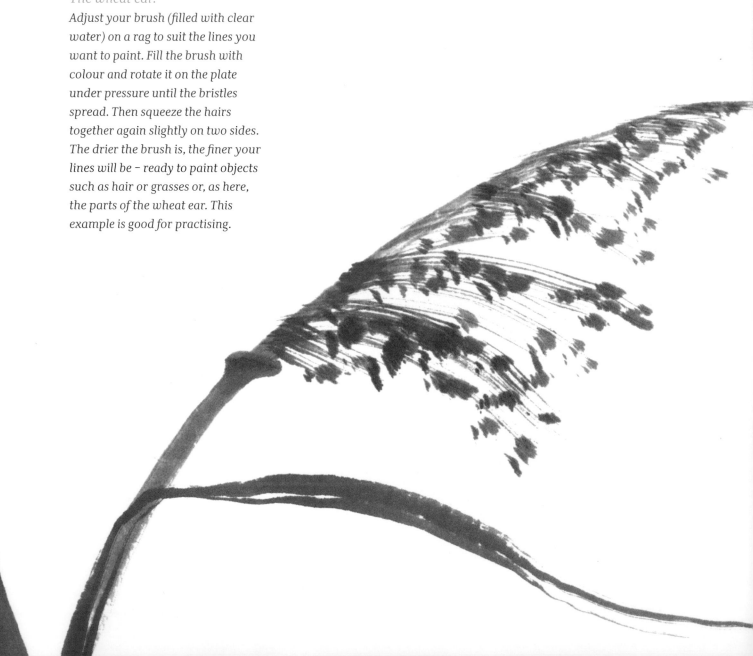

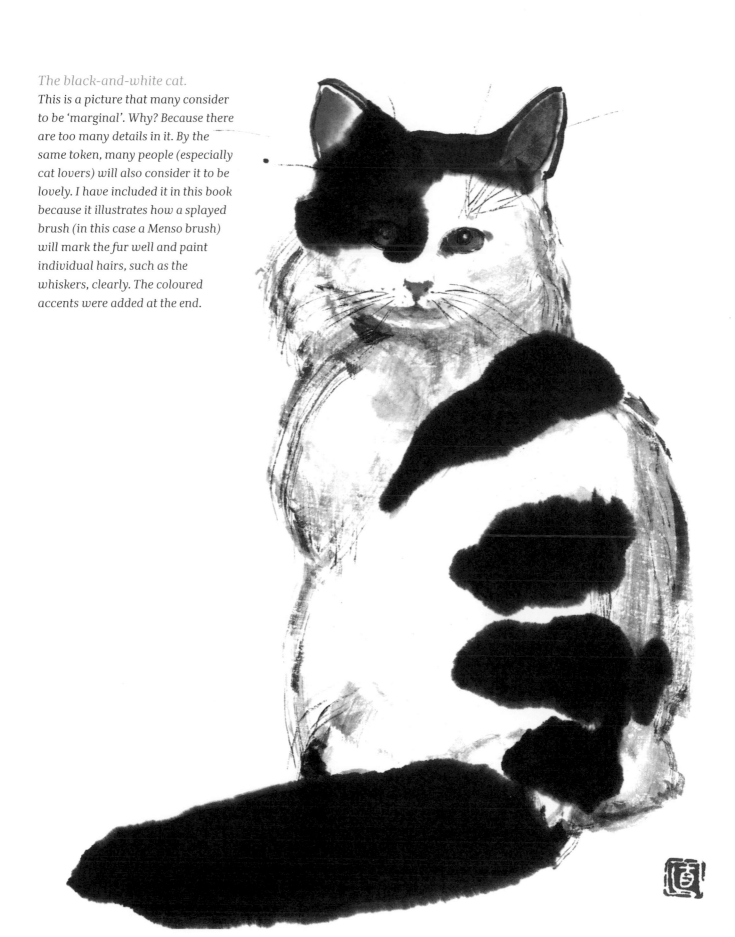

The black-and-white cat.
This is a picture that many consider to be 'marginal'. Why? Because there are too many details in it. By the same token, many people (especially cat lovers) will also consider it to be lovely. I have included it in this book because it illustrates how a splayed brush (in this case a Menso brush) will mark the fur well and paint individual hairs, such as the whiskers, clearly. The coloured accents were added at the end.

Coloured landscape painting

There is a long tradition of depicting landscapes in ink painting (see also page 66), and the original intent was to honour nature. Nowadays, landscape painting has many faces. In China, the birthplace of ink painting, we are more likely to encounter a spectacular or playful depiction of a landscape, or one that is influenced by European realism, than the traditional, stylised method that encourages reverent contemplation. As far as the use of colour is concerned, this painting is not bound to the often rigid rules and regulations that used to apply.

In contrast to China, Japan's tradition of ink painting was interrupted when the country opened up to the West in the 19th century. Sadly, since then, ink painting has been strongly influenced by Western naturalism, with the result that the white space is no longer seen nor felt. The only exceptions are the ink drawings and illustrations that accompany haikus.

I am constantly fascinated by the trees, especially if they stand in a line on or beside a mountain ridge. In the foreground, the single line represents a rambler. When his eyes perceive the mountain in the distance, time and space stands still for him. Thus, the eye of the observer is guided from the front to the back.

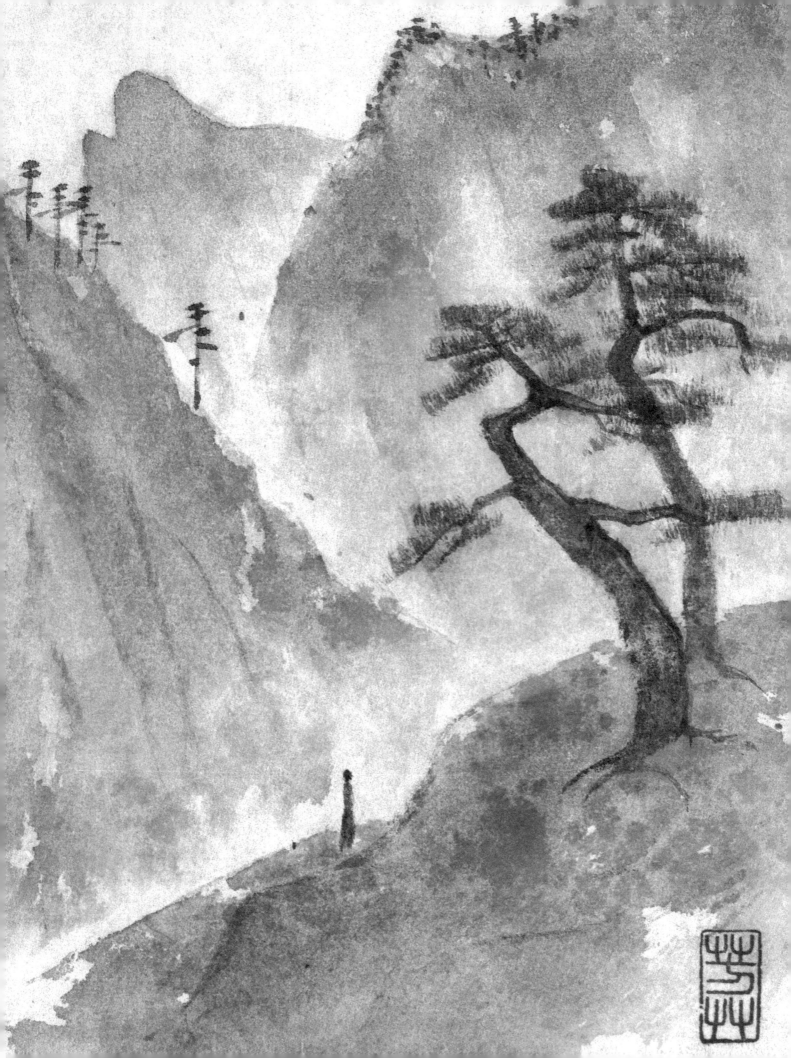

Thoughts on landscape painting

• The painter can express his (or her) feelings, soul and spiritual world in a landscape. The pictures are influenced by the association and communication of the soul with nature.

• The objective appearance of nature and the natural form are the foundation and means for depicting landscapes. The aim is the expression of the soul (spirit). The ideal cannot be expressed without subjectivity, nor can the truth be achieved without objectivity.

• In ink painting, the landscape is represented beyond reality with no restrictions imposed by time, space or the central perspective. It is often painted from a bird's-eye perspective, also with unrealistic distances, proportions and phenomena. What nature teaches us flows into the painting.

Olive tree.

I cannot remember whether I have ever seen an olive tree in ink painting. The fascinating form of the old trunks and branches that can often resemble the human form made me want to capture them with my brush. The old trunks and twisted branches that look as if they were dancing are typical, as are the delicate twigs and somewhat offset leaves.

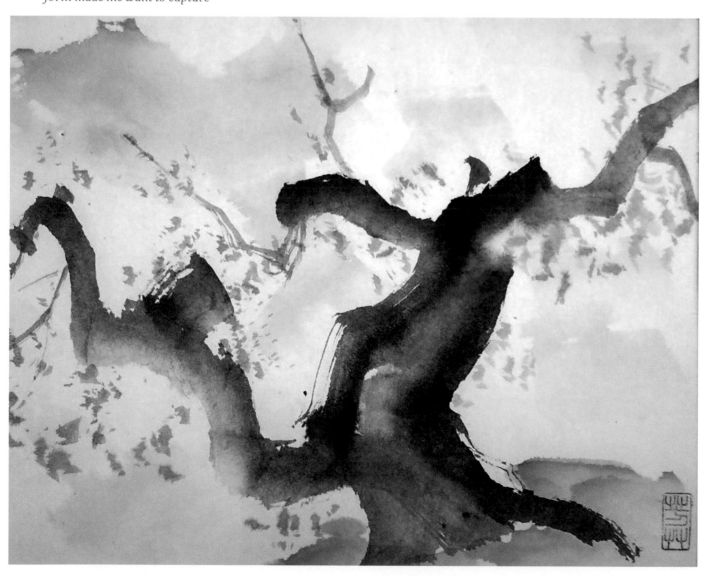

With few colours – stylised or classic landscape painting

The history of stylised landscape painting using just a few colours dates back to the Chinese Tang dynasty, around the 8th century.

In this style, the landscape is painted first using black ink and clear outlines. This is followed by dark planned areas in lighter ink to create space and add accents. The structure is similar to that of the rock studies (see page 72).

Once the ink is completely dry, the transparent colours – brown (perhaps burnt sienna), dark blue (such as Prussian blue), yellow (possibly permanent yellow) and red (for instance, carmine) – can be blended with a little black ink and applied in several very thin layers.

It is different in Impressionism, where very finely shaded colours are used to reproduce a motif at a very specific moment in time and under exceptional light and shadow conditions.

By contrast, in classic landscape painting, the motif is an extensive one, above all to emphasise seasonal moods. Colours are used with restraint in order to achieve the necessary objectivity. The result should not be photorealistic, nor should it be expressionistic.

Often, a particular colour will represent a specific object. The shadow is painted rather than it being the result of a specific light source. This is to create spatiality as a tool in capturing the overall picture.

In the following, a complex picture is painted – from the ink drawing – in the classic style. The same motif is transformed to reflect the four seasons. You will see just what effects can be achieved with only a few colours. The painting is created on Chinese or Japanese Gasen-shi paper.

The original.
First, the landscape is painted using black ink and clear outlines. Then, certain parts of it are modelled using very thinly diluted ink. Very thin blue is applied to a large area of the picture, which will be dark in the end result; and very thinly diluted brown is applied to areas that will be light. This base is then covered with layers of paint in the colours of the particular season.

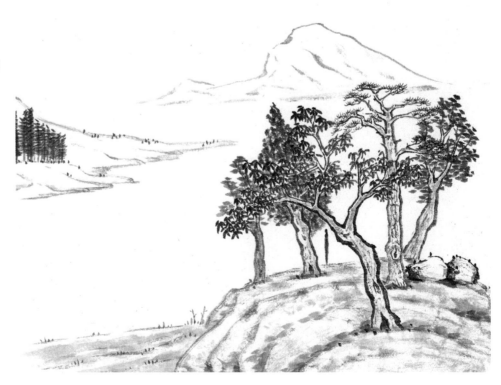

Spring.

Spring represents the beginning of the four seasons.

Step 1

The outline of the foreground is drawn in black ink. Start with the trees at the front and work from front to back (use the classic tree studies on page 65 for guidance). Then follow with the stones and rocks, hills and the valley bottom, and finally the trees on the promontory. The leaves are painted first and then the trunks. Take care not to make the trees too alike. Next, start on the overall shape of the promontory and then finish with the mountains in the background.

Step 2

In order to create space, apply diluted black ink as moss in a few eye-catching areas (such as the stones and at the foot of the trees).

Step 3

Paint any areas that are to remain in thinly diluted brown. These are the sea and the sky in this picture. Once the first layer of paint is dry, paint over the darker areas, such as the hill in the foreground, in a mixture of brown and thinly diluted black ink; paint really dark areas and the leaves in thinly diluted blue.

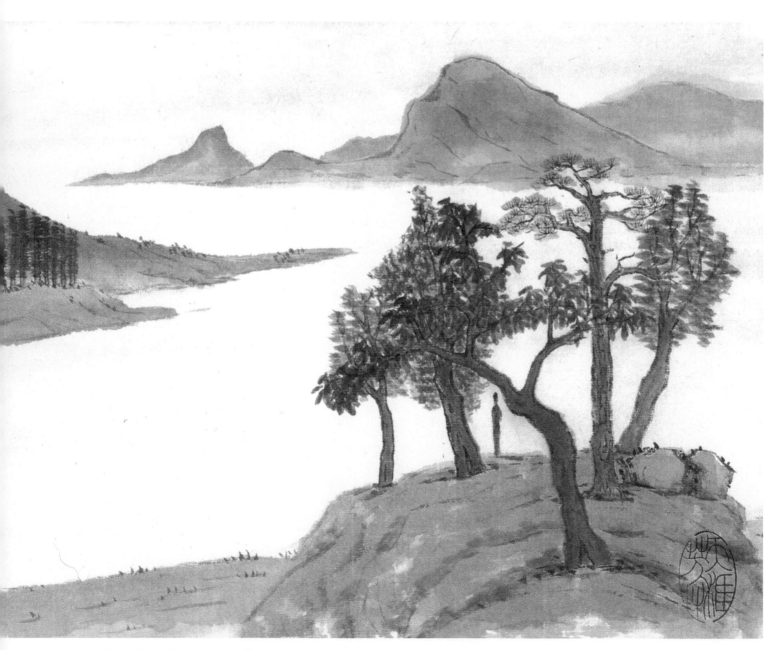

Step 4

Combine blue and yellow to make green, and paint over the leaves on the trees, the hill and valley bottom at the front, the promontory and the foot of the mountains over the lake, then the sky and the sea in even more thinly diluted yellow-green. Paint can be reapplied to areas that are already dry to highlight certain sections and to increase the depth and achieve an overall balance in the picture. The two-dimensional mountain range in the background is covered in a blue-purple without outlines.

Step 5

Finally, paint the areas that are to be further highlighted in more intense shades. If necessary, paint over any of the original ink lines that might have faded in order to darken them.

Summer.

In contrast to the spring picture, a lot of blue and only a little yellow (which could be omitted altogether) were used in this painting. Apart from the black ink, many pictures painted in the classic method are painted only in blue with a green cast, and brown with a yellow cast. Layering these two colours results in the dark blue-green of the foliage. The coolness of the sea is emphasised in blue.

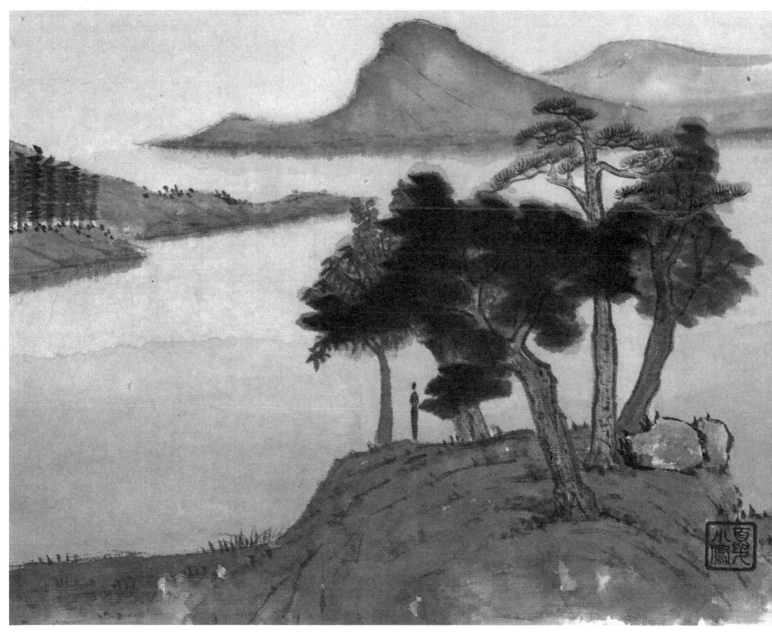

With few colours – stylised or classic landscape painting 123

Autumn.
A large proportion of brown
expresses the autumn mood. The
rather warm brown that is
appropriate to the season is made a
little cooler by the blue and the black
ink. The slightly orange foliage – the
result of yellow and brown or yellow
and red – creates an autumnal
mood. For the evening mood,
I applied brown and a little yellow
all over the picture. I then applied a
very thinly diluted blue to parts of
the sky and sea.

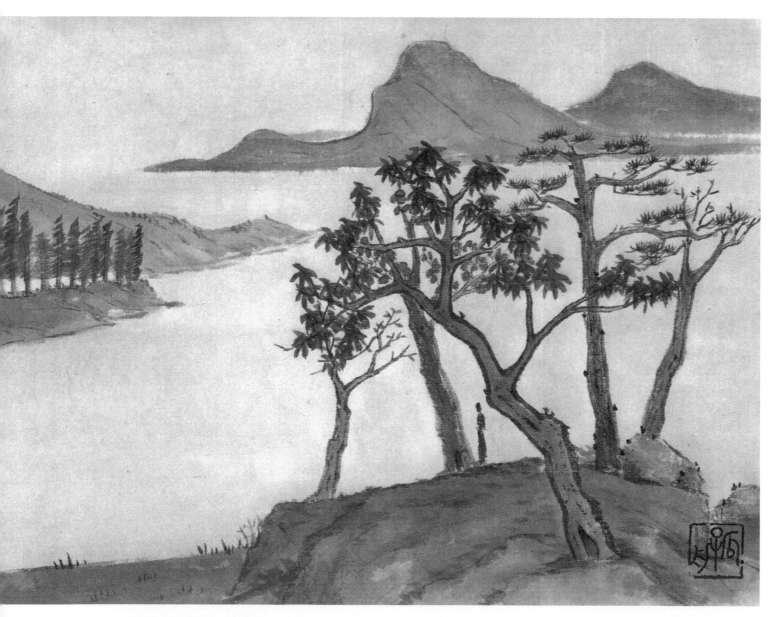

Winter.

The snow-covered surfaces are left unpainted at first. For the areas without snow, use thinly diluted black ink mixed with ochre (brown and yellow with a hint of blue). A few brushstrokes leave their traces on Gasen-shi paper. If they are irritating, moisten the area and then smudge them with a different brush filled with clear water. The brushstrokes will then not be quite so evident. However, in this picture, the strokes created by a flat brush make the overall effect more dynamic. The tree trunks are painted over in a combination of brown and thinly diluted black ink. This colour mixture is diluted even further and applied to a few areas of the snowy area, where the shadows are emphasised with a little blue and brown.

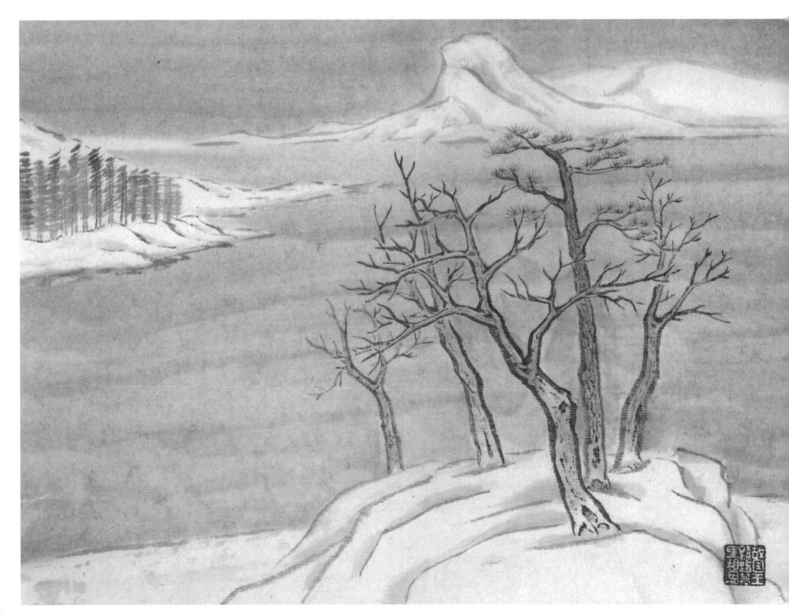

Painting without contours – filling areas without outlines

This method could also be called 'the shading method', which is also used in watercolour and silk painting. Any areas of the paper that are to have a smooth transition without contours are usually moistened in advance. This is best done with the Kumadori brush, the special shading brush (see page 18), which has a particularly firm tip. Pictures created using this method can be built up from the bottom upwards or, in other words, from the foreground to the background. This is due to the fact that the black ink is waterproof and the special texture of the paper surface to which the paint adheres well.

Papers with higher glue content are ideal for painting without contours. I recommend smooth Torinoko-shi, glued Dosabiki-Ma-shi or glued Gasen-shi. If it is moistened in advance, Kozo-shi paper is also good for shading.

Watercolour paints, gouache and ink sticks from China or Japan are used for painting.

The perfect equipment will be a brush for the paint, a shading brush and a water brush with soft sheep or goat bristles.

In the Bernese Oberland.

According to the old Chinese masters, if you want to paint the mountains, you have to go to them. And so I did. Despite my fear, the pine trees growing out of the mist encouraged me to keep climbing higher and higher until this was my view. I thought about what the trees really are, as they stand on a mountain like people. Then I started to paint like you normally start to paint in ink painting, namely at the point that is of the greatest interest to the painter. To me it was the trees in the foreground.

Step 1

Moisten a broad strip along the bottom edge of the picture with the water brush. Start by painting the tree trunks, and immediately smudge the lower part with the wet shading brush. Then, holding the brush horizontally, paint the pine shape starting at the tip and working down to the bottom. Then shade around the bottom of the trunk and further down.

Step 2

When the pines are quite dry, moisten the left side of the picture above them. Holding the tip of the brush flat, draw along the contour of the steep mountain slope. Smudge the lower part of the mountain area. Paint the mountain on the right side of the painting in the same way, but add more blue.

Step 3

Paint the mountain in the middle ground of the painting in thinly diluted paint, and shade it down to the bottom. Emphasise the higher parts of the mountain a little more in order to reinforce the expanse of sky.

Step 4

Finally, add a few pine trees in the form of tiny dots to the left flank of the mountain.

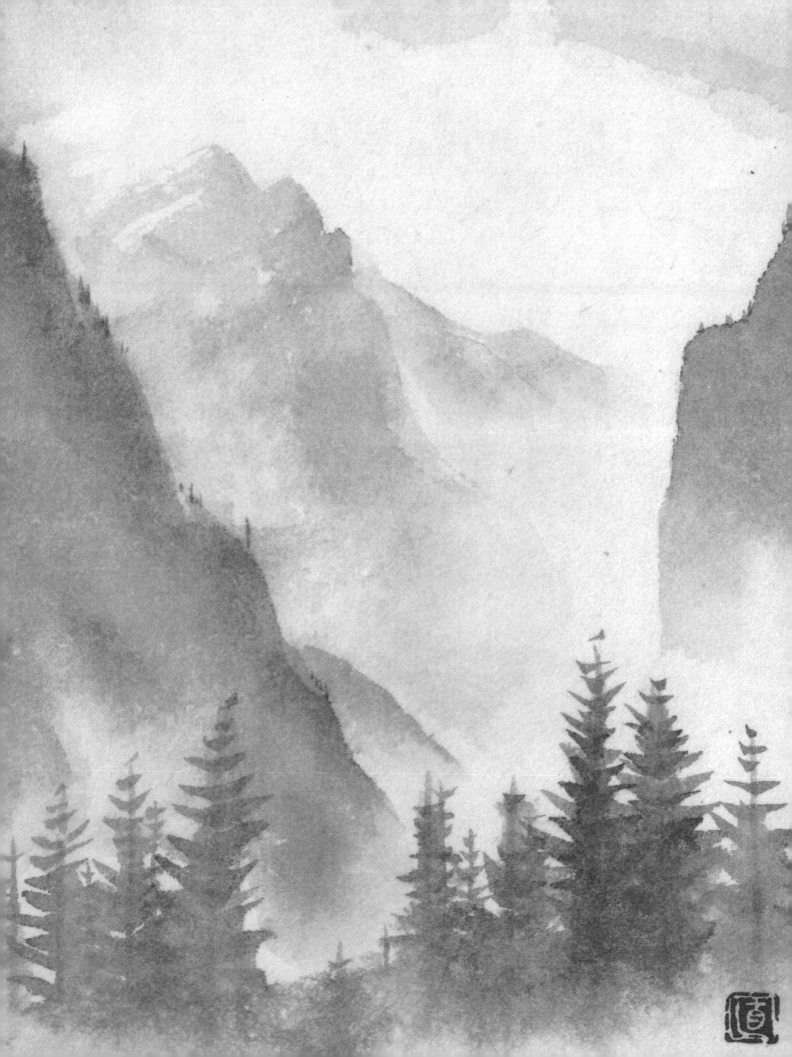

The coloured landscape sketch – a precious tool in developing a picture

The transition from sketch to picture has already been discussed as a practical tool for painting figures in black ink (see page 82).

A sketch can be even more useful in landscape painting because landscapes can be extremely varied. The division of the picture, direction of movement, the role of the paint etc. – all of these can easily be planned in advance using a sketch.

In fact, it is often better to start with a draft of your painting. Remember what it was that made you want to paint this motif (you might find your sketch actually tells you this). Leave everything unimportant out of the draft, and emphasise the essentials of your project. If you move your brush conscientiously and confidently, you may find that depth, the subconscious and the invisible that we attempt to express in our painting method, through the preparatory form of the sketch and design, will come. You will then paint easily and from the heart.

My painting of Tuscany

Somebody once told me that Tuscan soil has a dynamic strength. I did not really know what they meant until I went there myself.

The earth forms undulations that move within themselves, which have a certain rhythm and are in harmony with each other. It is fascinating to see so many things in nature that have a relationship with other things. These wave movements immediately reminded me of similar brushstrokes. I was fascinated by the cypress trees in the landscape. As I sketched them, I found myself wholly captivated by the atmosphere.

Close by were two cypress trees that stood together like people. There were so many of them lined up on the hills, it was as if they were guarding the old castle – the past. The cypresses on the mountain slope looked as if they were going there. The sky beyond the hills was as free and open as the sea. It is where transience passes into eternity.

Here are various sketches for the painting of the cypress landscape.

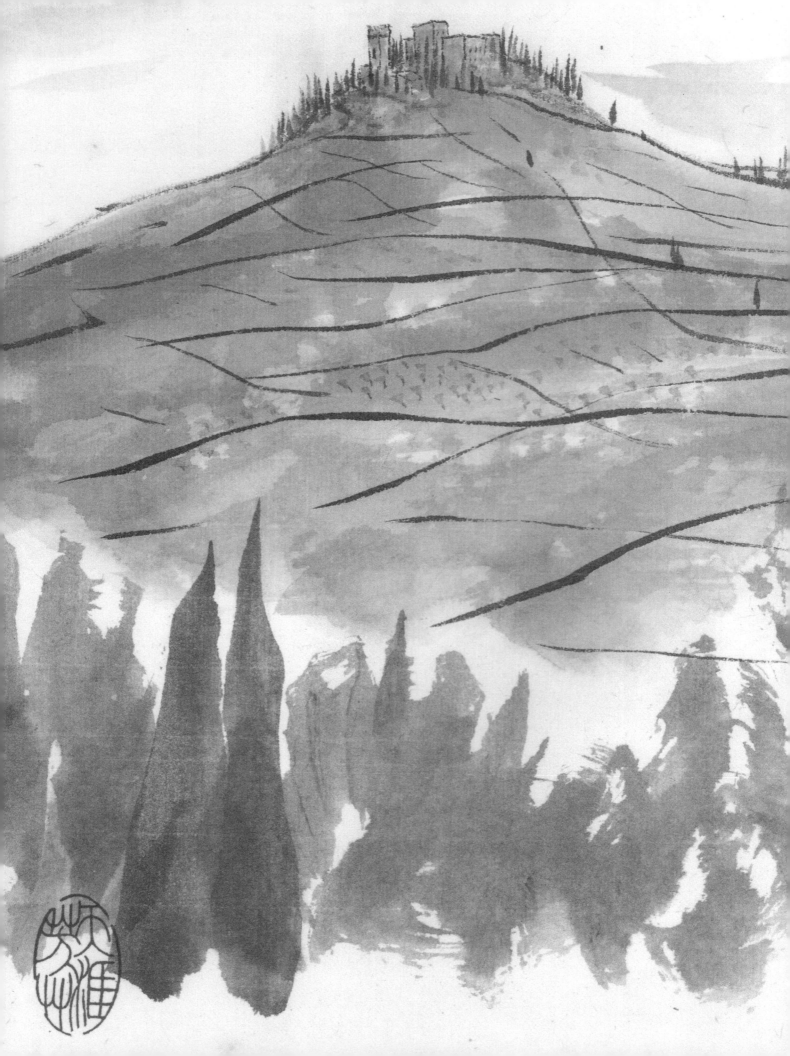

The white space in painting

The white space (see page 10) is often seen as merely unpainted or blank space, which is why paintings with intentionally blank spaces can often be identified as Japanese ink paintings.

Once, when I was talking with an acquaintance about the "fear of the void", I was suddenly reminded of the white space in visual art. Many people feel the need to fill the empty space. However, I often feel that, if a deliberate effort has been made to fill in a background, this can detract from the importance of the subject.

A comparison can be drawn between white space and the the impression of silence, or stillness. It seems to me that, among many cultures, falling silent is something unbearable.

In Japan, we can understand this sentiment conceptually, but cannot completely empathise with it, because in our culture it is precisely in the "formless form", in the "voiceless voice", that truth can be found. In Japan, we are accustomed to these invisibile, speechless forms. I think that we understand this emptiness in the same way as we understand white space and the Japanese idea of nature and the cosmos. When this natural emptiness is filled with artifice, we feel oppressed and uncomfortable.

If this stillness is suddenly broken, we feel troubled, because we feel that we can connect with nature through stillness.

Finally, white space is not something that can be understood merely as a visual construct, but rather also as a powerful, intuitive aesthetic. This is something which may not be entirely easy to comprehend. Ultimately, white space is something that is difficult to explain in words.

The white space on Sunago paper

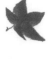

Autumn

The leaves are falling, falling as if from far up,
as if orchards were dying high in space;
each leaf falls as if it were motioning 'no'.

And tonight the heavy earth is falling
away from all other stars in the loneliness.

We are all falling. This hand here is falling.
And look at others: it's in them all.

And yet there is Someone, whose hands
Are infinitely calm, holding up all this falling.

(*Rainer Maria Rilke, 1875–1926*)

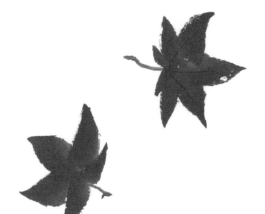

Autumn (about Rilke's poem).

This poem will tell you how I feel about the white space. The last sentence tells us that God is the One who catches everything in his hands. I also see this omnipotence in the white space. Its size makes it particularly striking in this painting on Sunago paper. Sunago is not only the name of the paper, but also the name of the associated traditional decorative technique that is used all over the world. Sunago paper is sprinkled with gold and silver; it is available in stores in many different colours. For this autumn picture, I painted two maple leaves in the large area. To me, the gold leaves were like stars in the sky, and I saw a shooting star (see page 149 on painting leaves).

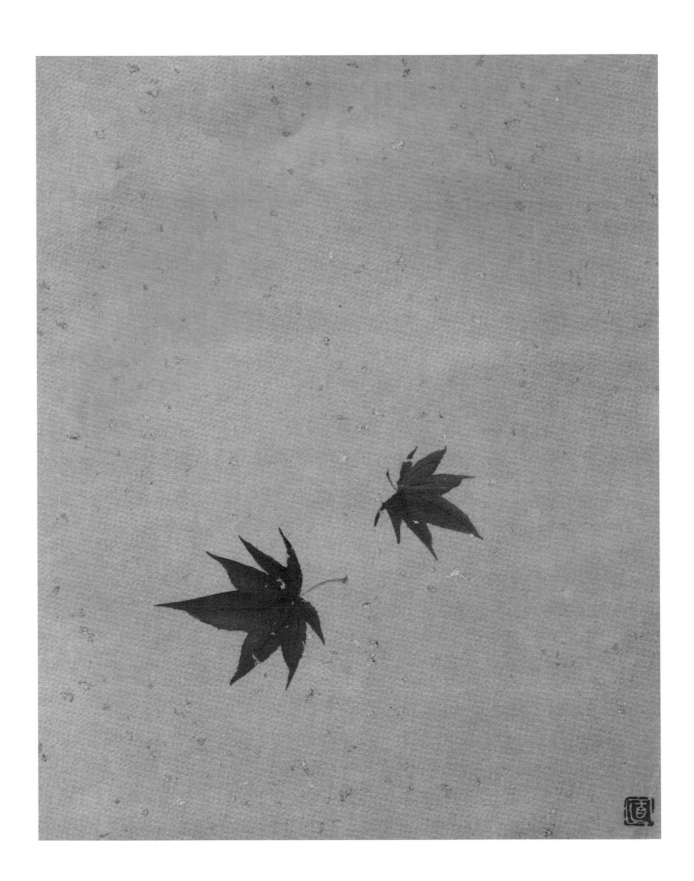

The white space on fibre paper

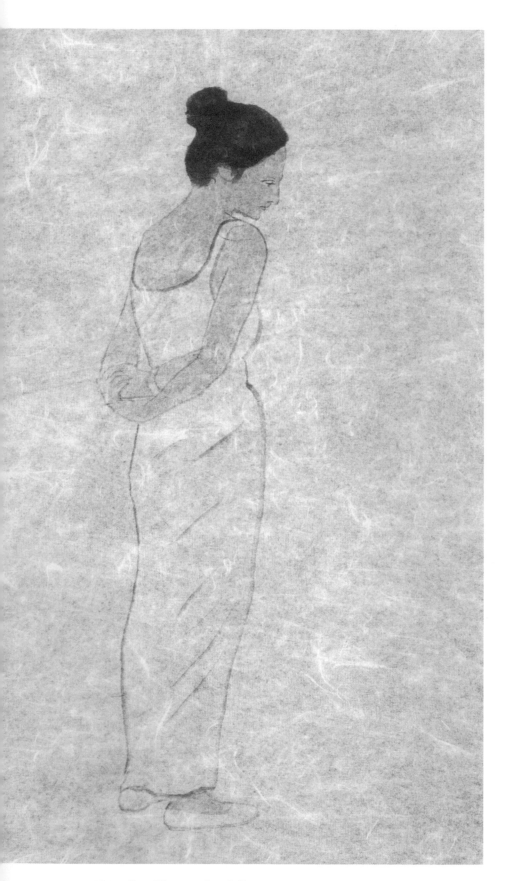

Picture of a woman with folded arms.

If the painting in the picture is seen as 'fullness' and the unpainted area as 'emptiness', it does not mean it really is empty, but that it is filled with soul and feeling. This figure is painted without a shadow. Although there is no background, there are three dimensions to the figure. This is due to the texture of the Japanese fibre paper. I glued brown paper to the back of it. This further enhanced the texture of the fibres. The surrounding lines are all in varying widths, which makes the painting more dynamic. The woman's face and body are painted in a single colour. This, and the reduction of lines, enabled me to highlight the woman's face to tremendous effect.

Creating white space by tinting the back of the paper – blocking out with alum

When it comes to representing rain, snow or moonlight, modern Chinese painting often uses alum (a crystallised salt) dissolved in water. Two completely different effects can be achieved to suit the particular purpose. These areas either create entirely diffused 'fringed' transitions, or they separate areas with particular clarity.

Fringes occur when the ink or paint comes into contact with any still-moist areas with alum; the ink or paint is unable to adhere to the area. Both painting materials are rejected, depending on the alum content. Sharp edges are created when areas that have been treated with a high percentage of alum are not painted until these areas are completely dry.

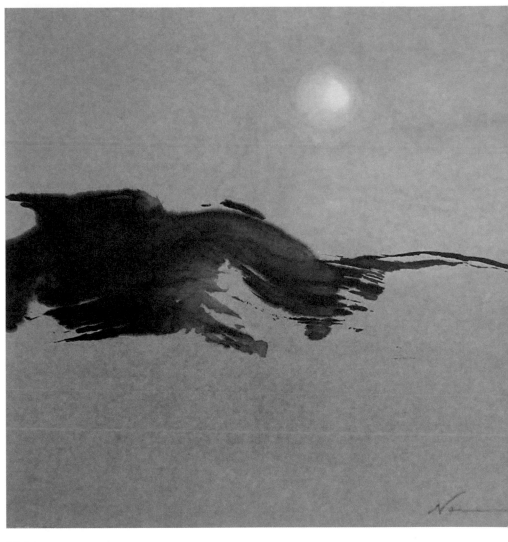

Night.

The coloured white space is not only an area that has been covered in colour. It also has depth and width. Here, it is under the moonlight, wrapped in the fragrance of the sea. In the stillness, all I perceived were the quiet waves and a gentle breeze. It was a deep, dynamic stillness. In this abstract representation, I coloured the back of the paper blue after applying alum in order to leave the area for the full moon unpainted. A painted background is often produced in this way to provide motifs with the dynamism of the brush control and black ink. However, this is only possible if the paper has not been treated.

The white space as an airbrush technique with a sieve

The white space is the same as the cosmos. It is full of the energy of life. The tiny and sprayed colour particles are part of this energy.

Does the scent of plum blossom float up to the moon and does it pay court to it?

(Yosa Buson, 1716–1784)

Plum tree branch in the moonlight.

This spraying technique requires a fine wire sieve and a firm shading brush. The paint distributed through the sieve looks like a coloured haze. Spray and draw black ink and paint on Gasen-shi paper. For the full moon, cut a nice round circle out of paper, ideally with a cutter. Place it on the picture where you want the moon to shine. To paint over the area, apply a tiny amount of diluted paint to the wire sieve, and move the shading brush over it so it sprays through the sieve like the finest mist. Make sure the brush is not too wet, though, or the paint will drip through the sieve. If you want the coloured area to be well spattered, fill more ink or paint and repeat the process. Clean the sieve when changing colours. The first spray application must be dry first so that the colours do not run. When you remove the paper disc, the moon will be bright white on the paper. Once the sprayed paint is dry – then, and only then – draw the branch in black ink, and paint the blossoms in white and the sepals and pollen in gold.

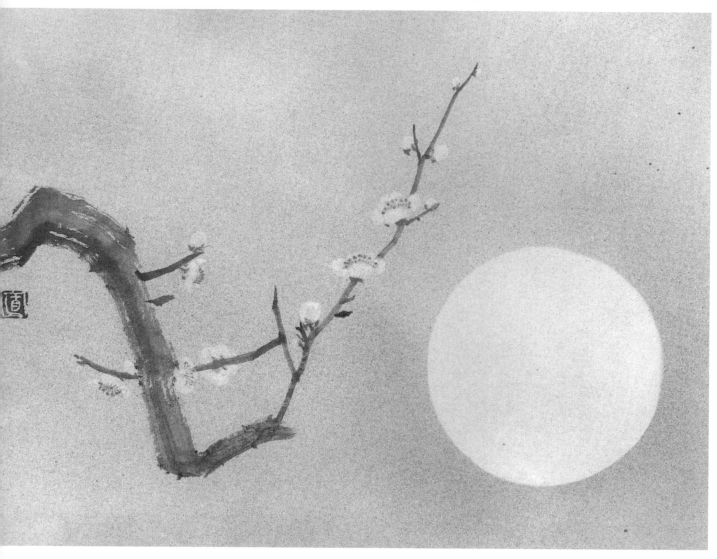

Gingko leaves.

In Japan, the colour of the gingko leaves is prettiest in autumn. When they fall, it looks as if they are rising up into the sky – just the same as when the cherry blossoms fall.

Watching makes us feel amused and relaxed. This picture was created using the same technique used for the plum tree branch (see page 50). The coloured white space is far more reduced here and sprayed a little unevenly. This creates a greater feeling of space. The leaves were painted in the second step of the process.

The white space on coloured recycled paper

It is well known that ink is absorbed by paper fibres, and remains there. This draws the painting into the space, and at the same time it creates space around the painting. The same applies to absorbent coloured recycled paper.

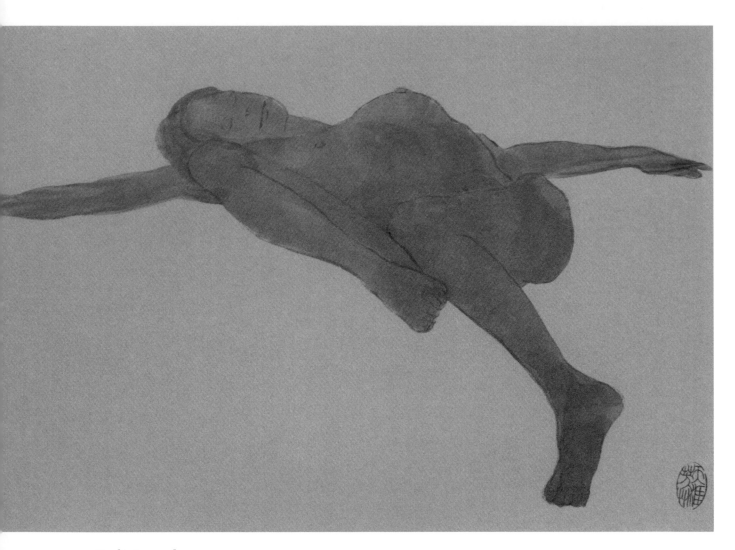

Reclining nude.

The outlines of the figure are drawn in a fine line of black ink using the Sakuyo brush. Using a wide brush and a mixture of black ink stick and liquid coloured paint, I then filled the areas between the ink lines carefully, as if feeling the body. The paper absorbed the ink, the figure was brought into the room – into a deep sleep and the world of dreams.

The white space as an airbrush technique by tapping on the handle of the brush

Unlike the spraying method using a sieve, with this method the motif is drawn first and then sprayed onto the area. This technique produces fewer but much coarser splashes of paint. They are not so evenly distributed because it is more difficult to control the application. However, this does make the picture much more dynamic.

Red flowers.

First, paint the long leaves in a single stroke and use a reduced shade of the black ink. For the abstract flowers, the dripping wet brush (filled with bright red paint) is moved swiftly over the paper. I had the impression that the red flowers in front of me were happy and dancing. Then came the spraying.

I flicked my fingers against the end of the brush handle. The very runny bright red paint sprayed out of the brush, scattering lots of red dots over the white space and making tiny flowers. This technique is often used in old ink paintings to represent snow using white paint or alum water.

Appendix

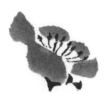

To finish, I would like to give you some ideas for using your paintings on cards and writing paper.

I will also include a few words about the nature and meaning of the seals, and what to do to your pictures to make sure they last a long time.

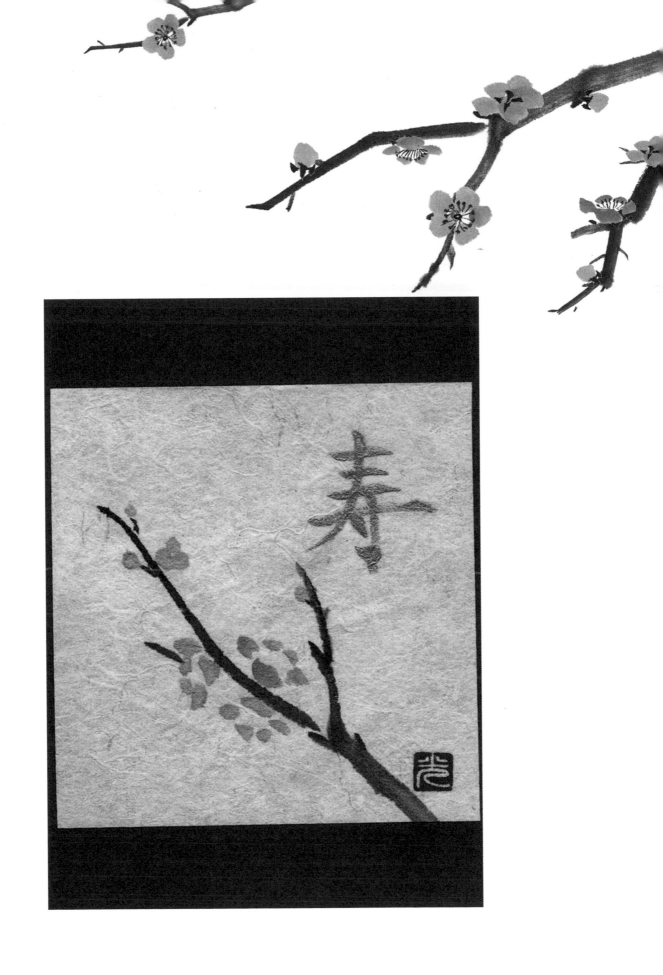

Collection of motifs for cards and stationery

The measurements provided here refer to my works, and they are not binding. They are just for guidance regarding sizes.

Ink paintings are usually attached to firm papers using double-sided adhesive tape.

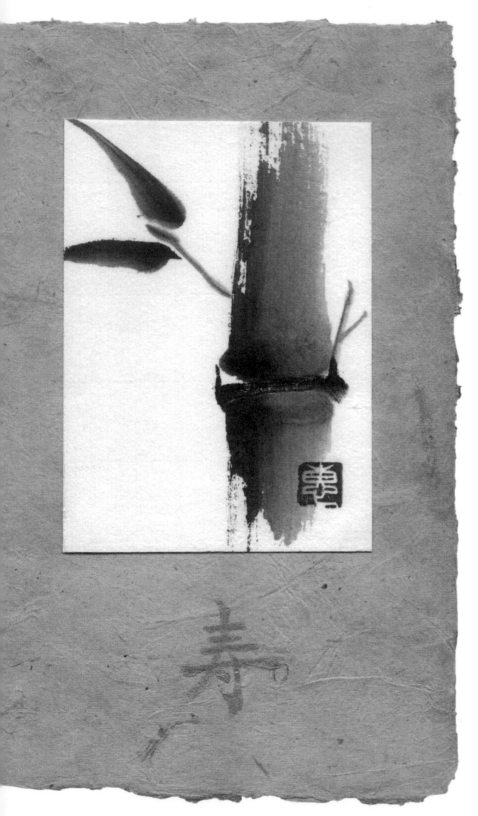

Bamboo motif on a congratulations card.
Bamboo is a symbol of strength in the Far East. Because of its appearance and characteristics – straight, but flexible – it is considered and appreciated as symbolic of how life should be lived. Its green leaves in winter also represent loyalty. Bamboo is also seen as a bringer of good fortune and is often used to welcome the New Year when, as on this card here, a symbol is sometimes added to it. The symbol used here has two meanings: 'long life' and 'good health'. In this instance, it is used more generally to convey 'congratulations' (please see page 47 for the instructions for bamboo).

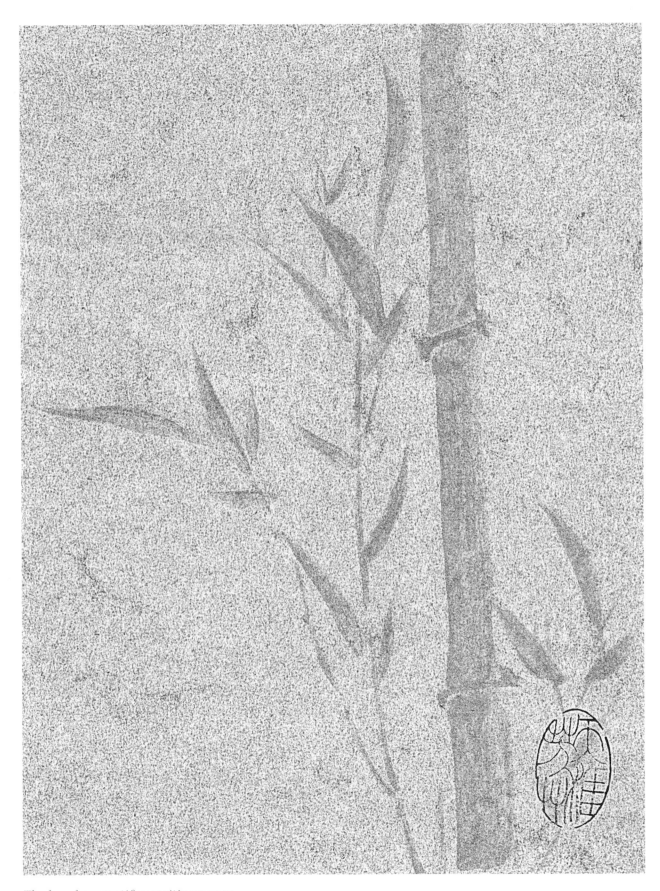

The bamboo motif as writing paper.
Here, the colour of the bamboo has been toned down,
and it is painted in watercolour paint. This allows the
writing on the elephant skin paper to remain
clearly legible.

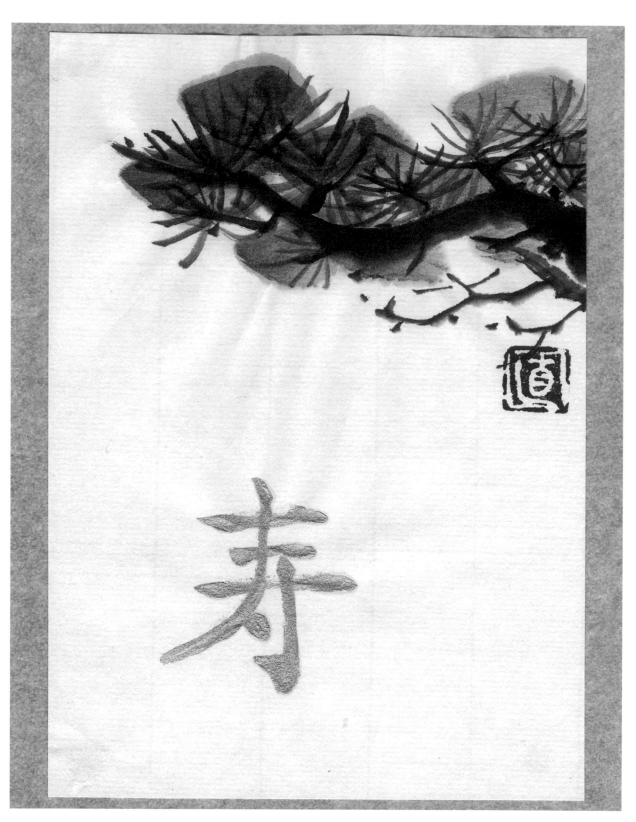

Pine branch and pine cone, winter motifs.

These motifs are a popular choice for New Year wishes. The symbol on this card is the same as the one on the bamboo card. The card with the pine cones is perfect for Christmas.

The materials used are thin Nepal paper 9cm × 11cm (3½in × 4in), glued onto coloured artist's paper 11.5cm × 17cm (4½in × 7in). I work with black ink, gouache in burnt sienna and yellow, as well as Chinese watercolour paint in indigo. When painting the pine cones, the brush is controlled as for the orchid stamens (see page 45).

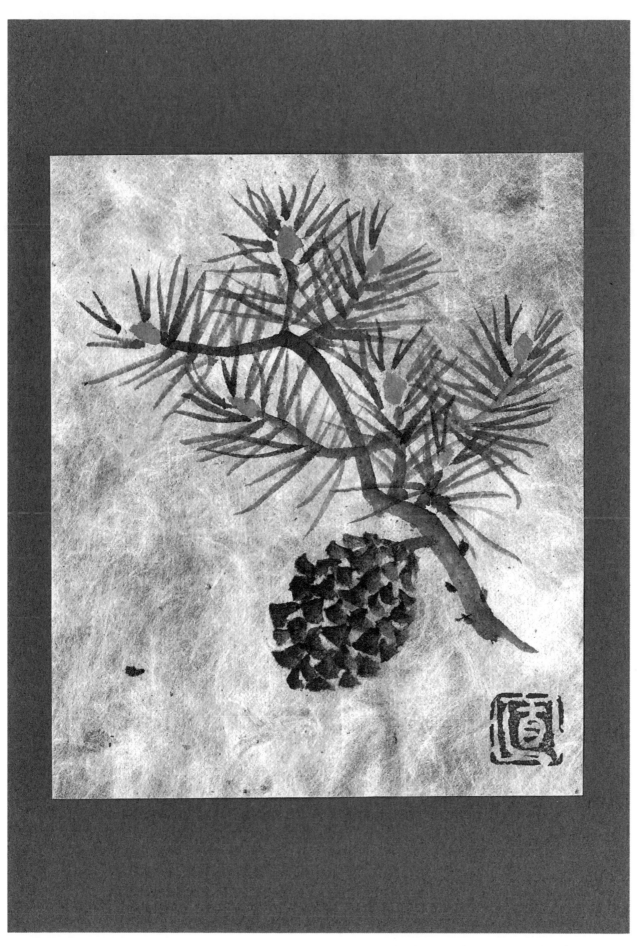

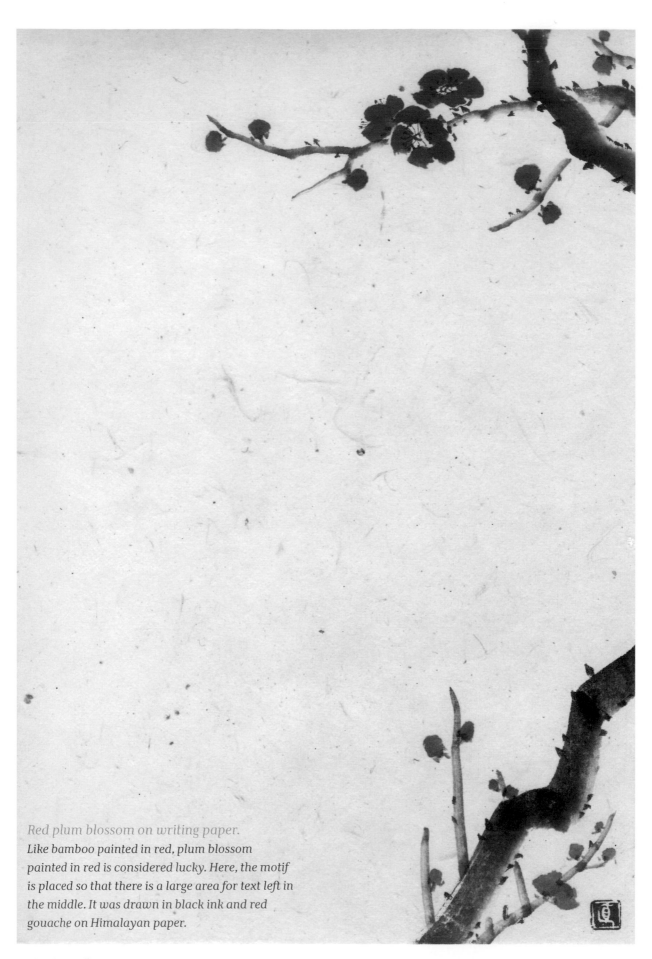

Red plum blossom on writing paper.
Like bamboo painted in red, plum blossom
painted in red is considered lucky. Here, the motif
is placed so that there is a large area for text left in
the middle. It was drawn in black ink and red
gouache on Himalayan paper.

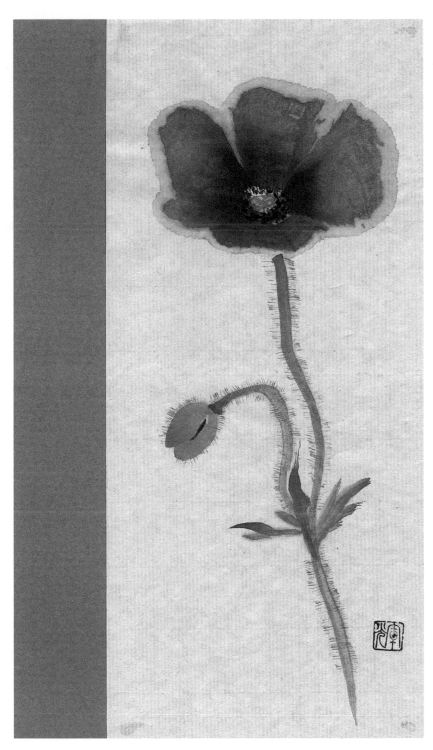

Red poppy.

Red poppies feature in many Japanese paintings created since the Middle Ages. In order to emphasise the flower, I have reduced everything else down to a minimum. The flower is drawn in the same way as the hibiscus (see page 104). Allowing the red paint to run created a delicate ring of colour, like an aura. This is painted with black ink and gouache in vermilion, yellow and indigo on Gasen-shi paper measuring 9cm × 21cm (3½in × 8in), glued onto coloured artist's paper measuring 11.8cm × 21cm (4½in × 8in).

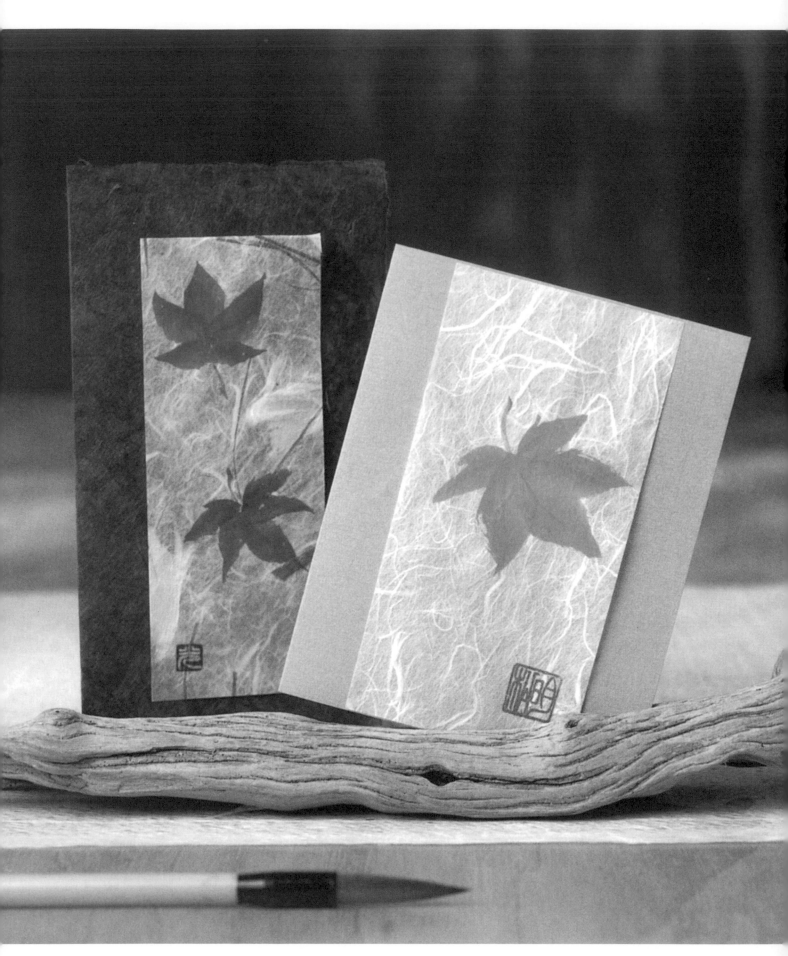

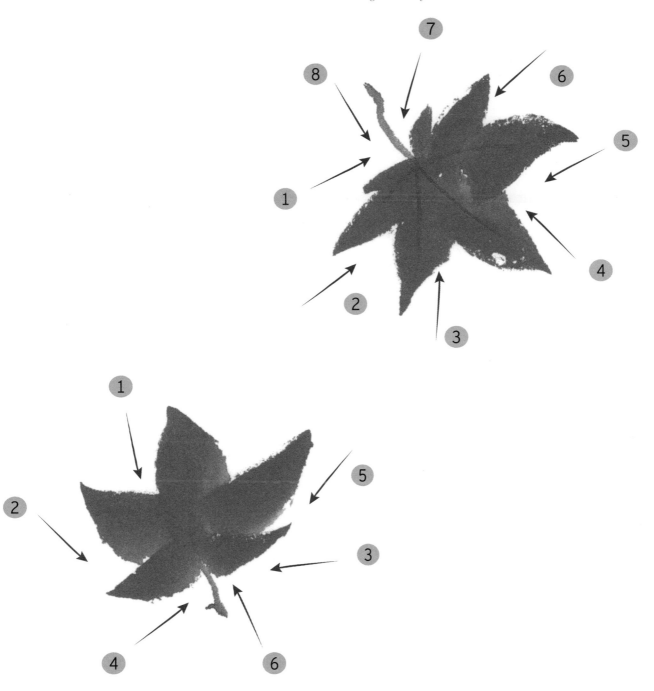

Painting the maple leaves.

In Japan, the Chinese symbol for 'red leaves' is used to describe the autumn colours of the trees, because that is where the red colour is particularly highly developed. The spatial depth and dynamism on the two cards is the result of the strong texture of the fibre paper, achieved with straw for the red leaves (6.9cm × 15.2cm / 3in × 6in), while the yellow one is painted on Unryu fibre paper (10.5cm × 14.4cm / 4in × 6in). The work was painted in light cadmium red gouache, medium yellow cadmium and ultramarine. The three colours were mixed for the veins and stalks. The yellow leaf was stuck on coloured artist's paper (10.2cm × 14.4cm / 4in × 6in), the red ones on Himalayan paper (10.5cm × 20cm / 4in × 8in).

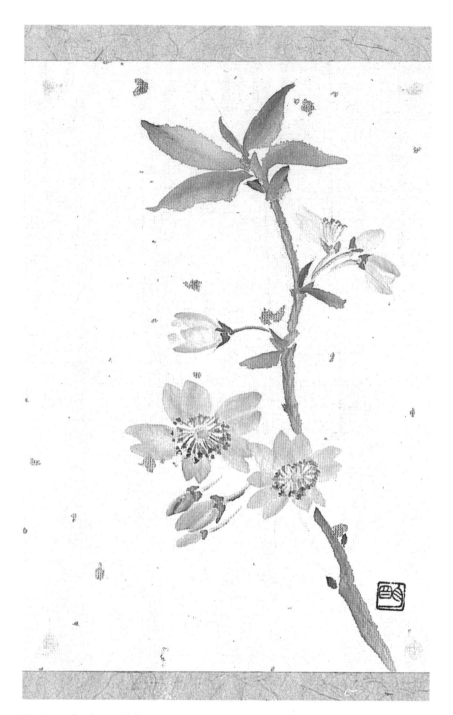

Twig with cherry blossoms.

Cherry blossoms are another popular motif in Japan. The beautiful but short-lived blossoms are a metaphor for the fleeting nature of life. The Japanese cherry blossom festival, which has now been immortalised in a German film entitled Hanami, is celebrated between March and May, depending on the region. It is the festival of life and the senses. This painting was created in black ink and white, red, brown and green gouache on white Sunago paper measuring 11.5cm × 17cm (4½in × 7in) glued onto firm silk paper measuring 11.5cm × 21cm (4½in × 8in).

A delicate rose, the flower of love.

This motif is essential on all sorts of cards. As in Europe (e.g. Madonna in the Rose Bower by Stefan Lochner, 15th century), roses have featured in Japanese paintings for centuries. A rose like this one has long been a symbol of love in Western culture, and the same now also applies in the East. This rose was painted in black ink and red gouache on Gasen-shi paper measuring 10.5cm × 19cm (4in × 7½in) using Kahari supporting paper (12cm × 21cm / 5in × 8in).

Mounting finished pictures

The moisture in paint very quickly causes the thin paper used for the brush technique to become wavy when paint is applied. This can be corrected by mounting the picture on reinforced paper using glue. Although this is quite a laborious process, it is worth it because

• the paper becomes smooth again
• it improves the brilliance and intensity of the colours, and
• the paper is made stronger.

What you will need for mounting

• Long-fibred, smooth, untreated supporting paper as a mount that needs to be 3–4cm (1–1½in) wider on all four sides than the picture being glued to it
• Thin glue made from wheat flour
• A spray bottle

• A soft glue brush, e.g. a wide goat's hair brush
• A soft wallpaper or clothes brush
• Old newspaper and paper towels
• A wooden rod (e.g. a ruler) to help lift the glued paper

Because you are using glue, it is best to work on a coated surface (e.g. kitchen counter). Glue the picture onto the mount on a vertical surface, such as a laminate-covered door, to dry.

How to do it

The following instructions apply for small formats, for which this method is ideal (there is another method in which you apply the glue to the back of the picture). Do work carefully, though, because wet paper can quickly tear.

Step 1

• *Place the painting face down on the table, parallel to the edge.*
• *Spray the back of the painting with clear water from a distance of about 30cm (12in).*
• *Carefully place the moistened picture face down on the newspaper.*
• *Dry the table and put the painting back on it.*

Step 2

• *Place the supporting paper face down so that all four sides extend beyond the painting by 3–4cm (1–1½in).*
• *Fold the right edge of the supporting paper up about 2cm (1in).*
• *Brush a strip of wheat glue – about 2cm (1in) wide – on the table in the spot where you folded up the supporting paper.*
• *Push the 2cm (1in), folded-up strip of supporting paper onto the strip of glue to set.*

Step 3

• *Lift up the supporting paper on the left side, and fold it to the right. Now, this side is face up and the folded section on the left.*
• *Spread glue over the front of the supporting paper, ideally in a cross (starting at the folded side), and then diagonally.*
• *Apply glue all over in parallel stripes.*
• *Place a wooden rod (or ruler) on the outer right side, and use it to fold the narrow strip of paper over to the left.*

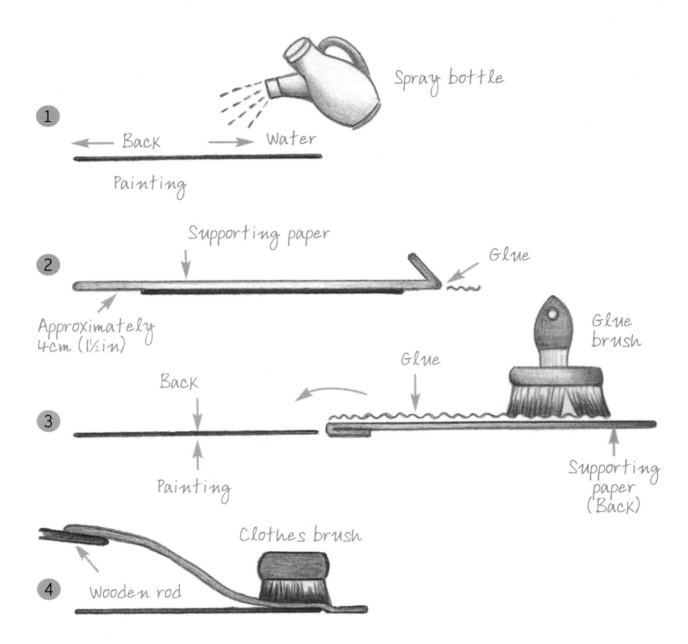

Spray bottle

1

← Back ─── Water →

Painting

Supporting paper

Glue

2

Approximately
4cm (1½in)

**Glue
brush**

Back

Glue

3

Painting

Supporting
paper
(Back)

Clothes brush

4

Wooden rod

Step 4

• Lift the back of the supporting paper with the wooden rod, and fold it to the left over the back of the painting. The glued strip of supporting paper will now be back on the right side. Make sure that the supporting paper extends by 3–4cm (1–1½in).

• Now, take a soft brush and brush in strips, starting on the right and working from top to bottom, to press the glued supporting paper onto the painting.

• Hold the left side of the supporting paper up until everything else has been pressed down. This will help to eliminate air bubbles. The supporting paper will now be glued smoothly to the back of the painting, and the excess backing paper to the table.

Good advice

Do not mount the picture for about a week or so, until it is properly dry.

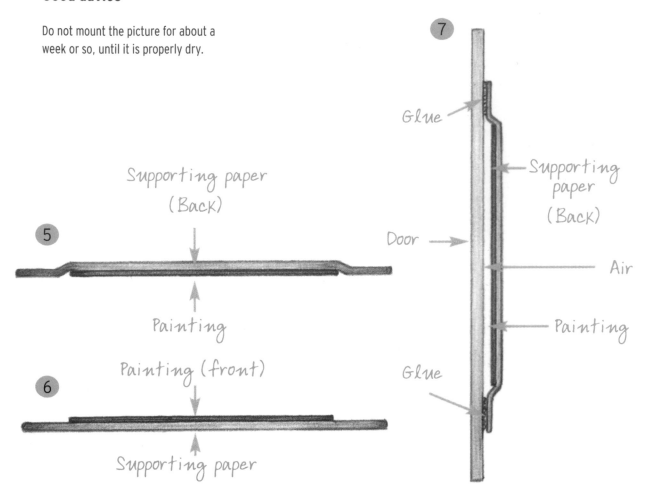

Supporting paper (Back)

↓

Painting

↑

5

Painting (front)

↓

6

↑

Supporting paper

7

Glue

Supporting paper (Back)

Door →

Air

Painting

Glue

Steps 5 and 6

• This newly created unit needs to be turned over.
• Remove the glued excess supporting paper and painting from the table, starting at the corner, and turn it over. The painting is now face side up.
• If you find it difficult to lift the new unit consisting of the painting and the supporting paper off the table, carefully slide a sewing needle between the paper and the table, and press against the supporting paper to lift.
• If the painting is soaked in glue, place newspaper on top and brush it with the brush, then remove the newspaper straight away.

Step 7

• Dry the picture. Apply another strip of glue, maximum 2cm (1in) wide, to the extending edges on the front of the supporting paper. To keep the glue off the painting, move the glue brush in short strokes at a right angle – away from the painting and towards the outer edge.
• Glue the top edge only of the supporting paper and the glued-on painting to a vertical (e.g. coated door or Resopal panel) and release. The other three edges will glue automatically as the painting moves down. An air bubble will remain in the middle for drying.
• Just to be sure, though, press firmly on all four edges again.

• Leave the painting for a few days until it is completely dry before removing.

The seal – the personal touch

'Fragrant Grass' was the name given to me by my master. Nothing very special; most people think it is a weed, but it is a fragrant weed! Later on, he gave me the name 'Little Elegance' and a seal to go with the name. It was an exciting moment when he told me that he was about to choose my name, because this is the equivalent of a certificate bestowed only after the conclusion of a long apprenticeship. It means that one has successfully completed one's study, and is able and ready to continue the journey. At first, I thought it was an indication of what my master thought of me, but then I found out that the name 'Little Elegance' is also the title of the oldest collection of Chinese lyric poetry.

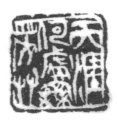

About the history of the seal

In ancient times, only rulers and institutions, such as temples, had their own seals. It was not until the 14th century in China, and the end of the 17th century in Japan, that individual artists, such as painters and calligraphers, used seals to sign their work.

Very special characters, so-called 'seal letters', are carved into the surface of conventional seals in a very specific style. Since the end of the Zhon Dynasty, from about 300 BC until the middle of the 6th century AD, a variety of seal letters were used.

Seals were used not only when a picture was completed but also as a sign of ownership. If one had acquired a picture or calligraphy, then applying one's seal to it not only made it one's property, but it was also an expression of appreciation. A seal can also be used as a signature.

If a poem or praise was added to the painting, the person would sign his name as well as attach his own seal. Many famous paintings have a great number of seals printed on them, signifying how much they were appreciated over time by their respective owners.

The appearance of the seal

The surface of the seal represents a small cosmos and, in a way, is a picture in itself. It often serves as an accent or balance to the composition, existing in harmony within the painting, each enhancing the other.

Today, there are no longer any restrictions on the use of characters. The Japanese syllabary, kana, as well as modern Chinese lettering and even Latin script are used today.

In the past, it was customary to produce white letters on a red background (negative) for official and institutional use, and red letters on a white background (positive) for the signature of an artist. But even this rule no longer applies to an artist's seal. The surface of a seal may be square, rectangular, oblong, oval or round.

In times past, artists chose oblong seals with texts written vertically in the upper right side. Oval and round seals often contained congratulatory texts, and later texts chosen by the artists, lines from a poem or a life philosophy.

1 Little Elegance
2 Fragrant Grass
3 Naomi (true, natural, beautiful)
4 Fragrant grass in the distance
5 Little Elegance
6 Truth
7 Clarity
8 Something different, a little wonderful
9 The traveller is getting old quickly
10 The dream is my home
11 A colourful room
12 Enchanted by the ink
13 Lonely boat (loner)
14 Even in the distance there is fragrant grass
15 Fragrant grass in the distance
16 Calmness makes change possible
17 Wake up
18 Fragrant Grass
19 The finished room
20 In the autumn the water gets cold

My seals

I have already mentioned that it is nice to have a number of seals so the right ones can be chosen to go with particular motifs or themes. My collection will show you just how varied they can be. You will probably notice that a number of seals can have the same name.

Making your own seal

If you are making your own seal, first choose a personal text. Make yourself a number of seals with different texts in different shapes and sizes, and then you can choose them to suit the graphics or composition of a particular picture.

Since ancient times, stones from the mountains of China, such as the Juzan or Sheiden stone, have been used as seal stamps. However, you can also use simple soapstone, or even carve one from a piece of wood.

There are special knives with two finished sides for cutting, but you can also use an etching needle or woodcarving knife. The ink that is used has the consistency of thick honey. It is made from vermilion, certain oils and plant fibres. However, due to the mineral pigments and the complicated production process that assure a beautiful, non-fading, durable ink with good adhesive properties, it is not cheap – but you can also use other chemically produced paints or inks.

Carving and placing the seal

• The surface of the stone must be smooth and even. If it is not, put a piece of sandpaper on a flat surface. Holding the stone vertically, move it over the sandpaper in large, circular movements, applying uniform pressure throughout.
• The letters are carved into the stone in mirror image. This is easy to do if you trace them back to front.
• Make sure that the cut or etched lines are not too weak. Here, too, dynamics are appreciated.
A balance between the carved and free space of the seal is important.

• When the seal is finished, the seal maker deliberately 'damages' lines and edges to make them irregular, which makes the seal appear to be old and venerable. This can make the lines crumble a little, but this is desirable and nothing to worry about.
• A seal is usually used in a place where there is an indication of movement in the painting or where it demands a counterweight for balance.
• As a general rule, a seal must never interfere with what has been painted.

A little about purchasing materials

The level of difficulty you experience when purchasing your materials depends on what your requirements are. The first requirement is that you should be able to work well with the materials.

Today, many stores selling artist's products stock sturdy quality grinding stones and ink sticks, as do all the specialists. Mail order companies (check the Internet) offer many of the materials I have mentioned, including original Japanese paintbrushes. In major cities, Japanese and Chinese shops often stock study quality materials for calligraphy, which are also ideal for ink painting.

Making brushes is still very much the task for skilled craftsmen in Japan, and that is invariably reflected in the prices. Do exercise caution when looking at so-called bargains. Likewise, the prices for European watercolour brushes made from the hairs of the Siberian Kolinsky marten are also high, even though

their production is now largely automated.
With regard to paper, the above sources also stock Chinese calligraphy paper from the two Chinese states: Taiwan and the People's Republic of China. Japanese shops in cities stock various practise papers, such as Hanshi for calligraphy. This paper is easy to use both with regard to format and handling, and is ideal for showing the tonality of the ink. Papers of this kind are usually made mechanically.

For those with very high requirements, major art suppliers also stock handmade paper, and the Internet is another source. Out of the vast range of Asian papers, the varieties Kahari and Lokta from Nepal are not really suitable for ink painting because they make the ink look very matt and monotonous.

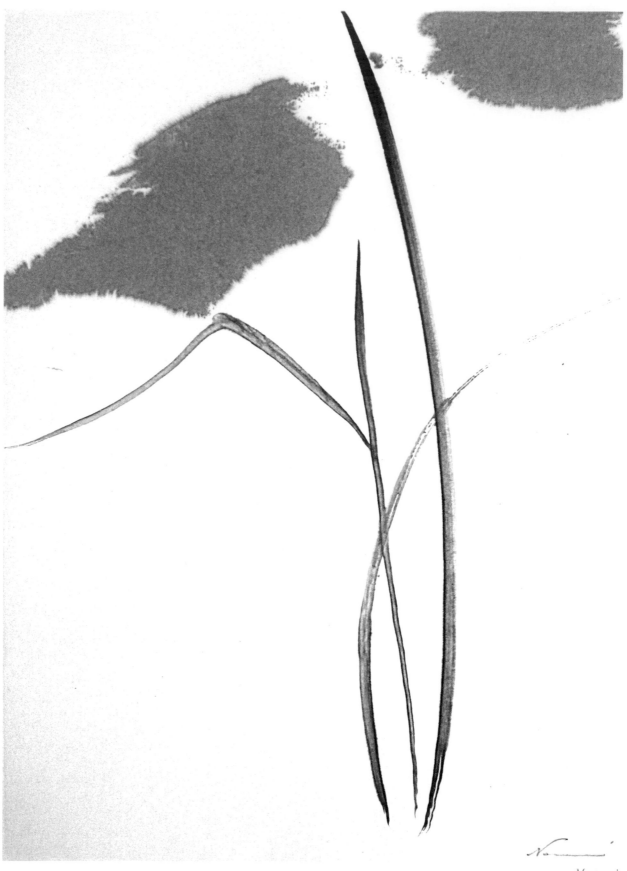

Moment

Afterword

By now, you may have found that working with the brush was not quite as easy as you first may have thought. However, your pictures can have a strong radiance even if they do not look quite like the originals. After all, they are your personal pictures and they are deserving of appreciation.

As far as technique is concerned, just remember the old adage 'practice makes perfect'. I really hope you have not been disappointed by your first attempts and that your passion for ink painting has not waned. If you did find yourself feeling a little frustrated from time to time, that could well be because of my very high standards and expectations! I am one of those people who are very critical of themselves and always strive for the highest standards.

Over the course of my journey, I initially explored many different directions in addition to the Japanese and Chinese methods. I explored Haiga, the pretty illustrations that go with haikus (short Japanese poems); Zen painting (which is very powerful but also sometimes quite monotonous); Chi Pai-Shih, a more humorous style of painting; as well as the old Japanese Maruyama school and contemporary Sumi-e painting. Eventually, in line with the Japanese aesthetic, I chose a specific direction and made it my own. I have dubbed it 'Japanese ink painting'.

This (my) kind of painting is not a doctrine. You can feel free to paint even just using some ink from a bottle and applying brushstrokes working in a monotone, or, you can paint some pretty illustrations in simple lines – anything really does go. The main thing is that you are happy with what you paint.

However, I would also advise you to address different style directions in ink painting and to try copying these pictures (see Thoughts on painting using originals, page 40). The more you do, the more your technique will improve. And a constant succession of 'aha!' moments will help you to understand the Japanese way of thinking.

These days when everyone is looking for instant fun and success, Japan still teaches traditional art using strict discipline and patient practise. So it goes without saying that learning something new requires a certain amount of effort: if you admire something terrific, you need to be disciplined as you learn about it. Practise the technique until you have completely mastered it and then you can introduce your own individual ideas into a picture.

Finally, I hope that both of us, you and me, have learnt something important and enduring from this book. Special thanks to my publisher for the trust they showed me and this project, and also to my editor, Manfred Braun, for his competent and friendly support and encouragement. Without them, this book would not have been possible.

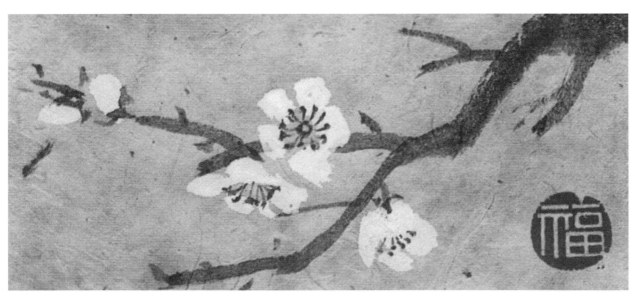

Note.
*I have written haikus to go with a number of the
pictures. These are short Japanese poems that originally
consisted of three lines of 5-7-5 syllables and are about
the natural environment. Poems by two of the most
important representatives of this art form were
chosen: Matsuo Basho (1644–1694) and
Yosa Buson (1716–1784).*

About the author

Naomi Okamoto was born near Tokyo, Japan in 1951. She studied painting, calligraphy, aesthetics, history of art and literature before moving to Germany in 1976. Over the years, she has studied under famous Japanese and Chinese masters of ink painting.

Naomi's artwork, which incorporates various Eastern and Western techniques, has been exhibited in Tokyo, Kyoto, Westerland-Sylt, Hamburg, Dortmund, Bonn, Cologne, Mannheim, Saarbrücken, Stuttgart, Munich and Münster.

Today, Naomi lives in Münster, Westphalia, Germany and teaches courses in Germany, Austria and Switzerland. She is a Member of the Federal Association of Artists or *Bundesverband Bildender Künstler* (BBK) and has published various books on the subject of ink painting in Germany and in the USA both under her own name as well as the pseudonym 'Emi Akamutsu'.

Publishing information

First published in Great Britain 2015
Search Press
Wellwood, North Farm Road
Tunbridge Wells, Kent TN2 3DR

Copyright © Edition Michael Fischer GmbH, 2013

Original German edition published as
*SUMI-E Japanische Tuschemalerei:
Techniken & kultureller Hintergrund*

This translation of *SUMI-E*, first published in Germany by Edition Michael Fischer GmbH in 2013, is published by arrangement with Silke Bruenink Agency, Munich, Germany.

English translation by Burravoe Translation Services

English typesetting by GreenGate Publishing Services, Tonbridge

ISBN 978-1-78221-144-0

Printed in China

For a complete list of all our books see
www.searchpress.com

FOLLOW US ON:

twitter
www.twitter.com/searchpress

facebook
Search Press Art and Craft Books

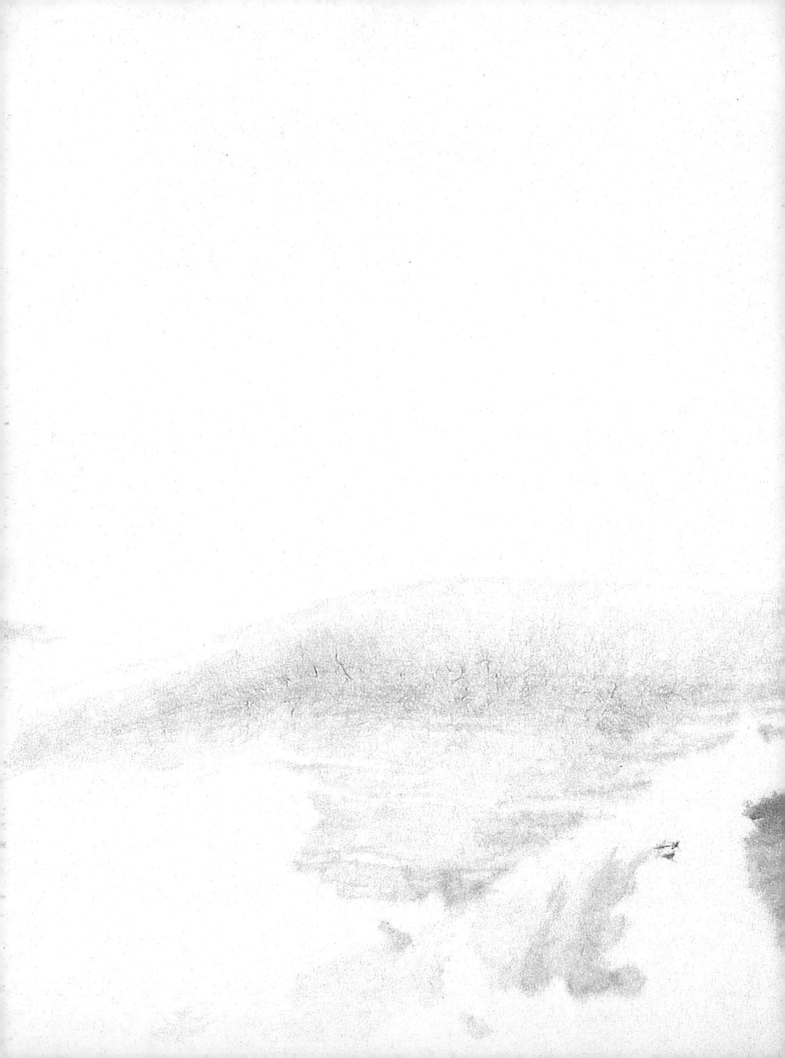